Edouard Manet
GRAPHIC WORKS

Edouard Manet
GRAPHIC WORKS
A DEFINITIVE CATALOGUE RAISONNÉ

JEAN C. HARRIS

Collectors Editions
NEW YORK

Contents

ERRATA

p. 14, lefthand column, line 14: FOCILLION, HENRI should read
FOCILLON, HENRI.

p. 244, lines 16-25: Acknowledgments for Fig 163(a-g)
should read:
Courtesy, Museum of Fine Arts, Boston, Gift of W. G.
Russell Allen
 a) *Under the lamp*
 c) *At the window,* state 2
 e) *The raven on the bust of Pallas,* state 2
 g) *Flying raven: ex libris*
Collection unknown
 b) *At the window,* state 1
 f) *The chair*
Cabinet des Estampes, Bibliothèque Nationale, Paris
 d) *The raven on the bust of Pallas,* state 1

ACKNOWLEDGMENTS

In an undertaking of such comprehensive scope, many people are involved. Needless to say, this publication would not have been possible had it not been for the good will, advice and encouragement of many individuals who freely rendered assistance to my endeavors.

I must first express my deep gratitude to the Faculty Grants Committee of Mount Holyoke College, whose generous contribution facilitated this publication. The grant which they awarded paid for the photographs, which are an essential part of this volume.

I wish to express my undying gratitude to all those overworked and sympathetic curators of print rooms in the United States and in France who helped me in my research. To Jean Adhémar and Michel Melot of the Cabinet des Estampes at the Bibliothèque Nationale in Paris I owe a special debt of gratitude for giving so much time to my problems and for facilitating trans-oceanic affairs so beautifully.

From the beginning of my interest in Manet's prints, Agnes Mongan and Ruth Magurn of the Fogg Art Museum have given me every available assistance and type of information at their disposal. Alan Shestack of the Yale University Art Gallery and Victor Carlson of the Baltimore Museum of Art have both been extremely generous with their time and assistance when I needed them. It would be impossible adequately to thank Heinrich Schwarz of the Davison Art Center, Wesleyan University, but I extend to him my heartfelt thanks for his helpful suggestions. Elizabeth Roth, curator of the Prints Division of the New York Public Library, has been most generous with the astounding wealth of material on Manet's graphics which is under her care. Without the superb resources of this institution, my task would have been almost impossible.

Finally, to my friends and colleagues who have helped me with answers to pesky questions and many other important details in my investigations, I express my thanks. I want particularly to thank Joel Isaacson of the University of Michigan, Alain De Leiris of the University of Maryland, and Anne Coffin Hanson of New York University. Without Mrs. Hanson's guidance and editorial advice, this volume would probably never have seen the light of day, for it was she who originally encouraged me to work it over for publication. Her careful reading and sound suggestions are really what have made this book possible. My deepest gratitude goes to her.

South Hadley, Massachusetts
July, 1969

Edouard Manet
GRAPHIC WORKS

Introduction

I: BACKGROUND AND INFLUENCES

ABOUT 1860, when Manet embarked upon his career as a graphic artist, Paris was in the throes of a revival of etching as a fine art. Historians of the graphic arts differ as to whether this renewal of interest actually constituted a genuine renaissance,[1] but the fact remains that the period was proclaimed by litterateurs and critics as a new era in French printmaking.[2] As etching was being enthusiastically taken up by some of the most "progressive" young artists of the time, Manet, setting forth in what was for him an untried medium of expression, was allying himself with one of the outstanding "avant-garde" movements of the period.[3] In order clearly to comprehend the fundamental characteristics of Manet's graphic works, it is necessary to examine briefly the sources, motivations, and general aesthetic which brought about the change in attitude toward etching and toward the graphic arts in general in the middle of the nineteenth century.

Before the 1850's very few major nineteenth-century painters became involved in making etchings.[4] Those etchings and lithographs which were produced were copies by very skilled artisans used to illustrate books and periodicals.[5] Although portfolios of etchings by outstanding artists were issued now and then, the public showed little eagerness to buy them, so that the practice was not widespread. The situation changed somewhat in 1850, when Méryon published his Paris set of etchings; by the 1860's, the movement had assumed large enough proportions that etching came to be considered truly another branch of the fine arts.[6]

The event which most clearly symbolizes the new status of etching was the formation, in May, 1862, of the Société des Aquafortistes.[7] This organization, started under the aegis of the publisher Cadart and the printer Delâtre, promised to its subscribers annual series of etchings executed by some of the outstanding artists of the time. The first publication of the group, issued in September, 1862, contained four plates, one each by Daubigny, Bracquemond, Legros, and Manet.[8]

Manet's first contact with the artists who were most closely associated with the formation of the Société des Aquafortistes and thus with the new prominence of etching came in 1859, when, probably through Baudelaire, who championed the graphic revival in his writings, he made the acquaintance of Bracquemond, Legros, and Ribot, as well as Whistler and Fantin-Latour.[9] Each of these artists had by this time already attained a competent and individual style in the graphic

[1] L. Rosenthal, *Manet aquafortiste et lithographe,* Paris, 1925, 14, takes the position of critics and writers on art of the sixties that there really was a genuine revival, even though it was limited in its appeal. F. Courboin, *La gravure en France des origines à 1900,* Paris, 1923, 178f., doubts the existence of such a revival; he feels that there was, generally speaking, about the same amount of interest in etching throughout the first sixty years of the nineteenth century in France, that etching, in other words, never really had died out as an art form.

[2] Note the enthusiasm expressed by Gautier, Burty and Baudelaire, quoted briefly in Rosenthal, *Manet,* 14.

[3] Rosenthal, *Manet,* 11.

[4] Ingres made only one etching, a portrait of M. de Pressigny, in 1816. Delacroix made 25 etchings, but none of them was ever published during his lifetime. Géricault made one etching, and Prud'hon one. L. Rosenthal, *La Gravure,* Paris, 1909, 357-58.

[5] Rosenthal, *La Gravure,* 356-60. Rosenthal cites many examples of etchers and lithographers whose major function was to reproduce the work of other artists in painting and printmaking. Men skilled in working upon the copper plate were also employed to copy daguerreotypes and to touch up photomechanically produced plates for printing in books and illustrated periodicals. See Josef Maria Eder, *History of Photography,* trans. by Edward Epstean, New York, Columbia University Press, 1945, 331.

[6] Rosenthal, *Manet,* 13. Some of the impressive series of etchings which began to appear in 1850 include the Paris views by Méryon, a *Cahier* by Daubigny, which appeared in 1851, and several individual pieces by Bracquemond, whose career as an etcher began in 1852 with the print *Le haut d'un battant de porte.*

[7] Rosenthal, *Manet,* 21.

[8] Rosenthal, *Manet,* 22.

[9] N. G. Sandblad, *Manet: Three Studies in Artistic Conception,* Lund, 1954, 55-56, suggests that Manet met Baudelaire in 1859. Both Whistler and Fantin-Latour were in Paris in 1858 and frequented the Louvre, where they might easily have met Manet. In 1859, Whistler, Fantin-Latour, Legros and Ribot all had their Salon entries refused and then exhibited at Bonvin's gallery in the Rue St. Jacques. Manet's entry to the Salon of 1859 was also refused by the jury. In view of the close relations between all of these young artists at this period, it would be very surprising if Manet had not encountered them even before he met Baudelaire. See discussion of these years in Léonce Bénédite, "Whistler," *Gazette des Beaux-Arts,* 33 (1905), 403-10.

medium. The influence of these masters on the novice is to be expected, but, interestingly enough, it is discernible only in a very general way in characteristics such as simplicity of composition, boldness and clarity of value contrasts, and spontaneity of drawing. At the same time, these same characteristics were by no means uniformly employed by the leading masters of the etching revival. Thus, from the start of his career as a graphic artist, Manet acted as an individual, developing and exploiting his own vocabulary of line and tone.

From the standpoint of chronology, both Bracquemond and Daubigny began etching before any of the other members of the Société des Aquafortistes.[10] Bracquemond was by far the most experienced technician of the group; each of the other painter-etchers seems to have sought his aid at some point in the process of etching.[11] But Bracquemond's style of etching shows little real affinity with that of the other members of the group. In his etchings of the fifties, such as *The Top of the Swinging Door* of 1852 (Béraldi 110), *The Raven* of 1859 (Béraldi 115), and *The Duck* of 1856 (Béraldi 116), he uses subtle gradations of value, precise drawing and very regular cross-hatching, devices which the others rarely used. Like the other painter-etchers, he favored the simple, limited motif, but unlike them, he used a wide variety of linear accents and a precision of detail.

In general, Manet's earliest etchings have more in common with the work of Legros and Daubigny than with that of Bracquemond. Legros' style, already distinctive in 1860 when he executed a series of etchings inspired by a trip to Spain, is much freer and bolder than Bracquemond's. In a print such as the *Spanish Church Choir* (Malassis-Thibaudeau 50), his use of strong value contrasts and simple surface divisions is evident. This and other prints from the Spanish series have little of the delicacy and finesse that characterize Bracquemond's works,

but are very spontaneous in their drawing. The same features are displayed in Daubigny's and Ribot's etchings of this period.[12]

In many ways, the new style of etching is most admirably illustrated in the works of Whistler, an artist who was not actively engaged in the organization of the Société des Aquafortistes. His first series of etchings, the *French Set*, aroused great enthusiasm among the young artists of Paris when they were exhibited in 1859.[13] Even in these early works, Whistler handled the etching needle with great refinement, depending upon breadth and economy of line to suggest forms. Manet undoubtedly knew Whistler's works, and although his prints differ from those by the American artist, he must have been very much in sympathy with Whistler's approach to the rendering of visual experience.

Manet's newly formed acquaintance with the leaders of the etching revival not only familiarized him with the most outstanding contemporary graphic works, but also added to his knowledge of the history of the graphic arts. It had become increasingly easy to obtain information about earlier graphic examples, for in the course of the fifties, a number of books had appeared which dealt with the work of the old masters of etching and engraving, men like Rembrandt, Goya, Callot, Canaletto, and the Tiepolos.[14] Manet was an avid collector of prints himself [15] and was, by the testimony of Duret, well versed in past productions in the graphic media.[16]

Although the new movement in etching was dependent to some extent upon the styles of the great etchers of the past, one of the major reasons for the renewal of interest was the recognition of its effectiveness as a medium of individual expression through its untraditional features and adaptability to a variety of styles. This characteristic resulted in a remarkable lack of stylistic consistency in the works of the fifties and sixties, in a stylelessness which might be described as deliberate informality. Partially as a reaction to

[10] See note 6 above. Daubigny apparently began etching seriously in 1851; Bracquemond in 1852. See Léonce Bénédite, "Bracquemond," *Art et Décoration,* 1905, 43.

[11] Manet often had recourse to Bracquemond's assistance, as did other artists, such as Courbet, who sought Bracquemond's help in biting the plate of his print version of *Les demoiselles du village.* Rosenthal, *Manet,* 37.

[12] See, for example, Daubigny's etchings *L'Ondée* (Delteil 85) of 1851 and *Le grand parc à moutons* (Delteil 95) of 1860. See Ribot's series of cooks, especially Béraldi 5, which shows a group of five servants.

[13] E. R. Pennell, *Whistler the Friend,* London-Philadelphia, 1930, 52.

[14] In 1859, the Goncourts published their first edition of *L'art du XVIIIᵉ siècle,* dedicated to Saint-Aubin. In 1860, E. Méaume published *La vie et l'oeuvre de Callot.* In 1859, Charles Blanc's book on Rembrandt appeared, ac-

companied by copies of his etchings made by several different artists. See Courboin, *La gravure en France,* 106-107, and Rosenthal, *La gravure,* 20.

[15] See the inventory of the contents of Manet's studio on his death, Paul Jamot, Georges Wildenstein, and Marie-Louise Bataille, *Manet,* Paris, 1932 (hereinafter cited as J.W.B.), I, 108, in which portfolios of prints are mentioned containing works by a great variety of etchers, from Goya and Debucourt of the eighteenth century to Legros and Bracquemond of the period contemporary with Manet. Jean Adhémar, "Notes et documents: Manet et l'estampe," *Nouvelles de l'estampe,* VII (1965), 230, draws attention to Manet's having obtained permission to work in the Cabinet des estampes at the Bibliothèque Nationale on November 26, 1858.

[16] Théodore Duret, *Histoire d'Edouard Manet et de son oeuvre,* Paris, 1926, 163.

the extreme style-consciousness of the earlier part of the century, each man associated with the etching revival strove to develop a personal style so as to avoid associational references. The artist-etchers strove to create each work anew, to see each motif as if for the first time, in other words, to be naïve. This desire for calculated artlessness led many artists to visual sources which were considered by most people non-art, such as caricature and fashion illustration.[17]

The recognition of the artistic worth of such forms of popular illustration was formulated in the criticism and aesthetics of the three outstanding champions of the graphic arts revival, Champfleury, Baudelaire and Gautier. In examining the critical writings of these men, one must credit them with a very important role in the development of the new interest in the graphic media, for their aesthetic positions would seem to have been clearly established for several years at least before the emergence of any considerable number of prints by important artists. Certainly, their encouragement must have played a large part in perpetuating the etching revival. For each of these men, the appreciation of so-called "popular" art forms provided an opportunity to criticize the ills of contemporary society and to suggest various means of curing those ills.

All three men were interested in caricature, although for somewhat different reasons. For Champfleury, the Socialist, the subject matter with which caricature dealt was what determined its true importance, while for Baudelaire and Gautier, it was the execution or personality evident in the handling of images which was the outstanding quality of such works. But, in the case of each of these writers, there is a unifying bond: a demand for sincerity and vigorous expression which they all found lacking in the work that turned up in the Salon every year.

Champfleury did not publish his *Histoire de la caricature moderne* until 1865, but his ideas on the subject had been formulated as early as 1845.[18] In this book, he indicates that for him the supreme importance of caricature lies in its expression of the feeling of the masses as opposed to those of the aristocracy:

La caricature est avec le journal le cri des citoyens. Ce que ceux-ci ne peuvent exprimer est traduit par des hommes dont la mission consiste à mettre en lumière les sentiments intimes du peuple.[19]

But this champion of the people also turned his attention to the stylistic aspects of caricature, its passions, its vivid expression of sentiments, in which "une sensation si vive se paye par un manque de correction." [20] He points to the innate primitivism of caricature: "il y a en caricature comme en peinture des primitifs auxquels on ne peut demander que la naïveté." [21] A lack of correction and a quality of naïveté, then, are Champfleury's estimates of the characteristics of the style of this "popular" art form. He also extols the artistry of caricature in the hands of Daumier and Goya, whose images form part of a universal language transcending boundaries of time and place, since their meaning can be grasped even when there are no titles attached to the pictures.[22]

Baudelaire's aesthetic includes an appreciation of various types of non-art. Thus, his sympathetic treatment of caricature is only one aspect of a critical position which encompasses many visual sources contributing to the formation of the "modern" style. Although his projected history of caricature never saw the light of day, his ideas on the subject are expressed in his essay *Le rire* and in his two articles on caricaturists.[23] In the latter, Baudelaire praises particularly Daumier and Goya as great artists whose works illustrate the importance of caricature in the hierarchy of human achievement in the visual arts. He draws attention to those qualities in Daumier's handling which betray the personality of the great artists:

Son dessin est abondant, facile, c'est une improvisation suivie; et pourtant ce n'est jamais du *chic*. . . . C'est la logique du savant transportée dans un art léger, fugace, qui a contre lui la mobilité même de la vie. . . . Ce qui complète le caractère remarquable

[17] Meyer Schapiro, "Courbet and Popular Imagery," *Journal of the Courtauld and Warburg Institutes*, 3-4 (April-July, 1941), 164-191, *passim*. Although the use of the word naïve by Baudelaire often refers to the power of the imagination as opposed to the intellect, there is also implied in his usage the concept of artlessness or ingenuousness, just as there is in Champfleury's usage. Because of their belief in artlessness, both of these writers single out non-art forms of expression as worthy of serious interest. See discussion below and note 32. For a further discussion of Baudelaire's use of the word "naïve," see Margaret Gilman, *Baudelaire the Critic*, New York, 1943, 127.

[18] According to E. F. Bouvier, *La bataille réaliste, 1844-1857*, Paris, 1913, 87, Champfleury began to think of caricature as a serious art form about 1846. Gilman, *Baudelaire the Critic*, 83, says that Baudelaire was planning to write a history of caricature from 1845 on; his first published views on the subject are found in 1857 in "Quelque caricaturistes français," and "Quelque caricaturistes étrangers," published in *Le Présent*, and in "De l'essence de rire," in 1855 in *Le Portfeuille*.

[19] Champfleury, *Histoire de la caricature moderne*, Paris, 1865, vii.

[20] Champfleury, *Caricature*, 59.

[21] Champfleury, *Caricature*, xvii.

[22] Champfleury, *Caricature*, 83.

[23] See note 18 above.

[3]

de Daumier, et en fait un artiste spécial appartenant à l'illustre famille des maitres, c'est que son dessin est naturellement coloré. Ses lithographies et ses dessins sur bois éveillent des idées de couleur. Son crayon contient autre chose que du noir bon à délimiter des contours. Il fait deviner la couleur comme la pensée; or c'est le signe d'un art supérieur, et que tous les artistes intélligents ont clairement vu dans ses ouvrages.[24]

The same emphasis upon the personality and its importance in appreciating the great work of caricature is found in Baudelaire's critique of Goya's work. Although he does not in *Le rire* concern himself as much with Goya's style of execution as with his quality of fantasy, "l'amour de l'insaisissable, le sentiment des contrastes violents, des épouvantements de la nature et des physiognomies humaines étrangement animalisées par les circonstances," [25] at the beginning of the section on the Spanish artist, he wholeheartedly recommends an article by Théophile Gautier in the *Cabinet de l'amateur* in 1842, in which we find an appreciation of Goya's technique and expressive style very similar to that written by Baudelaire about Daumier.

Les dessins de Goya sont exécutés à l'aqua-tinta, repiqués et ravivés de l'eau-forte; rien n'est plus franc, plus libre et plus facile; un trait indique toute une physiognomie, une trainée d'ombre tient lieu de fond, ou laisse deviner de sombres paysages à demi ébauches; des gorges de sierra, théâtres tout préparés pour un meurtre, pour un sabbat ou une tertulia de Bohémiens; mais cela est rare, car le fond n'existe pas chez Goya.[26]

It is clear that there was in Baudelaire's aesthetic position a predilection for the graphic arts which, although not specifically formulated

as an aesthetic of the medium of etching in itself, accords with his preference for the suggestive, evocative power of the work of art.

The penchant for caricature as a form of artistic expression shown by each of these critics is only one aspect of their interest in the graphic arts in general, which was formed because of their desire for the development of forms imbued with qualities of brevity, spontaneity, and naïveté, or ingenuousness. Both Baudelaire and Champfleury use the word "naïveté" in their critical writings as a term of approval. In his first Salon review, that of 1845, Baudelaire praises the same qualities of directness, boldness, and freedom in an etching by Charles Jacque that he admired in Daumier's lithographs and wood engravings.[27] In his review of the Salon of 1859, he recalls briefly his pleasure at seeing the etchings of Méryon, which possess qualities of sureness and spontaneity.[28]

Baudelaire's aesthetic of etching, if it can be specifically called this, is set forth most clearly in 1862, when he wrote two articles, "L'eau-forte est à la mode," and "Peintres et aqua-fortistes," published at the time of the formation and the first issue of the Société des Aquafortistes.[29] In these two articles, he explicitly states what he considers the most praiseworthy characteristics of etching. As in his discussions of caricature, the qualities which he most admires are those of brevity, spontaneity, and intimacy.[30] He also emphasizes the rather *recherché* aspects of etching, those qualities which prevent it from becoming very popular among the masses, as well as its similarity to literature as an artistic form.[31]

The qualities most admirable in the arts of etching and caricature Baudelaire also singles out as being most laudable in modern art in general. These views are expounded in *Le peintre de la*

[24] *Oeuvres complètes de Charles Baudelaire,* Jacques Crépet ed., Paris, 1922-1953, II, 417-19.

[25] Baudelaire, *Oeuvres complètes,* II, 437.

[26] This essay by Gautier is reprinted in *Voyage en Espagne,* Paris, Charpentier, 1875, 118.

[27] Baudelaire, *Oeuvres complètes,* II, 70. "M. Jacque est une réputation nouvelle qui ira toujours grandissant, espérons-le.—Son eau-forte est très-hardie, et son sujet très-bien conçue.—Tout ce que fait M. Jacque sur le cuivre est plein d'une liberté et d'une franchise qui rappelle les vieux maîtres."

[28] Baudelaire, *Oeuvres complètes,* II, 342-43. "J'ai rarement vue représentée avec plus de poésie la solennité naturelle d'une ville immense. Les majestés de la pierre accumulée, les clochers *montrant du doigt le ciel,* les obélisques de l'industrie vomissant contre le firmament leurs coalitions de fumée, les prodigieux échafaudages des monuments en réparation, appliquant sur le corps solide de l'architecture leur achitecture à jour d'une beauté si paradoxale, le ciel tumultueux, chargé de colère et de rancune, la profondeur des perspectives augmentée par la pensée de tous les

drames qui y sont contenus, aucun des éléments complexes dont se compose le douloureux et glorieux décor de la civilisation n'était oublié."

[29] "L'eau-forte est à la mode," *Revue Anecdotique,* April 2, 1862; expanded version, "Peintres et aqua-fortistes," *Le Boulevard,* September 14, 1862, in Baudelaire, *Oeuvres complètes,* III, 111-18; 466-67.

[30] "Non seulement l'eau-forte est faite pour glorifier l'individualité de l'artiste, mais il est même impossible à l'artiste de ne pas inscrire sur la planche son individualité la plus intime." From "L'eau-forte est à la mode," Baudelaire, *Oeuvres complètes,* III, 466.

[31] "C'est un genre trop personnel, et conséquemment trop aristocratique, pour enchanter d'autres personnes que les hommes de lettres et les artistes, gens très amoureux de toute personnalité vive. . . . Parmi les différentes expressions de l'art plastique, l'eau-forte est celle qui se rapproche le plus de l'expression littéraire et qui est la mieux faite pour trahir l'homme spontané." From "L'eau-forte est à la mode," Baudelaire, *Oeuvres complètes,* III, 466.

vie moderne, which appeared in 1863.[32] This coincidence of noteworthy qualities shows how closely linked were his conceptions of caricature, etching and modern art.

In this essay, Baudelaire also indicates other types of non-art besides caricature which are profitable sources of inspiration for the modern artist, such as fashion prints and depictions of contemporary manners. At the same time, he explains that the truly modern artist is one who is like a child, naïve, and who thus produces truly modern works.[33]

It is evident, then, that Baudelaire's championing of etching as a form of expression, "si subtil et si superbe, si naïf et si profond, si gai et si sévère, qui peut réunir paradoxalement les qualités les plus diverses, et qui exprime si bien le caractère personnel de l'artiste," [34] is inextricably bound up with his views on modern art and caricature. His own definition of modern art can be said to include all the facets of his appreciation which we have examined, "Qu'est-ce que l'art pur suivant la conception moderne? C'est créer une magie suggestive contenant à la fois l'objet et le sujet, le monde extérieur à l'artiste et l'artiste lui-même." [35]

This same approach to etching as a form of artistic expression is found in other writings of the sixties which deal with the subject. In his preface to the first annual publication of the Société des Aquafortistes, published in 1863, Théophile Gautier says: "Every etching is an original drawing. . . . There is nothing finite or labored about an etching. It never belies the simplicity of the spirit in which it was conceived. It conveys its meaning by a hint, by a suggestion." [36] Again, the emphasis is upon brevity, naïveté, and intimacy of the etched impression.

The most complete statement of the aesthetics of etching is found in the writings of an English-man, Philip Gilbert Hamerton, who had worked in France and knew the French etchers well. His book, *Etching and Etchers,* published in 1868,[37] contains a thorough analysis of those qualities of etching which seem to distinguish it from painting and of the forms of expression in which etching excels. The basic ideas expressed by Hamerton are those already expressed by Baudelaire and Gautier, but they are more thoroughly developed. Although, Hamerton states at the beginning of his treatise, painting has advantages over etching, since it does not resort to lines which do not exist in nature, painting is not so well adapted to the expression of transient thoughts. The application of the colors in painting entails an abandonment of the form, while etching can attain a better idea of form in a short time, for good etchings are always done quickly. Hamerton stresses the importance of keeping the limitations of the two media, painting and etching, distinct; for him, "the aim of an etching is power by abstraction and concentration." [38] In a later chapter, he develops this idea of the abstraction of etching, qualifying his remarks by asserting that etching really is a synthesis, implying a selection which gives the sum of truths. "It is not the abstraction of etching that makes it unintelligible to the people, but the complexity of the truths which it attempts to interpret simultaneously." [39] For Hamerton, the prime concern of the etcher should be not the "motif," but the feeling communicated. Like Baudelaire and Gautier, he stresses the personal and intimate nature of the etched impression to which the artist must always subordinate himself.[40]

The rather extraordinary, and too much neglected, feature of all these writings is their formulation for the medium of etching of an aesthetic which seems not unlike that of the style of painting termed Impressionism, not in terms

[32] "Pour le croquis de moeurs, la représentation de la vie bourgeoise et les spectacles de la mode, le moyen le plus expéditif et le moins couteux est évidemment le meilleur. Plus l'artiste y mettra de beauté, plus l'oeuvre sera précieuse; mais il y a dans la vie triviale, dans la metamorphose journalière des choses extérieures, un mouvement rapide qui commande à l'artiste une égale vélocité d'exécution. Les gravures à plusieurs teintes du dix-huitième siècle ont obtenu de nouveau les faveurs de la mode, comme je le disais tout à l'heure; le pastel, l'eau-forte, l'aqua-tinte ont fourni tour à tour leurs contingents à cet immense dictionnaire de la vie moderne disseminé dans les bibliothèques, dans les cartons des amateurs et derrière les vitres des plus vulgaires boutiques." Baudelaire, *Oeuvres complètes,* III, 54.

[33] Section III of "Le peintre de la vie moderne" is entitled "L'Artiste, homme du monde, homme des foules et enfant." In many phrases, we find Baudelaire likening the artist to a child: "L'enfant voit tout en *nouveauté; il* est toujours *ivre.* . . . Mais le génie n'est que *l'enfance retrouvée à*

volonté. . . . Tous les matériaux dont la memoire s'est encombrée se classent, se rangent, s'harmonisent et subissent cette idéalisation forcée qui est le résultat d'une perception *enfantine,* c'est-à-dire d'une perception aiguë, magique à force d'ingénuité!" Baudelaire, *Ouvres complètes,* III, 55-65.

[34] From "Peintres et aquafortistes," Baudelaire, *Oeuvres complètes,* III, 113.

[35] From an incomplete article, published posthumously as "L'art philosophe," probably written about 1859. Baudelaire, *Oeuvres complètes,* III, 119. See, also, Gilman, *Baudelaire the Critic,* 216.

[36] Quoted in translation in Claude Roger-Marx, *French Original Engravings from Manet to the Present Time,* New York, Paris, London, 1939, 9.

[37] Philip Gilbert Hamerton, *Etching and Etchers,* London, 1868.

[38] Hamerton, *Etching,* 2.

[39] Hamerton, *Etching,* 46.

[40] Hamerton, *Etching,* 63.

of colored pigment, but of black and white. Impressionist innovations in painting, of course, reached a much wider public than did those in etching and thus achieved more notoriety, but they are similar in many ways to those qualities which were most admired by connoisseurs of etching in the fifties and sixties. It is no wonder, then, that so many of the artists whose names are associated with the radical developments in painting are also linked with the revival and development of etching. Indeed, in certain instances, the innovations found in the paintings of the seventies, the "high" Impressionist period, were first tried out in the etchings of the previous decade.

There is still another feature of the renaissance of the graphic arts which remains to be be more fully evaluated—its remarkable coincidence with the mania for photography. The mention of photography in connection with the development of French art of the mid-nineteenth century immediately raises very complex problems. Photography, almost from its inception, was regarded by writers and artists as a threat to other forms of visual arts. Its slavish and mechanical character was constantly derided by critics like Baudelaire and Gautier. In fact, in his preface to the 1863 publication of the Société des Aquafortistes, Gautier points to the emergence of interest in etching as a reaction against the vicious and soulless influence of photography.

In these times, when photography fascinates the vulgar by the mechanical fidelity of its reproductions, it is necessary to assert an artistic tendency in favor of free fancy and picturesque mood. The necessity of reacting against the positivism of the mirror-like apparatus has made many a painter take to the etcher's needle; and the gathering of these men of talent, annoyed at seeing the walls crowded with monotonous and soulless pictures, has given birth to the Société des Aquafortistes. It has been founded to fight photography, lithography, and aquatint and all engraving whose recrossed hatchings show a dot in the center. In other words, they are against the regular, automatic and uninspired work which deprives an artist's idea of its very nature and they wish their plates to speak to the public directly at their own risk and peril.[41]

Photography is here presented as the *bête noir* of the etching revival, the common foe against which all artists are fighting for their existence as individuals capable of personal, intimate and individual expression. It is a symbol of

the machine age, of the Industrial Revolution, against which the Romantic generation had been fighting for almost one hundred years.

At the same time, photography had a positive influence on artistic developments. Avant-garde artists recognized that all kinds of visual material, particularly those not classified as art by the academicians, could provide them with inspiration for depictions of modern life.[42] Not only did the painters learn about new subject matter from photography, from scenes such as cityscapes and sequence photographs known as cartes-de-visite, but they also learned much about the way we see as recorded by the camera eye. For instance, photographic prints of the period reproduce images in terms of bold contrasts and simplified modeling because film was not sufficiently sensitive to any but the strongest value contrasts.[43] Such bold contrasts were often exploited by avant-garde painters of the late fifties and sixties; typical examples are Manet's early figure paintings which are conceived primarily as value studies, color being used mainly to create tonal contrasts on the surface rather than to create three-dimensional structure. Compositionally, the new space of the camera image seems to have had an effect upon artists, for the camera did not record depth as artists had traditionally produced it. If the lens was focused upon objects close at hand, the area behind those objects became an indistinct blur. If a photographer wished to record a more spacious view with greater depth of focus, he had to select a vantage point quite far away from the motif. This new "visual" perspective (as opposed to the academic "artificial" or "linear") appears in paintings in the form of a telescoping of distances between near and far objects, an emphasis upon breadth of handling and modeling rather than upon detailed sharpness, lessons learned by the painters from the evidence of the "impersonal objectivity" of that very scientific instrument, the camera.

Finally, with reference particularly to the graphic arts themselves, photography provided one means, although admittedly a minor one, of keeping graphic techniques alive during the lean years of the first half of the century. From the time of the invention of the daguerreotype, pictorial images copied from metal plates were reproduced by means of lithography, aquatint, and wood-engraving to serve as illustrations in popular magazines and journals. Although one

[41] Quoted in translation in F. L. Leipnik, *History of French Etching from the Sixteenth Century to the Present Day*, London, New York, 1924, 106.
[42] Schapiro, "Courbet and Popular Imagery," *passim*.

[43] See A. Scharf and A. Jammes, "La réalisme de la photographie et la réaction des peintres," *Art de France*, IV (1964), 176f., for a discussion of this problem.

cannot equate the mere craftsmanship required for mechanical reproduction with the free and spontaneous drawing effects favored by the champions of the printmaking revival, it cannot be denied that the existence of such graphic reproductive processes provided a partial catalyst for more creative achievements which occurred in the sixties.

In summary, it can be seen that a rather curious situation existed in French art between about 1848 and 1860, that period which has been characterized as being "between the past and the present." [44] The camera and other means of mass reproduction represented for average people visible symbols of progress, measures of the new scientism which would eventually enable man to put an end to all the miseries of the human race. On the other hand, those artists and writers who were fighting for individuality damned these mechanical reproductive processes as blasphemous and encouraged, as a means of combatting their pernicious influence, the increased distribution of works of art which glorified the artist's touch and uniqueness.

Manet's graphic work betrays the ambivalence of the position of the graphic arts at this period. Each of his prints has the unique stamp of his personality upon it, as recommended by Romantic critics like Gautier and Baudelaire. At the same time, his work also shows a desire to exploit the graphic media as a means of placing his art before a wider public than he could otherwise have done.[45] He failed in this latter aim; this failure is undoubtedly an important factor in his gradual abandonment of printmaking in the last decade of his life.

II: STYLISTIC DEVELOPMENT

Manet's graphic works can and should be recognized as sincere and independently expressive creations. Although by no means as numerous as his paintings, his prints nevertheless exhibit many significant characteristics which must be of interest to serious students of the artist's achievements. His activities as a printmaker were somewhat sporadic, but there is no reason to doubt that when he involved himself in the graphic procedures, he took his work seriously.[46] At the same time, however, Manet was not at all interested in the technical complexities of the printmaking processes. He was perfectly content to entrust the actual pulling of proofs to an experienced printer, and he quite naturally had frequent recourse to the assistance of friends more knowledgeable than he in the graphic techniques when it came to matters such as biting the plate or applying aquatint. These evidences of his technical limitations provide no basis for the conclusion that Manet did not execute his own prints, however, for careful scrutiny of their handling reveals close similarities between his graphic and painted works as well as awareness of the special expressive qualities of the printmaking media themselves.[47]

The subjects which Manet treated in his graphic works are the same as those he treated in his oils and were, in many instances, taken directly from the paintings. His graphic interpretations of these subjects also share with the oils a sense of having been done freshly, *tout d'un coup*. In one sense, the prints give this feeling more vividly than do the oils because they are much closer to drawing. Manet may not have been a draughtsman in the usual sense of the word,[48] but he had a distinctive manner of recording what he saw and transforming it into an artistic image. He thought primarily in terms of value relationships rather than of contours and emphasized contrasts of large, massed dark with white areas. Naturally, such a procedure lent itself readily to translation into the graphic media, although in his etchings, the approach was not

[44] This is the title of Joseph C. Sloane's study, *French Painting Between the Past and the Present*, Princeton, 1951, which deals primarily with the years from 1850 to 1870. J. Richardson, *Manet*, New York, 1967, 5, characterizes Manet as a Janus-like figure, whose work and attitudes contain both progressive and conservative tendencies.

[45] Adhémar, *Nouvelles*, 231, quotes from a letter written by Manet to Degas in August, 1868, stating a desire to enable simple folk to enjoy more works of art through the dissemination of inexpensive graphic copies.

[46] As an example, we can point out that 33 of his 66 etchings were carried beyond one state before being finished, while many motifs were reworked in a succession of plates before they were considered complete.

[47] E. Moreau-Nélaton, in the Preface to his 1906 catalogue of Manet's graphic works (reprinted in M. Guérin, *L'oeuvre gravé de Manet*, Paris, 1944, 11-21) takes care of accusations, which he says have appeared in the press, that Manet did not execute his own prints (Guérin, *Manet*, 15), by asserting that he (Moreau-Nélaton) has discussed the matter with Bracquemond, who says that his only assistance was in technical matters such as biting the plate, applying aquatint and pulling prints. The same kind of assistance was rendered by Henri Guérard, the husband of Eva Gonzalez, who, after 1876, did all of Manet's printing for him. Actually, very few of the painter-etchers did their own printing; particularly in the '60's, Delâtre, who was one of the leading proponents of the etching revival, a printer and an etcher himself, did the printing for the artists (Rosenthal, *Manet*, 16).

[48] See P. Courthion, *Edouard Manet*, New York, 1961, 42.

particularly evident at first. In addition, Manet always managed to retain boldness and spontaneity in his graphic works, for he consciously avoided exploiting decorative or elegant qualities for their own sake.[49] Throughout his career as a graphic artist, then, certain unique hallmarks of his style are constant, especially his nonchalant, abbreviated form of notation coupled with a charming wit in selecting the motif.

However, despite the presence of recognizable elements which are constant in his graphic works, there are certain discernible changes in his handling of the printmaking media. These changes correspond to developments in his painting, but must be described in much more schematic terms because they are observable in a far smaller number of cases. The development of his graphic style can be seen to fall into three periods —periods which correspond to phases in his artistic development as a whole, but which are less subtly varied in character than is the case with the development in his painting style.

The first significant period falls between the early part of 1860 and the end of 1862. This block of time was Manet's most productive as a printmaker. Largely because of his involvement with the etching revival, almost all of the prints executed in this period were etchings (thirty-four out of thirty-nine). It was also during these months that he made the largest number of prints which were published with his authorization or exhibited during his lifetime. The months covered by this period coincide with the first significant phase of his career as an independent painter.[50] As in his oils, the subjects of the prints are picturesque Baroque and Romantic figure studies, Spanish dancers and Titianesque female nudes, as well as, peripherally, scenes of everyday social activity.[51]

Stylistically, although exhibiting some characteristics in common with the oils, Manet's prints of this first period manifest a greater tendency toward diversity of vocabulary than is true of the paintings. This stylistic diversity is not, of course, without its own logic. In general, Manet seems to have experimented with two quite distinctive classes of handling. One was a romantic, improvisatory manner, composed of deeply bitten, long, straight lines and active, curved strokes, similar to the style favored by contemporary etchers such as Legros, Ribot, Daubigny and Jongkind, as well as Whistler and

Seymour Haden. These artists themselves, of course, owed much in their styles to the study of the late works of Rembrandt, as well as to certain works by Goya and Tiepolo. The emphasis in this manner was upon the artist's distinctive touch, upon expressive linear activity, often independent of structural function, conveying the impression of a free and vigorous, as well as spontaneous drawing directly on the plate. In addition to being the style favored by most contemporary painter-etchers, it was also, as we have seen, the one most admired by the writers and critics who were active in promoting the etching revival.[52]

Manet very quickly developed a notable facility in this spontaneous manner during 1860 and 1861. Some of the plates from the first months of this period which were abandoned after the first state, such as *The Travelers* (cat. 4), *The Man with a Dog* (cat. 10), and the first plate of the portrait of his father (cat. 6), retain, in spite of their obvious lack of technical assurance, the impression of vigorous and free drawing on the plate. By the beginning of 1861, Manet had created several works which amply testify to his competence and understanding of this method: for example, *The Reader* (cat. 13), *The Spanish Singer* (cat. 12), and *The Little Cavaliers* (cat. 5). As a further enrichment of this method, he experimented at this time with certain devices which he must have observed in Goya's etchings, especially in those which are etched copies of paintings by Velazquez and Ribera.[53] The fine etched copy of the portrait of Philip IV in the Louvre, then believed to be by Velazquez (cat. 15), although of 1862, is an especially remarkable work of this type, both in its strong delineation of areas and shapes by means of tonal contrasts and in its retention of the feeling of spontaneous drawing on the plate.

The other treatment of etching which Manet developed during this first period presents, in marked contrast to the active linear method discussed above, a quiet tonal emphasis. Subtle shading of areas rather than bravura slashes are emphasized by means of hatching with very dense networks of lightly bitten, short strokes. Sometimes a coat of aquatint was added to reinforce the tonal qualities. This handling is in some ways less dependent upon tradition than the more spontaneous form, but some precedent is to be found in the early prints of Rembrandt,

[49] See *supra,* note 24.
[50] Sandblad, *Manet,* 18-20.
[51] Sandblad, *Manet,* 28-29.
[52] Jean C. Harris, "Manet's Graphic Work of the Sixties," in J. Isaacson, *Manet and Spain* (exhibition catalogue), Ann Arbor, 1969, 2. Here I called the manner "subjective."

[53] Goya made sixteen etched copies of works by Velazquez. That Manet was familiar with many of them cannot be doubted; as a specific documentation, we might point out that the *Portrait of Zola* of 1868 (Louvre, Paris) contains a representation of Goya's etched copy of *Los Borrachos.*

as well as in some of Goya's prints (particularly in those with aquatint). The contemporary print-maker whose works most nearly resemble Manet's in this alternate manner is Bracquemond, whose works are certainly tighter and more finicky than those of the other painter-etchers associated with the etching revival.

The tonal manner first appeared in Manet's works early in 1861 in plates such as the second version of the portrait of his father (cat. 7) and *The Candle Seller* (cat. 8). Both works are characterized by a subtle atmospheric suggestion. Later in the spring of 1861, a similar quality is found in the very lovely, almost fragile-looking handling of *The Boy with a Dog* (cat. 11), in which Manet uses the style to interpret a contemporary image in a subtly expressive manner. He also uses the style successfully to translate some of his own canvases onto the plate, notably *The Boy with a Sword* (the third version; cat. 26), *The Boy Carrying a Tray* (cat. 28), and the beautiful image of *The Urchin* (cat. 31).

By the middle of 1861, then, Manet had developed a mature competence in two quite different ways of handling etching. During the fourteen months from the middle of 1861 to the winter of 1862, he etched what are generally considered to be some of his finest and most individual prints, and in these works, he used both handlings with consummate expressiveness and ease. Beginning with the two etchings taken from his oil of *The Old Musician, The Absinthe Drinker* (cat. 16), and *The Little Girl* (cat. 19), the spontaneous linear manner received a series of vigorous interpretations, the climax of this manner occurring in two large and bold prints, *The Gypsies* (cat. 18) and *The Toilette* (cat. 20), both from the middle of 1862. The tonal manner, although not used as much as the linear manner, appears in the particularly beautiful etched version of the oil portrait of *Lola de Valence* (cat. 33), which was executed during the autumn of the year. During the autumn, also, Manet seems to have been influenced anew by Goya's etchings, but this time it was not the copies of oil paintings that interested him, but Goya's own inventions, the *Tauromaquia*. The etchings of *Mariano Camprubi* (cat. 34), *The Espada* (cat. 35), and *The Posada* (cat. 36) share actual motifs as well as the technique of fine, lightly bitten lines and free sketching with the Spanish master's series. The manner is obviously similar to that seen in *The Toilette* and

The Gypsies, but is less aggressive in its effect.

The publication by Cadart of the portfolio of nine etchings in September and the single etching of *The Gypsies* in October, 1862, were the climactic events of this first period of Manet's graphic career. Taken as a group, these works provide, as Manet no doubt intended they should, a comprehensive picture of both his graphic and painting achievements. The aspect of his print-making activity, relatively neglected in this first period as compared with his later career, was lithography. Although Manet executed five lithographs during this initial period, all of them fresh and competent, he obviously was much less interested in the technique than he was in the etching process. Three of the lithographs were commissioned works, the caricature of *Emile Ollivier* (cat. 1), the *Moorish Lament* (cat. 29), and the bust of *Lola de Valence* (cat. 32), and are handled in an appropriately bold and expressive manner. The fourth, *The Urchin* (cat. 30), although unpublished, shares with *Moorish Lament* and the portrait of *Lola* an ease and competence which shows his grasp of the technique. Only the fifth, *The Balloon* (cat. 23), presents any serious problems of analysis and interpretation, for it is frankly crude in its drawing and inexpert in composition. It is particularly noteworthy in Manet's oeuvre because it represents one of the few contemporary scenes which he executed during this first period.

The second period in the development of Manet's graphic art runs from 1863 through 1870. In these years, he was less active as a print-maker, creating only thirty-one prints in the whole span of seven years, as compared with thirty-nine executed during the two years just considered. In part because of an increased preoccupation with painting, but also in part because of serious discouragement with the reception accorded his paintings, Manet's creative activity definitely slackened at the end of the sixties.[54] The prints of this period are less experimental than they were in the first period, as is to be expected, but they are also easier to analyze and discuss stylistically because they exhibit the same stylistic concerns and developments as his paintings in the same years. The style which appears most often in the works of the late sixties, often termed "synthetist,"[55] is the one that is often considered the outstanding achievement of the first half of his career. In espousing this style, Manet forced himself to

[54] Richardson, *Manet,* 1967, 25, points to these reasons as being responsible for his diminished output in 1868.
[55] The term "synthetism" is employed by Sandblad, *Manet,* 85-87, to characterize the combination or synthesis of two- and three-dimensional forms appearing in many of Manet's

works of the '60's. In this handling, flattened or broadly painted areas are combined with diffuse, broken-color areas, but the essential structure of the picture is defined with clear surface divisions.

reject temporarily many elements which had played a prominent role in his early prints, qualities such as spontaneity, calligraphy and deep biting, in favor of a reinforcement of simplified areas and two-dimensional compositions.

The new emphasis did not appear immediately, for at the beginning of this period, Manet developed further the light, sketchy manner seen in the Goyesque prints of the end of the first period such as *The Espada* and *The Posada*. Two of the four prints which can justifiably be assigned to 1864 and 1865, the *Marine* (cat. 40) and *The Races* (cat. 41), clearly demonstrate a concern with activity and atmosphere in an almost Impressionist manner. But after his return from Spain in the fall of 1865, the "synthetist" manner makes its appearance in Manet's graphic works, becoming by the end of the decade a simplified and directly forceful artistic language.

We see the tentative beginnings of this new style in an etching of 1866 such as *The Philosopher* (cat. 47), and from this beginning we can trace the development of the manner through plates such as *The Tragic Actor* (cat. 48) of the same year, which is both richer and subtler in its tonal suggestions than the earlier print, on to the very intricate and much worked plate of the *Dead Christ with Angels* (cat. 51), ending with the refined and boldly simplified handling of the second etched version of *Olympia* (cat. 53), which appeared in Zola's brochure published on the occasion of Manet's one-man exhibition at the Pont de l'Alma in the spring of 1867. In the last two years of the decade, Manet used his new, remarkably pure style, with its carefully controlled, subtly evocative and yet directly communicative appeal, to create some of the most noteworthy examples of his mature oeuvre. In each of these works, all created to accompany literary works, *Exotic Flower* (cat. 57), *The Cats' Rendezvous* (cat. 58), and *The Cat and Flowers* (cat. 65), as well as in the stylistically related *Dead Toreador* (cat. 55), we recognize the "synthetism" of the oils of the same period translated into a graphic vocabulary with extreme economy and control of tonal variation.

Curiously, but perhaps not surprisingly, Manet did not entirely abandon his interest in subtle, tonal atmospheric handling in the late sixties, even though the bulk of his output tended toward a synthetist crispness and clarity. In the etching, *The Boy with Soap Bubbles* (cat. 63), we see the continuation of the older, subtle, tonal manner with its feeling of merging shadows and misty surroundings. In the transfer lithographs of the café scene (cat. 66, 67), on the other hand, we find a spontaneous, immediate method of recording a visual experience which seems to be prophetic of things to come in the seventies rather than to be directly the outgrowth of the work of the sixties. What does seem at this point to have disappeared from his work is the bold, linear, calligraphic style so favored by the majority of the etchers of the period.

The third period of Manet's career as a graphic artist is the longest and also the least productive numerically. From 1871 to the end of his career, he executed only twenty works, some not even carried out in a graphic process by the artist, as compared with the thirty-nine done during the "heroic" period, 1860-62. What distinguishes this third period from the two earlier ones is that during its course Manet changed his approach quite radically and thoroughly, remaining committed to the new manner to the end of his life. During the middle years of the seventies, he developed a quite novel and "modern" language for relating visual forms. This new language represents a conscious rejection of the intricate subtleties and complexities of prints like *The Urchin* and *The Boy with Soap Bubbles*, as well as of the artificial elegance of the synthetist manner seen in *Exotic Flower, Dead Toreador*, and *The Cats' Rendezvous*. In a way, the new style could be thought of as an extension of the earlier spontaneous, linear calligraphy, but its expressive results are less emphatically romantic, more centered upon the image itself than on the manner of recording that image. The new style is most admirably stated in the medium of transfer lithography, for here Manet found a means of transcribing the essence of a form simply and directly by means of a few bold strokes with a brush which had all the virtues of a rapid notation. The new treatment was not confined to lithography; it also effected a change in his handling of etching.

The war and Commune years form a natural break in Manet's career. He did little painting or printmaking, as he was quite occupied with his duties as a member of the National Guard, and the times were not very conducive to artistic activities. The years from 1871 through 1873 form an interlude between the second and third periods, in which some works seem to herald the advent of a totally new procedure, while others continue to exhibit features of the previous decade's activity. The three war-time prints, the etching of *The Line at the Butcher Shop* (cat. 70) and the two lithographs, *The Barricade* (cat. 71) and *The Civil War* (cat. 72), are still essentially within the tradition of the work of the

sixties, although perhaps in the latter, there is a greater economy of line and tone than is found in the earlier works in this medium. As late as the spring of 1874, there remains in Manet's prints a certain conservatism, manifested stylistically in the two lithographic versions of the portrait of Berthe Morisot (cat. 73, 74), in the more freely handled etched version of the same oil (cat. 75), and in the color lithograph of Polichinelle (cat. 80). It is also discernible in the publication of the decidedly retrospective collection of etchings issued in a new portfolio edition during that same period, in which all the works, including the frontispiece, which was a plate of 1862 reworked slightly for the occasion (cat. 39), were etchings done in the sixties.

But the retardataire element in Manet's works of mid-1874 presents only half of the picture of the state of his work, for, at the same time, a new, decidedly modern or avant-garde handling appeared. During the next eighteen months, he executed more graphic works than he had done for several years, all in this new manner. To some extent, this renewed activity was inspired by contacts with new friends in the literary world who commissioned work from him. His friendship with Stéphane Mallarmé, which began in 1873,[56] must especially be credited with spurring him on, for in the next two years, in collaboration with the poet, he created the most successful prints of the later part of his career. It is also undoubtedly true that his associations with the younger Impressionist painters, Monet and Renoir, as well as with Berthe Morisot, had some role to play in the formation of this new style.[57]

The productions in the new manner are not numerous as compared with his earlier graphic output, for only eleven works were executed between 1874 and 1882. Beginning with the eight little etched vignettes executed in the spring of

1874 to accompany Charles Cros' poem *Le fleuve* (cat. 79), he created a series of sparkling images, the little wood-engraved illustrations for Mallarmé's *L'après-midi d'un faune* of 1876 (cat. 84), as well as the transfer lithographs *Au Paradis* (cat. 86) and the unpublished image of *La belle Polonaise* (cat. 87). Perhaps the most significant and successful works are the bold and evocative illustrations for Mallarmé's translation of *The Raven* by Edgar Allan Poe (cat. 83) executed in 1875. Even today, these illustrations impress one with their contemporaneity and vigor as well as with the succinct and bold handling of the wash areas which compose their forms. It is particularly notable, too, that Manet was able to provide scenes which enhance the poetry's dramatic content forcefully despite the fact that they do not really share in the poem's lugubrious mood. Undoubtedly, Manet's adoption of simplified brush drawing was in part inspired by his acquaintance with similar works by the Japanese printmaker Hokusai, whose works were widely circulated in the Parisian art world of the period.[58] But nowhere in Manet's personal interpretations of the transfer lithographic technique do we see any of the deliberately contrived elegance which is such an important part of the Japanese aesthetic.

The unique character of Manet's illustrations of the seventies, as well as of all his late graphic works, lies in what I have called elsewhere the "invention of a new kind of 'imaginization' or image-centered language," which was this one artist's "way out of the century's dilemma—'the dead end of the pedestrian banality of Impressionism.' "[59] This type of imagery in Manet's late works links them with the beginnings of the Symbolist movement, not in terms of any parallel literary content, but in terms of a parallel emphasis upon what Mallarmé called the calculated effect, or, in the case of Manet's art, the Aspect.[60]

[56] Manet's relationship with Mallarmé has been studied with various emphases. For recent studies see Jean C. Harris, "A Little Known Essay on Manet by Stéphane Mallarmé," *Art Bulletin,* XLVI (December, 1964), 559-63; Jean C. Harris, "Edouard Manet as an Illustrator," *Philadelphia Museum of Art Bulletin,* LXII (April-June, 1967), 229-33; and K. Berger, "Mallarmé and the Visual Arts," *Les Mardis: Stéphane Mallarmé and the artists of his circle* (exhibition catalogue), University of Kansas Museum of Art, n.d., 51-58.

[57] Richardson, *Manet,* 1967, 26, places a good deal of emphasis upon the influence of Berthe Morisot's style on the change in Manet's handling. J. Rewald, *The History of Impressionism,* New York, 1961, 341, emphasizes Monet much more as a formative influence here. Certainly, the last word has not been said on this subject.

[58] Among the first Japanese works reproduced in French publications during the '70's and '80's were some of Hokusai's images from the *Manga,* all very succinct, and many

very humorous sketches of single figures and animals reproduced as black and white woodcuts. For an idea of the character of these images known during the last quarter of the century, see T. Duret, *Livres et Albums illustrées du Japon,* Paris, 1900; also T. Duret, *L'art japonais—Les livres illustrées: Hokusai,* Paris, 1882. This material is also discussed in Anne C. Hanson, *Edouard Manet: 1832-1883* (exhibition catalogue), Philadelphia Museum of Art, 1966, 149.

[59] Harris, "Manet as Illustrator," 233.

[60] In his article on Manet which was printed in England in 1876, Mallarmé put these words into Manet's, and all Impressionists', mouths: "I content myself with reflecting on the clear and durable mirror of painting that which perpetually lives yet dies every moment, which only exists by the will of Idea, yet constitutes in my domain the only authentic and certain merit of nature—the Aspect." (Harris, "Essay on Manet by Mallarmé," 562.)

There can be little doubt that, in his late works, Manet did achieve what Robert Goldwater has suggested of Monet's later work, "the Mallarméan (symbolist) principle of suggestion by infinite nuance alone." [61] Images such as the illustrations for *Le fleuve* or for *L'après-midi d'un faune* ought, perhaps, to be called "glyphs" rather than symbols, but they share with the verbal usages of the Symbolist poets the elimination of extra-artistic allusion and a concentration upon the fragmentary. In many of his late works, Manet deliberately isolates objects and portions of objects, and these little motifs (called "object-images" or "signature motifs" by De Leiris) [62] as they appear in Manet's letters and in his graphic works and oils, serve to signify the whole of which they are a part.

At the same time, however, the concentration upon the object, whether treated singly or as a fragment, explains why many critics are reluctant to link Manet too closely with the Impressionists, particularly with Monet. For Manet, light and air alone are not enough to form the motif of a painting; there must be some relationship to the social existence of the human being implied in his motif. The motif is affected by accidents of atmosphere, but it triumphs over the transient environment. The insistence on the thematic in Manet's art is seen most especially in his prints, for even in the most fleeting images, there is a stable structural form which offsets the evanescent vision. This stability is conveyed in part by compositional devices as it is in the paintings, but also in part by the handling of the black and white contrasts, for Manet almost always employs in his prints the widest value range possible within the medium. Most often, those forms which are depicted in starkest white or deepest black are presented in those areas of the print which stabilize its structure and anchor the fleeting impression to the framework established by the page or frame. It may well be that Manet's preference for a wide range of values described with a minimum of gradations between the poles is responsible for his increased use of transfer lithography as a medium, for, with it, he could preserve the spontaneous effects of drawing and also convey the full range of values without linear hatchings.

Nevertheless, Manet never rejected the use of line completely in his graphic works. In almost all of his prints, line plays an important role, not as an independently active element, but as a form-defining contour or series of hatchings. The line is never an end in itself; Manet rarely used line as Aubrey Beardsley used it, for instance, for its rhythmical, sinuous properties and decorative elegance. In fact, Manet very consciously avoided the element of stylization inherent in such usages. For this reason, one must never make the mistake of thinking of Manet as an abstract artist, for he was, first and foremost, a realist, as his contemporaries insisted. For him, the objective visual experience was the fundamental source of the work of art. Nevertheless, in a sense, his graphic works are more abstract than his oils. They are all at least two steps removed from the initial visual experience, for in every case in which any sort of preliminary drawing or sketch has been preserved, it is obvious that the print was further abstracted from the study. [63] Manet himself clearly recognized the dangers which such an abstracting procedure might have, for he consciously tried to retain in his prints a spontaneous air by a calculated incompleteness or some awkwardness in draughtsmanship, so that no mechanical looking lines or shapes would overwhelm the vitality that was for him the chief value of the expressive work of art.

Manet's last etching, *Spring* (cat. 88), represents a logical extension in the last decade of his career of his various usages in black and white. In many ways, it is his most personal graphic work. It contains a wide variety of strokes, a slight toning with aquatint in the lower part of the background, an extremely selective and purified use of line in the profile drawing of the girl's face. Each of these devices was used in varying degrees in his other graphic works, but in none were all of these devices combined as skillfully and reticently as they are here. In this final work, Manet's style most clearly exhibits its right to be equated with Mallarmé's poetry with its careful selection of significant words and concisely expressed images.

[61] Robert Goldwater, "Symbolic Form; Symbolic Content," *Acts of the XXth International Congress of the History of Art*, Princeton, 1963, IV, 116.
[62] Alain De Leiris, *The Drawings of Edouard Manet*, Berkeley and Los Angeles, 1969, 80-83.
[63] See, as an example, the succession of works which Manet executed dealing with the races at Longchamps as discussed in Jean C. Harris, "Manet's Race-Track Paintings," *Art Bulletin*, XLVIII (1966), 78-82. See also Anne C. Hanson, "A Group of Marine Paintings by Manet," *Art Bulletin*, XLIV (1962), 332-36, for a discussion of various treatments of a seascape motif.

SELECTED BIBLIOGRAPHY

Books

BAUDELAIRE, CHARLES, *Oeuvres complètes de Charles Baudelaire,* edited and annotated by Jacques Crépet, 17 vols., Paris L. Conard, 1922-1953.

BAZIRE, EDMOND, *Manet,* Paris, Quantin, 1884.

BOUVIER, EMILE FRÉDÉRIC, *La bataille réaliste, 1844-1857,* Paris, Fontemoing and Co., 1913.

CHAMPFLEURY [JULES FLEURY], *Histoire de la caricature moderne,* Paris, Dentu, 1865.

COURBOIN, FRANÇOIS, *La gravure en France des origines à 1900,* Paris, Delagrave, 1923.

COURTHION, PIERRE, *Edouard Manet,* New York, Harry N. Abrams, 1962.

————, *Portrait of Manet by Himself and His Contemporaries,* trans. by Michael Ross, London, Cassell, 1960.

DE LEIRIS, ALAIN, *The Drawings of Edouard Manet,* Los Angeles and Berkeley, The University of California Press, 1969.

DURET, THÉODORE, *L'art japonais: les livres illustrées, les albums imprimés, Hokousai,* Paris, Quantin, 1882.

————, *Histoire d'Edouard Manet et de son oeuvre,* Paris, Floury, 1902, 1906, 1926.

GILMAN, MARGARET, *Baudelaire the Critic,* New York, Columbia University Press, 1943.

GLÄSER, CURT, *Die Graphik der Neuzeit,* Berlin, Bruno Cassirer, 1922.

GUERIN, MARCEL, *L'oeuvre gravé de Manet,* Paris, Floury, 1944.

HAMERTON, PHILIP GILBERT, *Etching and Etchers,* London, Macmillan and Co., 1868.

HAMILTON, GEORGE HEARD, *Manet and His Critics,* New Haven, Yale University Press, 1954.

HANSON, ANNE C., *Edouard Manet: 1832-1883* (exhibition catalogue), Philadelphia Museum of Art, 1966.

ISAACSON, JOEL, *Manet and Spain* (exhibition catalogue), Ann Arbor, University of Michigan, 1969.

JAMOT, PAUL, WILDENSTEIN, GEORGES, and BATAILLE, MARIE-LOUISE, *Manet,* 2 vols., Paris, Les Beaux-Arts, 1932.

LEIPNIK, F. L., *History of French Etching from the Sixteenth Century to the Present Day,* London, John Lane, New York, Dodd, Mead and Co., 1924.

MANET, EDOUARD, *Lettres de jeunesse d'Edouard Manet,* Paris, Louis Rouart et fils, n.d.

Les Mardis: Stéphane Mallarmé and the Artists of His Circle (exhibition catalogue), Lawrence, University of Kansas Museum of Art, n.d.

MONDOR, HENRI, *Vie de Mallarmé,* 2 vols., Paris, Gallimard, 1941.

MOREAU-NÉLATON, ETIENNE, *Manet graveur et lithographe,* Paris, Loys Delteil, 1906.

———— *Manet raconté par lui-même,* 2 vols., Paris, Laurens, 1926.

MORISOT, BERTHE, *Correspondence of Berthe Morisot,* comp. and ed. by Denis Rouart, trans. by Betty W. Hubbard, New York, Wittenborn, 1957.

NOULET, E., *L'oeuvre poétique de Stéphane Mallarmé,* Paris, E. Droz, 1940.

PENNELL, E. R., *Whistler the Friend,* London, Philadelphia, Lippincott, 1930.

PROUST, ANTONIN, *Souvénirs d'Edouard Manet,* Paris, Barthélemy, 1913.

REWALD, JOHN, *The History of Impressionism,* New York, The Museum of Modern Art, 1961.

RICHARDSON, JOHN, *Edouard Manet, Paintings and Drawings,* London and New York, Phaidon Alpha Books, 1958, 1967.

ROGER-MARX, CLAUDE, *French Original Engravings from Manet to the Present Time,* London, Paris, New York, Hyperion Press, 1939.

ROSENTHAL, LÉON, *Manet aquafortiste et lithographe,* Paris, Le Goupy, 1925.

————, *La Gravure,* Paris, Renouard, 1909.

SANDBLAD, NILS GOSTA, *Manet: Three Studies in Artistic Conception,* trans. by Walter Nash, "Skrifter Utgivna av Vetenkaps Societenen I Lund," 46, Lund, CWK Gleerup, 1954.

SCHAFFER, AARON, *Parnassus in France,* Austin, University of Texas Press, 1929.

TABARANT, ADOLPHE, *Manet et ses oeuvres,* Paris, Gallimard, 1947.

ZOLA, EMILE, *Correspondance,* ed. by Eugène Fasquelle, 2 vols., Paris, Charpentier, 1907.

Articles

ADHÉMAR, JEAN, "Notes et documents: Manet et l'estampe," *Nouvelles de l'estampe,* VII (July, 1965), 230-235.

————, "Le portrait de Baudelaire gravé par Manet," *Revue des Arts,* II (December, 1952), 240-242.

BAZIN, GERMAIN, "Manet et la tradition," *L'amour de l'art,* XIII (May, 1932), 153-175.

BÉNÉDITE, LEONCE, "Bracquemond," *Art et Decoration,* 1905, 40-47.

————, "Whistler," *Gazette des Beaux-Arts,* XXXIII (1905), 403-410, 496-511; XXXIV (1905), 231-246.

CHESNEAU, ERNEST, "Le japon à Paris," *Gazette des Beaux-Arts,* XVIII (1878), 385-397.

DAVIES, MARTIN, "Recent Manet Literature," *Burlington Magazine,* XCVIII (May, 1956), 169-171.

EBIN, IMA N., "Manet and Zola," *Gazette des Beaux-Arts,* 6, XXVII (June, 1945), 375-378.

FOCILLION, HENRI, "Manet en blanc et noir," *Gazette des Beaux-Arts,* 5, LXIX (December, 1927), 335-346.

FRIED, MICHAEL, "Manet's Sources: Aspects of His Art, 1859-1865," *Artforum,* VII (March, 1969), 28-82.

GOLDWATER, ROBERT, "Symbolic Form; Symbolic Content," *Acts of the Twentieth International Congress of the History of Art* (Princeton: Princeton University Press, 1963), IV, 11.

HANSON, ANNE C., "A Group of Marine Paintings by Manet," *Art Bulletin,* XLIV (1962), 332-336.

HARRIS, JEAN C., "Edouard Manet as an Illustrator," *Philadelphia Museum of Art Bulletin,* LXII (April-June, 1967), 223-233.

————, "A Little Known Essay on Manet by Stéphane Mallarmé," *Art Bulletin,* XLVI (1964), 559-563.

————, "Manet's Graphic Work of the Sixties," in Joel Isaacson, *Manet and Spain* (exhibition catalogue), Ann Arbor, University of Michigan Press, 1969, 1-7.

————, "Manet's Race-Track Paintings," *Art Bulletin,* XLVIII (1966), 78-82.

KAHNWEILER, DANIEL-HENRY, "Mallarmé et la peinture," *Les Lettres,* numéro spécial (1948), 63-66.

MALLARMÉ, STÉPHANE, "The Impressionists and Edouard Manet," *Art Monthly Review,* I (September 30, 1876), 117-122.

REFF, THEODORE, "Manet's Frontispiece Etchings," *Bulletin of the New York Public Library,* LXVI (March, 1962), 143-148.

————, "The Symbolism of Manet's Frontispiece Etchings," *Burlington Magazine,* CIV (May, 1962), 182-186.

SCHAPIRO, MEYER, "Courbet and Popular Imagery," *Journal of the Courtauld and Warburg Institutes,* III-IV (April-July, 1941), 164-191.

SCHARF, AARON and JAMMES, ANDRÉ, "Le réalisme de la photographie et le réaction des peintres," *Art de France,* IV (1964), 176-178.

SHEYER, ERNST, "Far Eastern Art and French Impressionism," *Art Quarterly,* VI (Spring, 1943), 117-142.

SLOANE, J. C., "Manet and History," *Art Quarterly,* XIV (Summer, 1951), 93-106.

ZIGROSSER, CARL, "Manet's Etchings and Lithographs," *Print Connoisseur,* I (1921), 380-398.

FOREWORD TO THE CATALOGUE RAISONNÉ

COMMENT during Manet's lifetime about his efforts in the graphic media is almost nonexistent.[1] This lack of notice is largely due to the fact that so few examples were known to the public at large. Only a small number of etchings, relatively speaking, were issued in editions of any size (see list of editions following this foreword), while an even smaller number were included in exhibitions of his work.[2] Even so, in view of the fact that so much comment was forthcoming about Manet's paintings, it is somewhat surprising that so little notice was taken of his prints; certainly, this silence indicates unequivocally how minor a role they were considered to play in his work as a whole.

Only a few of the writers who have discussed his art as a whole have considered his graphic work, except peripherally. Théodore Duret, in the first edition of his biography and catalogue listing of Manet's oeuvre,[3] devoted a chapter to the graphic works, but found it almost impossible to locate many of the prints and abandoned the attempt in later editions of his study. In the two major catalogues of Manet's oeuvre, that by Paul Jamot, Georges Wildenstein and Marie-Louise Bataille in 1932,[4] and that by Adolphe Tabarant in 1947,[5] a brief discussion of the prints which are related to specific paintings is included, but no attempt was made to produce a complete listing.

The first serious attempt to catalogue the graphic works alone was undertaken by Etienne Moreau-Nélaton in 1906.[6] Although he also was hampered by the lack of prints of whose existence he knew from photographs taken in Manet's studio after his death,[7] he managed to discover several prints which had been unknown to Duret. In the preface to his catalogue, he wrote a brief appreciation of Manet's graphic work, an appreciation which seems, however, to lack conviction, as he devoted most of the space to an emphasis on the relative unimportance of prints in Manet's work as a whole.

The other catalogue of Manet's prints was produced during World War II by Marcel Guérin,[8] who was fortunate to have discovered many unknown states of etchings as well as trial proofs of hitherto undiscovered plates. Since his work is a catalogue only, he attempted no discussion of the stylistic development of Manet's printmaking activities; as an introduction to his volume, he simply reproduced the preface written by Moreau-Nélaton.

The only thorough attempt to study Manet's graphic works both as independent creations and within the framework of the artist's achievements in oil painting was undertaken in 1925 by Léon Rosenthal.[9] For this critic, the graphic work was far from unimportant; rather, it was of major significance for the understanding of Manet's

[1] The few critical comments which did appear in the press were quite favorable, interestingly enough, but they seem to have had little influence on public opinion of his work. We have discovered only five or six mentions of the graphic works in contemporary journalistic criticism. Several of them are quoted by J. Adhémar, "Notes et documents: Manet et l'estampe," *Nouvelles de l'estampe*, VII (July, 1965), 231-234. The others are found in Baudelaire's "Peintres et Aquafortistes," published in *Le Boulevard*, Sept. 14, 1862 (see *Baudelaire, Critique d'art*, Paris, 1956, 166-67).

[2] At the Salon des Réfusés in 1863, he exhibited *The Little Cavaliers, Philip IV*, and *The Gypsies*. These three etchings were included in his one-man show at the Pont de l'Alma in 1867. Finally, in the 1869 Salon, he entered the *Dead Toreador* and *Exotic Flower*. These five prints, then, were the only ones which the general public could have seen, as it had no access to private collections in which the publications of the Société des Aquafortistes would be represented.

Only at the time of the Memorial Exhibition of Manet's work, in 1884, were a large number of his etchings exhibited. In the catalogue of this show, seven groups of etchings (nos. 155-161) are listed: 155: *The Urchin,* *The Little Girl, The Toilette;* 156: *At the Prado, Exotic Flower, At the Prado;* 157: *The Reader, The Infanta Marguerita, The Convalescent;* 158: *The Absinthe Drinker, The Gypsies, Boy Carrying a Tray;* 159: *Philip IV, Dead Christ with Angels, The Candle Seller;* 160: *Boy with Sword facing left, The Little Cavaliers, Boy with Sword facing right;* 161: *Spanish Singer, Lola de Valence, Dead Toreador, The "Espada."*

[3] T. Duret, *Histoire d'Edouard Manet et de son oeuvre,* Paris, 1902.

[4] P. Jamot, G. Wildenstein, and M.-L. Bataille, *Manet,* 2 vols., Paris, 1932, hereinafter cited as J.W.B.

[5] A. Tabarant, *Manet et ses oeuvres,* Paris, 1947.

[6] E. Moreau-Nélaton, *Manet graveur et lithographe,* Paris, 1906.

[7] The photographer Lochard took pictures of all the works left in Manet's studio in 1884. These have provided a valuable record for authenticating works and for documenting the existence of works which seem to have disappeared. J. W. B. I, 109.

[8] M. Guérin, *L'oeuvre gravé de Manet,* Paris, 1944.

[9] L. Rosenthal, *Manet aquafortiste et lithographe,* Paris, 1925.

artistic development and personality. Rosenthal even went so far as to point out the experimental nature of much of Manet's work in black and white, indicating that many new and individual devices and effects with which the painter is credited appeared first in his graphic works.

The one lack in Rosenthal's pioneer study was that he made no attempt to discover in Manet's graphic works any evolution or development; indeed, he was convinced that none existed. Thus, instead of attempting to establish a chronology for the prints, he arranged his study according to the themes with which the prints deal, such as Spanish subjects, out-of-doors scenes, and the female nude.

To date, therefore, no analysis of the sequence and development of Manet's graphic output exists. The present study has been undertaken in part to correct some errors in Guérin's catalogue and in part to attempt such a chronological study, problematic as some of the solutions offered herein may be.

In the course of selecting those works to be included in this catalogue of graphic works, we have, somewhat arbitrarily perhaps, omitted those works by Manet which were reproduced from his drawings by some means other than a specific graphic process. This means, therefore, that we have excluded from our listing drawings which were subsequently reproduced by photographic processes in books or periodicals. We have included all known works which Manet executed himself in a graphic process or for which he made the initial drawings for the graphic artist, as was the case with his wood engravings.[10]

In the description and analysis of individual items in the catalogue, we have attempted to present an accurate account of each work, its physical appearance, its editions as a print, and its exhibition during Manet's lifetime. We have also included an extended commentary on each work, with discussion of related works in oil, watercolor or drawing media and of the chronological position of the print within the sequence of Manet's graphic works. In listing bibliographical references, only those have been cited which contribute significant information or analysis of the work in question.

[10] Three wood engravings included by Guérin in his catalogue have been eliminated from this catalogue listing. These are: *Nude Woman with Black Cat* (Guérin 87); *Olympia*, wood engraving by Moller (Guérin 88); and *Chemin de Fer*, wood engraving by Prunaire (Guérin 89). Since I can discover no evidence that Manet made drawings especially for these prints, and since none of them appeared in graphic form until after his death, I have chosen to eliminate them from consideration just as I have done with the drawings which were reproduced photographically without any direct intervention on his part.

KEY TO ABBREVIATIONS OF FREQUENTLY CITED
BIBLIOGRAPHICAL REFERENCES

Adhémar, *Nouvelles*	Jean Adhémar, "Notes et documents: Manet et l'estampe," *Nouvelles de l'estampe,* no. 7, July, 1965, 231-234.
De Leiris	Alain De Leiris, *The Drawings of Edouard Manet,* Berkeley and Los Angeles, The University of California Press, 1969.
Duret	Théodore Duret, *Histoire d'Edouard Manet et de son oeuvre,* Paris, Floury, 1902. Subsequent French editions 1906 and 1926. Years will be given when specific text pages are cited.
Guérin	Marcel Guérin, *L'oeuvre gravé de Manet,* Paris, Floury, 1944.
Hanson	Anne C. Hanson, *Edouard Manet: 1832-1883* (exhibition catalogue), Philadelphia, Philadelphia Museum of Art, 1966.
Harris	Jean C. Harris, "Edouard Manet as an Illustrator," *Philadelphia Museum of Art Bulletin,* LXII, April-June, 1967, 222-235.
Isaacson	Joel Isaacson, *Manet and Spain* (exhibition catalogue), Ann Arbor, University of Michigan, 1969.
J. W. B.	Paul Jamot, Georges Wildenstein, and Marie-Louise Bataille, *Manet,* 2 vols., Paris, Beaux-Arts, 1932.
M-N	Etienne Moreau-Nélaton, *Manet: graveur et lithographe,* Paris, L. Delteil, 1906.
Rosenthal	Léon Rosenthal, *Manet aquafortiste et lithographe,* Paris, Le Goupy, 1925.
Sandblad	Nils Gosta Sandblad, *Manet: Three Studies in Artistic Conception,* trans. by Walter Nash, "Skrifter Utgivna av Vetenkaps Societenen I Lund," 46, Lund, CWK Gleerup, 1954.
Tabarant	Adolphe Tabarant, *Manet et ses oeuvres,* Paris, Gallimard, 1947.

KEY TO ABBREVIATIONS OF EDITIONS
OF MANET'S GRAPHIC WORKS

1860 *Diogène*	Caricature of *Emile Ollivier* (cat. 1), *Diogène,* April 14, 1860 (photographic facsimile of lithograph).
1862 Bosch	*Portrait of Jérôme Bosch* (cat. 29), lithographic cover for sheet music of *Plainte moresque.*
1862 Lola	*Portrait of Lola de Valence* (cat. 32), lithographic cover of music and poem (*Serenade*) by Zacharie Astruc dedicated to the Queen of Spain.
1862 Soc.d.A.	*The Gypsies* (cat. 18), on single sheet as part of portfolio issued by Société des Aquafortistes on September 1, 1862.
1862 portfolio	*Huit gravures à l'eau forte par Manet,* published by Cadart, October, 1862. Number of the edition not known. 1. *The Spanish Singer* 2. *The Little Cavaliers* 3. *Philip IV* 4. *Mlle. Victorine in the Costume of an Espada* 5. *The Absinthe Drinker* 6. *The Toilette* 7. *The Boy with a Dog* 8. *The Urchin—The Little Girl.*
1863 Lola	October, 1863: *Lola de Valence* (cat. 33) issued on single sheet by Société des Aquafortistes.

1867 Zola	Emile Zola, *Ed. Manet, étude biographique et critique*, Paris, Dentu, 1867. *Olympia* (cat. 53) as frontispiece.
1868 Lemerre	*Sonnets et Eaux-fortes*, Paris, Lemerre, 1868. *Exotic Flower* (cat. 57) as accompaniment to sonnet by Armand Renaud.
1869 Baudelaire	Charles Asselineau, *Charles Baudelaire, sa vie et son oeuvre*, Paris, Lemerre, 1869. Two portraits of Baudelaire (cat. 59, 61) appeared. 50 proofs on thin paper issued at time of publication. Successive examples of each plate (number unknown) were later issued by Lemerre, who owned the plates.
1869 Champfleury	Limited edition of *The Cats' Rendezvous* (cat. 58) as a poster to advertise forthcoming publication of Champfleury's *Les Chats*. A few proofs without letters must have been made, for the lithograph is reproduced thus in October, 1868 (see discussion in cat. 58).
1870 Champfleury	Champfleury [Jules Husson Fleury], *Les Chats,* second (deluxe) edition, Paris, Rothschild, 1870. *Cat and Flowers* (cat. 65), on p. 40.
1874 portfolio	*Edouard Manet: Eaux-fortes,* published by Cadart in an edition of 50 examples on Japan paper. The exact contents of the portfolio have not been verified, as no complete examples have been discovered recently. However, Moreau-Nélaton (1906) gives the list as follows: *Lola de Valence, The Gypsies, The Spanish Singer, The Urchin, The Little Girl, The Toilette, The Little Cavaliers, The Infanta Marguerite, The Dead Toreador*
1874 Nina	*Portrait of Nina de Callias, La Parisienne* (cat. 78), in *Le Revue du Monde Nouveau,* February 15, 1874.
1874 Cros	Charles Cros, *Le fleuve,* Paris, Librairie de l'Eau-forte, 1874. 100 numbered and signed examples on Holland paper. Eight small etchings (cat. 79a-h).
1875 Poe	Edgar Allan Poe, *Le Corbeau,* trans. by Stéphane Mallarmé, Paris, Lesclide, 1875. 240 numbered examples, signed by the poet and the painter. An ex-libris, a cover drawing and 4 illustrations in transfer lithography on Japan paper separated from the text (cat. 83).
1876 Polichinelle	*Polichinelle* (cat. 80), lithograph in seven colors, on Japan paper, 25 examples, numbered and signed "E. M.," printed by Lemercier.
1876 Mallarmé	Stéphane Mallarmé, *L'Après-midi d'un Faune,* Paris, Derenne, 1876. 195 examples; 175 on Holland and 20 on Japan paper. 4 wood-engravings, some heightened with watercolor (cat. 84). 3rd edition, 1887, reproduced the 4 wood-engravings in slightly reduced size photographically.
1880 Revue	*La Revue de la Semaine,* vol. II, no. 12, 1880. *Au Paradis* (cat. 86), transfer lithograph, number not known.
1884 Memorial	Six lithographs issued posthumously in editions of 100 examples, some of them known to be at the time of the memorial exhibition at the Ecole des Beaux-Arts in 1884: *The Races* (cat. 41); *Execution of Maximilian* (cat. 54); *The Barricade* (cat. 71); *The Civil War* (cat. 72); *Portrait of Berthe Morisot* (cat. 73); *Portrait of Berthe Morisot* (cat. 74).
1884 Bazire	Edmond Bazire, *Manet,* Paris, Quantin, 1884. *Odalisque* (cat. 56) and *The Convalescent* (cat. 85) issued for first time. 100 examples of each, 50 on Japan paper, 50 on creamy laid paper.

1890 portfolio	"Recueil de 24 planches sur Japon impérial, format ½ colombier. Edité à l'imprimerie de Gennevilliers (Seine)." (This edition was arranged by Mme. Edouard Manet.)
	1. *Frontispiece;* 2. *The Spanish Singer;* 3. *Lola de Valence;* 4. *The Dead Toreador;* 5. *Mariano Camprubi;* 6. *The Infanta;* 7. *The Little Cavaliers;* 8. *The Toilette;* 9. *Edgar Allan Poe;* 10. *Charles Baudelaire* (cat. 21); 11. *Berthe Morisot;* 12. *The Tragic Actor;* 13. *Silentium;* 14. *The Gypsies;* 15. *The Little Girl;* 16. *The Urchin;* 17. *Olympia* (cat. 52); 18. *The Smoker* (cat. 50); 19. *The Cats;* 20. *Boy with a Dog;* 21. *The Line at the Butcher Shop;* 22. *Boy with Soap Bubbles;* 23. *Spring: Jeanne;* 24. Ex-libris by Bracquemond, with motto, "Manet et Manebit."
1894 Dumont	In this year, M. Dumont bought from Mme. Edouard Manet the 23 plates listed above and the following:
	The Water Drinker; The Philosopher; Théodore de Banville (cat. 82); *Marine; The Smoker* (cat. 49); *Eva Gonzales* (cat. 68); *Olympia* (cat. 53).
	Dumont issued an edition of 30 examples of each of these 30 plates.*
1899 Mégnin	Paul Mégnin, *Notre ami le chat,* Paris, Rothschild, 1899. *Cat and Flowers* printed as frontispiece.
1902 Duret	Théodore Duret, *Histoire d'Edouard Manet et de son oeuvre,* Paris, Floury, 1902.
	The Urchin (cat. 31) and *Olympia* (cat. 53) included in the edition.
1902 GBA	*Gazette des Beaux-Arts,* XXVIII, 1902.
	Jeanne: Spring, between pp. 428 and 429; 50 examples on Japan paper for deluxe edition.
1905 Strölin	Dumont's successor, Alfred Strölin, became owner of the 30 plates issued in 1894. He brought out an edition of 100 examples and then cancelled each plate with two small holes.
1906 Moreau-Nélaton	Etienne Moreau-Nélaton, *Manet graveur et lithographe,* Paris, Loys Delteil, 1906.
	Portrait of Félix Bracquemond, as frontispiece, 225 numbered copies.
1910 Duret	Théodore Duret, *Histoire d'Edouard Manet et de son oeuvre,* Berlin, 1910.

* Note on paper and watermarks:

The two different editions of etchings issued by the Dumont-Strölin succession (1894, 1905) are not readily distinguishable insofar as their paper is concerned. Many print collections contain examples with a watermark of a fleur-de-lys and the initials VGZ (which stand for Van Gelder Zonen) or the words Van Gelder. These marks occur in a heavy, ivory-colored, laid paper. Such examples are quite commonly found in collections, which leads to the supposition that they are part of the larger, 1905 edition. These plates are usually heavily printed in a dark brown ink, giving the impression that the plates were quite worn. The same kind of inking is evident in the examples printed on a blue-green paper which are quite commonly found in print rooms. The supposition is that these examples, too, form part of the 1905 Strölin edition of etchings.

Other watermarks which seem to occur with some frequency are an isolated crown and a crown and shield in white laid paper. Etchings on this paper are printed in a blacker ink than those on the ivory laid paper and appear to be sharper, suggesting that the plates were less worn when the impressions were taken. This fact suggests that these examples may form part of the earlier and smaller 1894 Dumont edition.

In a few cases, etchings were printed on a thin white "China" paper mounted on a heavier paper. Such is the case, for instance, with the edition of *The Spanish Singer* (cat. 12) which was issued by *L'Artiste.* Other isolated examples of such a practice can be found in print rooms, but their scarcity shows that it was not common procedure in the case of etchings. On the other hand trial proofs of etchings on thin China paper occur quite commonly in print collections; in fact, such paper seems to have been most common in pulling trial proofs.

Quite the opposite is true of lithographs, however. Almost all of Manet's lithographs, at least some examples of each edition, were printed on a paper which was composed of two layers, one a heavy wove, with a thin China paper to take the inking more effectively.

Profile Portrait of Baudelaire (cat. 21) from canceled plate;
Portrait of Berthe Morisot (cat. 75) from canceled plate.
The English editions of 1910 and 1912 contain only the *Portrait
of Berthe Morisot.*

Additional editions of etchings, no dates known:

Porcabeuf, grandson of Félix Bracquemond, received the plates
of *The Absinthe Drinker, The Boy Carrying a Tray,* and the second
plate of *Au Prado* (cat. 45) from the printer Salomon, who had
received them from Bracquemond. At some time before 1906,
when Moreau-Nélaton published his catalogue, Porcabeuf pulled
a dozen examples from each plate and then canceled the plates.

Catalogue Raisonné

Familiar French titles for the prints are given
in brackets following the English titles.

Dimensions are cited with height preceding width.
The measurements refer in all cases to the size of
the composition or drawing unless otherwise stated.

P following the title of a print indicates that
the plate is preserved in the Cabinet des Estampes,
Bibliothèque Nationale, Paris.

1.

CARICATURE OF EMILE OLLIVIER (Fig. 1)

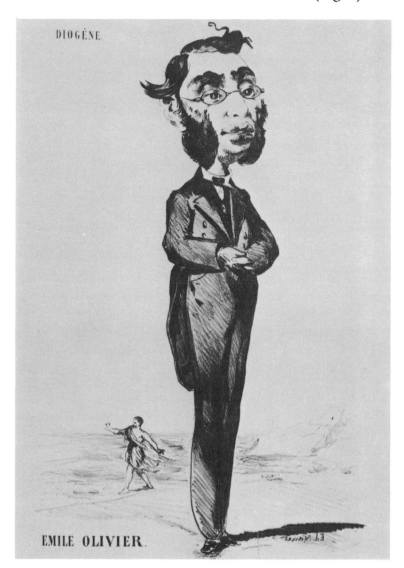

Fig. 1

Lithograph: only one proof known
Signed lower right in reverse: "Ed. Manet;" undated
Dimensions: 374 x 267 mm.
Date: 1860, before April 14
Editions: 1860 *Diogène*
References: Guérin 67

COMMENTARY: Although this is the only example of caricature in Manet's graphic oeuvre, there are several instances among his early drawings, for example, *Pierrot ivre* (De Leiris 1). Manet seems to have been known as a skillful and witty draughtsman as early as 1848-49, when he instructed his fellow shipmates in the art of drawing and made caricatures of the ship's company during the trip to Rio de Janeiro (*Lettres de jeunesse d'Edouard Manet,* Paris, n.d., 55).

The representation here is not in any way unique or remarkable; the politician is represented in a manner conventional for the period. A similar treatment of figures with much enlarged heads and small bodies is seen in Monet's first caricature drawings (see William C. Seitz, *Monet,* New York, 1960, figs. 64, 65), but the handling testifies to Manet's competence with the tools of the draughtsman.

Several traits of Manet's handling of the lithographic medium seen in this early effort were to remain constant in his style: the wide value range, the simplified shadings and the limitation of tones to three basic values — white (the paper), middle gray, and black.

2.

PORTRAIT OF EDGAR POE[p] (Fig. 2)

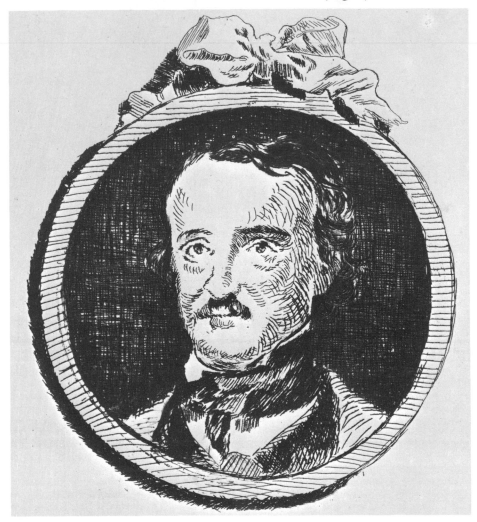

Fig. 2

Etching: one state
Unsigned; undated
Dimensions: 190 x 150 mm. (plate); 132 x 114 mm. (composition)
Date: 1860
Editions: 1890 portfolio; 1894 Dumont; 1905 Strölin
References: M-N 46; Guérin 55; Rosenthal, 70, note 2; Hanson, no. 137, p. 151

COMMENTARY: The image from which Manet copied this portrait, and which it reproduces in reverse, is called the Whitman daguerreotype (Fig. 3). Taken in Providence in 1848, it was included in the Redfield biography of Poe. Manet executed two other images of the writer, each derived from a different photographic source. One, a drawing in the Bibliothèque Nationale in the Cabinet des Estampes (De Leiris 215; Fig. 4), is from an earlier photograph and is handled in a rather tight, linear manner, perfectly consistent with the date of the etched version. The other drawing was reproduced in the Brussels edition of Mallarmé's translations of Poe's poems (1888) and in the Paris edition (Vanier) of 1889 and is in a much later, freer style of brush drawing. It reproduces the so-called Pratt daguerreotype of Poe (for a discussion of the various likenesses of Poe, see Amanda Pogue Schulte, "The Portraits and Daguerreotypes of Edgar Allan Poe," *Facts About Poe,* ed. James Southall Wilson Charlottesville, 1926, 35-58). It is quite likely that both the etching and the drawing in Paris are related to Baudelaire's projected edition of critical articles on the American poet.

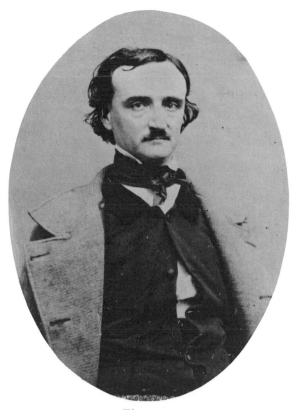

Fig. 3

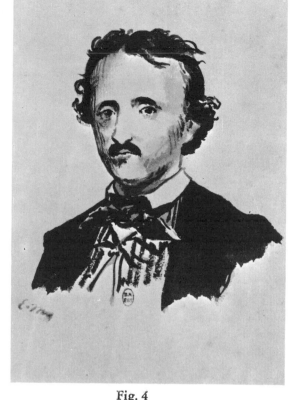

Fig. 4

In a letter to Nadar, dated May 16, 1859, Baudelaire mentions the portrait: "Les différents livres ou brochures que j'aurai prochainement à publier sont: L'ensemble des articles critiques sur Poe (ici, un portrait, je me charge de fournir les éléments nécessaire pour le portrait encadré dans les figures allégoriques réprésentant Jésus-Christ au milieu des instruments de la passion.) — le tout d'un romantique forcène, s'il est possible." (Oeuvres complètes. IX, 227-28)

Baudelaire expanded his ideas for etched portraits of Poe in the following letter to the publisher Alfred Guichon, dated July 13, 1860:

"Il y aura deux portraits, l'un, qui est en tête de l'édition posthume des oeuvres de Poe (chez Redfield, N. Y.), reproduction d'une peinture qui était chez Griswold; ce Griswold est l'auteur américain chargé de mettre en ordre les papiers de Poe, et qui non seulement s'est si mal acquitté de sa tâche, mais encore a diffamé son ami défunt en tête de l'édition; — l'autre, qui orne l'édition grand in-8° illustrée des poésies, édition de Londres.

"Il y a d'autres éditions et aussi d'autres portraits; mais ils ne sont jamais que la reproduction plus ou moins altérée de ces deux portraits types.

"Si je réussis à faire mon enterprise, je les ferai reproduire avec un soin parfait. L'un (édition américain) représente Poe avec la physiognomie comme du gentleman; pas de moustaches, — des favoris; le col de la chemise relevé. Une prodigueuse distinction. L'autre (édition des poésies, de Londres) est fait d'après une épreuve daguerrienne. Ici, il est à la française; moustaches, pas de favoris, col rab-

attu. — Dans les deux, un front énorme en largeur comme en hauteur; l'air très-pensif, avec une bouche souriante. Malgré l'immense force masculine du haut de la tête, c'est, en somme, une figure très féminine. Les yeux sont vastes, très beaux, et très rêveurs. — Je crois qu'il sera utile de donner les deux." (Oeuvres complètes, IX, 227-228)

According to Jean Adhémar ("Le portrait de Baudelaire gravé par Manet," Revue des Arts, II [December, 1952], 240-42), Baudelaire had commissioned illustrations for his edition of articles about Poe from Bracquemond, but was dissatisfied with Bracquemond's work. He then told Nadar what he wanted (see letter quoted above), and Nadar suggested that he try Manet. Although the letters of 1858 and 1859 to Nadar suggest that Baudelaire had a sense of urgency about his project, the letter of 1860 to Guichon quoted above seems to indicate that no definite images had yet been etched. It would seem likely, then, that Manet did not undertake his etching until after this last letter was written.

In keeping with the feelings of Baudelaire about the images of Poe as cited in the Guichon letter of 1860 above, Manet framed his etched image with a circular band culminating in a bow suggesting both a Victorian type of picture frame, and also perhaps, something of the "feminine" quality of Poe's features which Baudelaire mentions.

It is not difficult to understand why Baudelaire did not pursue the matter of Poe portraits with Manet. In executing this image, Manet may have been following Baudelaire's dictum, to reproduce

the image "avec un soin parfait," but the result is far from successful. The areas of darkest value, the hair, coat collar and tie, are handled with some assurance in finely etched, densely spaced, parallel and cross hatchings, but the lighter value areas betray a lack of confidence. Especially in the features, the lines are short and aimless in their function. The background is covered with a regular cross-hatching, a type favored by portrait etchers such as Bracquemond and Legros (i.e., Legros, *Portrait of Barbey d'Aurevilly*, 1862, Béraldi 10).

Baudelaire may later (in 1861) have approached Legros to try out an etched portrait (see Baudelaire, *Oeuvres complètes,* IX, 227, note 1); at least we know that in 1861, Legros made a series of eight etched illustrations for some of Poe's *Tales* (Béraldi 148-155), but they were never published. Among them is an illustration for *The Black Cat* in which the famous creature later used by Manet in *Olympia* makes its appearance (see M. C. Salaman, *Alphonse Legros,* London, 1926, pl. I).

There was one other occasion for which Manet might have etched the portrait in question. This was in 1876, in connection with a projected memorial volume of tributes to Poe. Mallarmé, with whom Manet had been collaborating (see cat. 83 and 84), wrote to Miss Sara Rice in Baltimore that he would be delighted to comply with her request for some verses of tribute to Poe and that his friend Manet would also like to submit something (E. Noulet, *L'oeuvre poétique de Stéphane Mallarmé,* Paris, 1940, 248; also, J. Harris, "A Little Known Essay on Manet by Stéphane Mallarmé," *Art Bulletin,* XLVI [1964], 563, note 36). When the memorial volume appeared, no image by Manet was included, but it is possible that the drawing finally used in the 1888 Brussels edition of Mallarmé's Poe translations, which is in a style characteristic of Manet's works of the '70's, might be a trial work for this commission.

Finally, we might mention that Mondor and Jean-Aubry, in their "Notes" to the Pléiades edition of Mallarmé's *Oeuvres complètes* (Paris, 1945, p. 1923), quote from a letter written by Mallarmé to Emile Verhaeren on January 15, 1887, in which Mallarmé states that he has ready for publication translations of poems by Poe and a portrait of Poe by Manet. The work here referred to is probably *not* the etching, but the other image of Poe used by the publisher in 1888.

Mme. Manet owned the plate of the etching and had it included in the 1890 portfolio edition of Manet's prints.

3.

SILENTIUM[P] (Fig. 5)

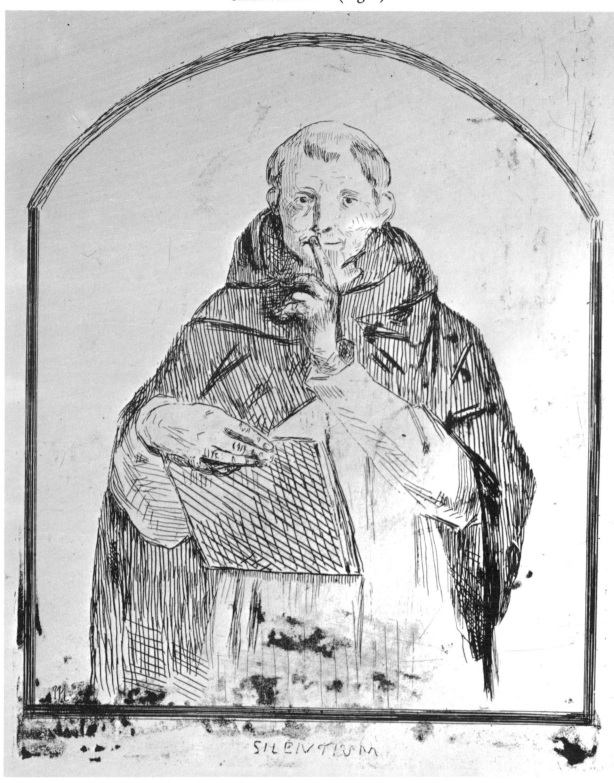

STATE 1 Fig. 5

Etching: two states
Signed lower left: "M.;" undated
Dimensions: 228 x 158 mm. (plate in first state);
 206 x 158 mm. (plate in second state);
 182 x 152 mm. (composition)

Date: 1860

Editions: 1890 portfolio; 1894 Dumont; 1905 Strölin

References: M-N 22; Guérin 4; Rosenthal, 27; Hanson, no. 2, p. 39

1st state: A faint horizontal line just above the etched frame limits the drawing. The corners of the plate are sharply defined. A second pulling of this state (illustrated here) shows spots marring the surface of the plate.

2nd state: The plate is cropped to 206 mm. in height and the corners are rounded off. There is no change in the drawing, but the spots have been removed from the plate. The horizontal line above the frame also has been removed.

COMMENTARY: Manet made two trips to Italy in the '50s, one in 1852-53, the other in 1856-58. These trips provided him with an admirable opportunity to examine and to copy in drawings the paintings of major Italian artists. He seems particularly to have been impressed by fifteenth and sixteenth century works. Today we know one hundred and thirty such drawings copied from the "old masters" (see De Leiris, p. 6). Rosenthal points out that the figure in *Silentium* is very similar to a depiction of St. Peter Martyr in S. Marco in Florence by Fra Angelico.

Duret (1902, 123) says this is one of Manet's first etchings. It seems quite likely that this etching was done after the portrait of Poe (cat. 2), for the handling of the needle is more expressive and controlled than in the former. Very little cross-hatching is used, but where it does appear, the lines are widely spaced, providing maximum vigor and individuality to the strokes.

4.

THE TRAVELERS [Les voyageurs] (Fig. 6)

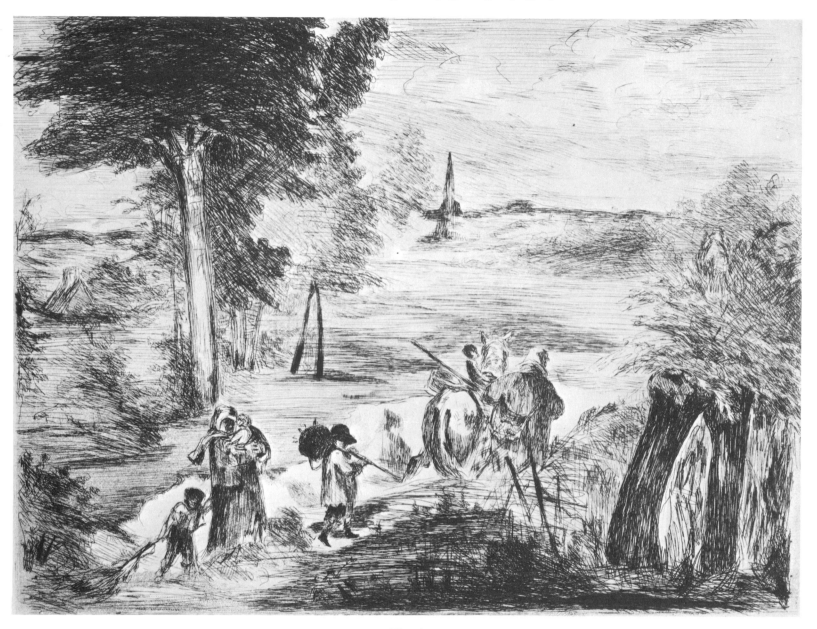

Fig. 6

Etching and aquatint: one state, trial proofs only
Unsigned; undated
Dimensions: 228 x 302 mm.
Date: 1860
Editions: none
References: M-N 70; Guérin 1; Tabarant, 34; Rosenthal, 145, note 1;
 Hanson, no. 12, p. 47

COMMENTARY: Both Tabarant and Guérin thought that this was Manet's first etching. The landscape background, especially the motif of the spire in the distance, is certainly similar to other works of the period 1859-61, when Manet made a number of landscape drawings at Gennevilliers using this motif. For example, the same spire framed by trees appears in the oil painting, *Fishing at St. Ouen* (J. W. B. 30; New York, Metropolitan Museum) and in *L'étudiants de Salamanque* (J. W. B. 29), which is signed and dated 1860. The handling in this print is similar also to landscape etchings of 1859 and 1860 by Whistler and Seymour Haden, particularly to the latter's etchings of Kensington Gardens (Harrington 12 [1859], and 28 [1860]).

Like so many of Manet's works of this period, this etching seems to have been derived from Flemish or Venetian art of the sixteenth and seventeenth centuries (see Sandblad, 32, for a discussion of the use of such sources). In the case of this particular etching, there is some resemblance to the work of Ruisdael (see his etching, *Les voyageurs*, illustrated in Riat, *Ruysdael,* Paris, n.d., opposite p. 12). There is also a marked similarity to some landscape etchings by Daubigny (Delteil 49, *Les petits cavaliers*).

Unlike the etching *Silentium,* this print emphasizes atmospheric effects achieved with many complex strokes. The lines are fine, varied in direction and density. Foliage is indicated with free calligraphy combined with straight lines to shade masses. Fine, parallel hatchings are employed in the figures and tree trunks to shade forms. Although there are some contour lines, they are for the most part obscured by hatching so that individual shapes merge into an overall effect. The use of aquatint and ink wash in the lower part of the print further enhances the atmospheric quality of the picture. The practice of leaving a marked tone on the plate instead of wiping it clean was a particular feature of the printing technique of Delâtre, to whom most of the outstanding etchers entrusted their plates for printing (P. G. Hamerton, *Etching and Etchers,* London, 1868, 40; Rosenthal, 16).

5.

THE LITTLE CAVALIERS {Les petits cavaliers} (Figs. 7, 8, 9)

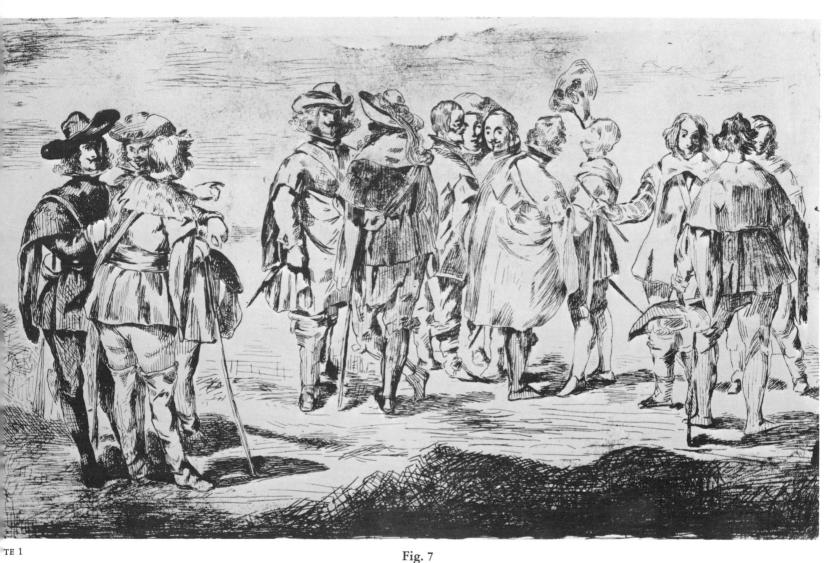

Fig. 7

Etching: four states

Signed in the third state: "Ed. Manet d'après Velasquez;" undated

Dimensions: 245 x 387 mm. (plate)

Date: 1860 for the first three states; 4th state after 1874 (?)

Editions: 1862 portfolio, 1874 portfolio, and 1890 portfolio, all the third
 state; fourth state in 1894 Dumont and 1905 Strölin

Exhibited: 1863 Salon des Réfusés; 1867 one-man show

References: M-N 5; Guérin 8; Rosenthal, 142; Adhémar, *Nouvelles,* 231;
 Hanson, no. 4, p. 41; Isaacson, no. 1, pp. 24-25

1st state: The composition is lightly indicated with widely spaced lines; in
 the foreground an area of dark and dense cross-hatching exists. Other-
 wise, the value range is high. There is an example of this state touched
 with watercolor (Fig. 10; De Leiris 146).

2nd state: The whole plate is reworked with additional hatching in the
figures and in the ground.
3rd state: Addition of the letters in the lower right on the plate: "éd.
Manet d'après Velasquez;" at the left: "Cadart et Chevalier éditeurs
rue Richelieu 66;" in the center: "Imp. Delâtre, Paris."
4th state: Elimination of name of editors from lower left and a slight
reduction (about 1 centimeter) in height by elimination of name.

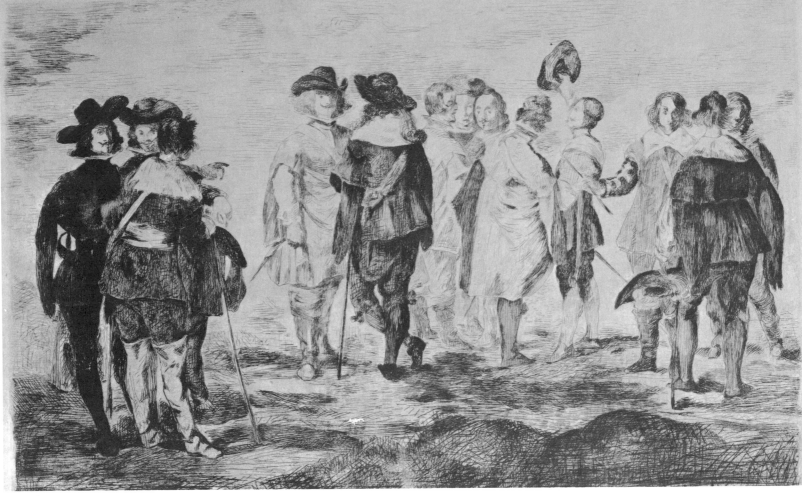

STATE 2

Fig. 8

COMMENTARY: The oil painting of which this is a
transcription was made by Manet from a painting
in the Louvre, attributed to Velazquez, which rep-
resents a group of artists who were contemporaries
of the Spanish master (see Sandblad, 32, for a dis-
cussion of the influence of this painting on Manet's
work).

The letter quoted by Adhémar which mentions
an accident that befell the plate of *The Little Cava-
liers* cannot be dated, as he says, to 1861, since
Manet did not live at 49 rue St. Petersbourg at the
time (he lived there from 1867 to 1878). It seems
most likely that the letter dates from 1867 (when

a Monday the 10th would have occurred in June),
as Manet refers to "mon exposition" as being cur-
rent history (the verb "figurent" is in the present
tense). The "accident" to the plate, then, may have
resulted in a change *before* the 1874 publication,
in which case there may be in existence another
state between Guérin's 3rd and 4th. Whatever
changes were necessitated by the accident must
have been minor, however, for the drawing on the
plate was not discernibly changed.

Stylistically, this etching is in many ways similar
to the etching of M. Manet (cat. 6), which is dated
1860 on the plate. The bold linear contrasts and

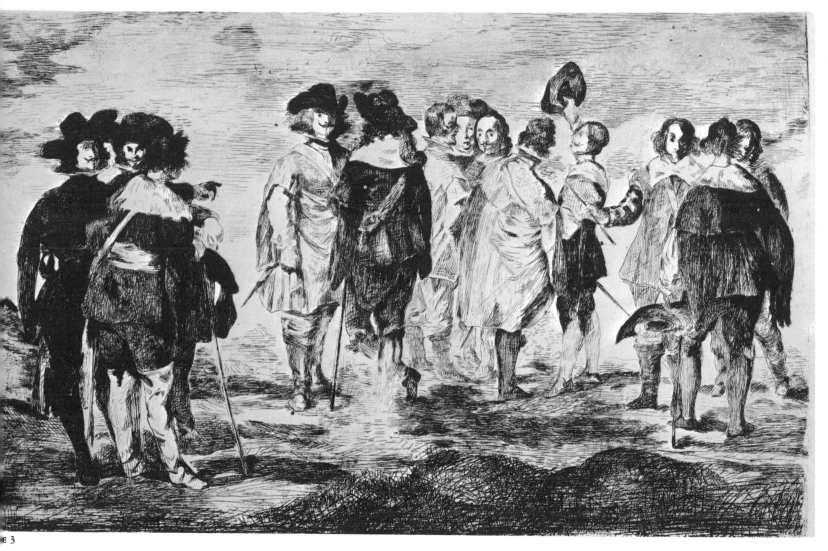

Fig. 9

subtle variety of hatching, as well as the assured handling of masses, are analogous. At the same time, *The Little Cavaliers* is handled with greater confidence than the other etching. In most areas energetic strokes are carefully subordinated to areas. A wide value range is employed, with each tonal area depicted in a slightly different manner. In the lightest portions, as in the center, very lightly bitten, discontinuous lines are used. Here shading is accomplished almost entirely with parallel, vertical hatchings. In the middle value sections, particularly in the darkest figure in the center group and the figure at the far right, lightly bitten, parallel verticals

are combined with short, widely spaced horizontals to create the darker value and, at the same time, to preserve some relation to the light areas around them. The blackest areas of the print, the figure at the far left, for instance, are composed of cross-hatchings which are so dense that individual strokes are almost obliterated. Even here, however, Manet preserved the dominance of the vertical hatchings to contrast sharply with the predominantly horizontal strokes which define the ground and sky. Certainly, this is Manet's most accomplished early etching, both in its complexity and in the control with which this complexity is mastered.

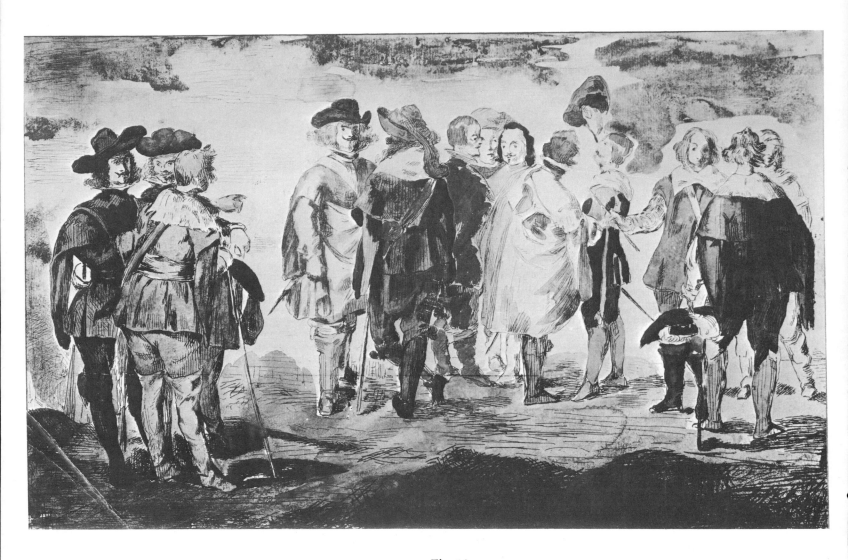

Fig. 10

6.

PORTRAIT OF M. MANET [M. Manet Père] (Fig. 11)

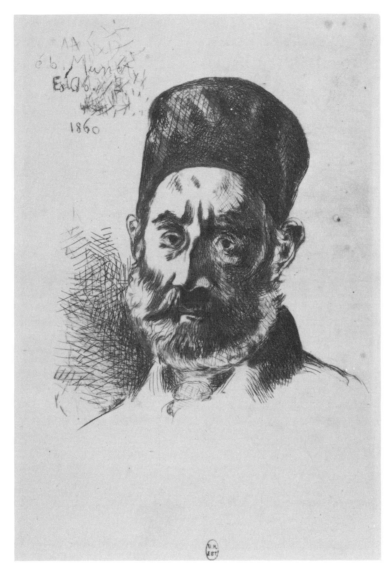

Fig. 11

Etching: one state, trial proofs only
Signed and dated upper left, then scratched out:
 "éd. Manet 1860"
Dimensions: 174 x 115 mm.
Date: 1860
Editions: none
References: M-N 50; Guérin 5; Rosenthal, 71

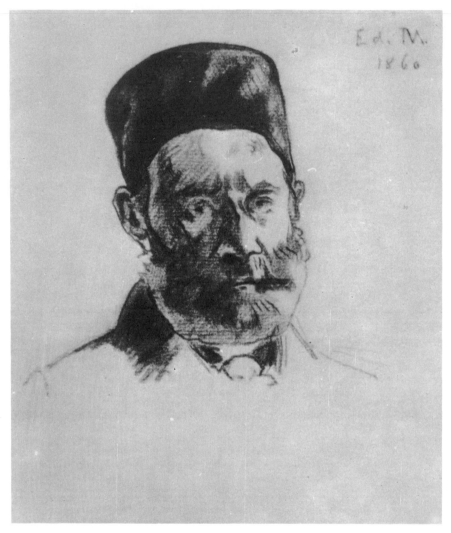

Fig. 12

COMMENTARY: The portrait reproduced in this print was taken from the oil portrait of his parents painted late in 1860 and exhibited in 1861 at the Salon (J. W. B. 37; Rouart Collection, Paris). The likeness of M. Manet was transferred to the etching plate through the intermediary of a chalk drawing (De Leiris 149, Rouart Collection; Fig. 12). The correspondence in the measurements of this drawing (17 x 14 cm.) and those of the etching suggest that the drawing may have been used to trace the portrait onto the plate. The plate is even signed in the same manner as the drawing.

The use of the vignette as a means of rendering a portrait was popular during the '60's. A notable example is Bracquemond's *Portrait of Charles Méryon* (Béraldi 77, dated 1853, illustrated in *Gazette des Beaux-Arts* of 1884, opposite p. 518). Another example is found in the work of Théodule Ribot (*Portrait of Cadart,* Béraldi 1).

The handling here is close to that seen in *The Little Cavaliers.* Sharp value contrasts bring out the character of M. Manet's face even more sharply than in the oil, and bold, deeply bitten cross-hatchings to the left of the head in the background help to give immediacy and vigor to the image.

7.

PORTRAIT OF M. MANET [M. Manet Père] (Figs. 13, 14)

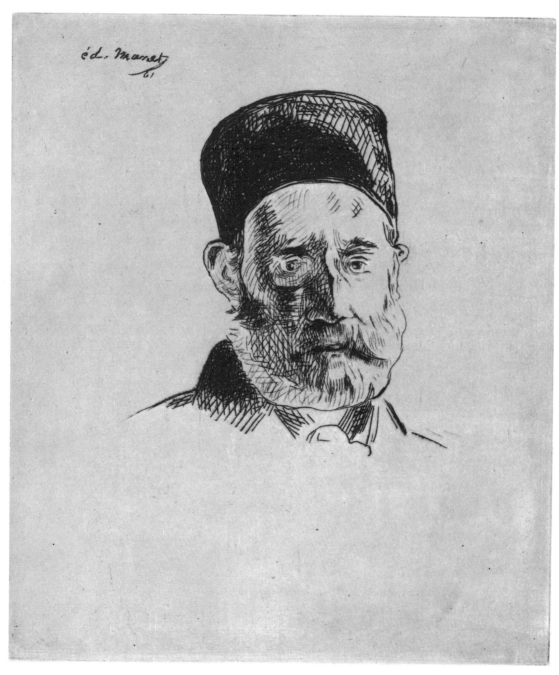

STATE 1

Fig. 13

Etching and aquatint: two states, trial proofs only
Signed upper left: "éd. Manet 61"
Dimensions: 186 x 155 mm.
Date: spring, 1861
Editions: none
References: M-N 51; Guérin 10; Rosenthal, 71
1st. state: Pure etching; the form is lightly indicated with a minimum of
 shading with rather widely spaced cross-hatchings.

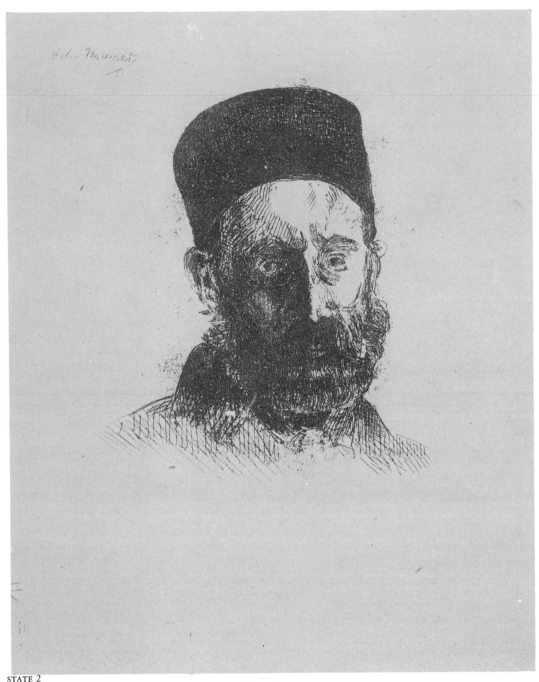

STATE 2

Fig. 14

2nd state: Addition of aquatint to the hat, beard and left side of face makes
the shadows much more dense. There is no work on the background,
but some few areas of aquatint escape beyond the confines of the
image itself.

COMMENTARY: This second version of the portrait of Manet's father is clearly a reworking of the first version (cat. 6). It is likely that Manet traced from a trial proof of the first plate to make the drawing for the second plate. Although the dates on the two plates are different, they could have been executed within a few weeks of each other during the winter of 1860-1861. The oil portrait was exhibited at the Salon during the spring of 1861.

As compared with the preceding plate, this one is more subdued. The emphasis is on tone rather than on linear boldness. The addition of aquatint reinforces the emphasis upon area. The resemblance to some of Rembrandt's etched portraits of his father (for instance, Hind 92) executed in the early 1630's, hints, in fact, that Manet may have been attempting to achieve chiaroscuro effects similar to those of the great Dutch master.

8.

THE CANDLE SELLER [La marchande de cièrges] (Figs. 15, 16)

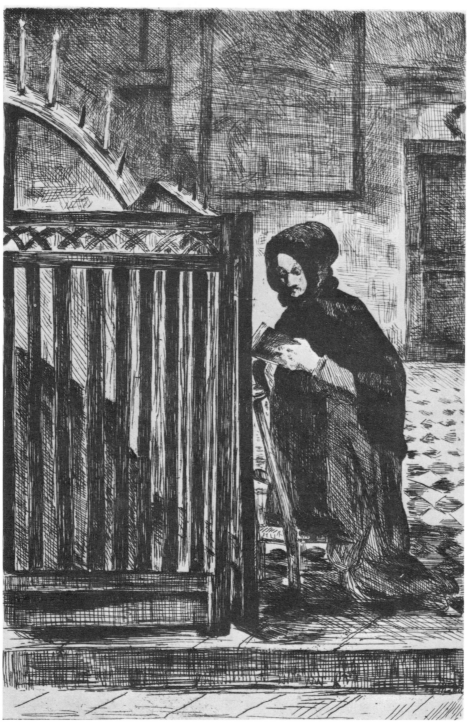

Fig. 15

Etching and aquatint: two states
Signed lower right: "éd. Manet;" undated
Dimensions: 339 x 227 mm. (plate); 307 x 201 mm. (composition)
Date: Spring, 1861
Editions: none

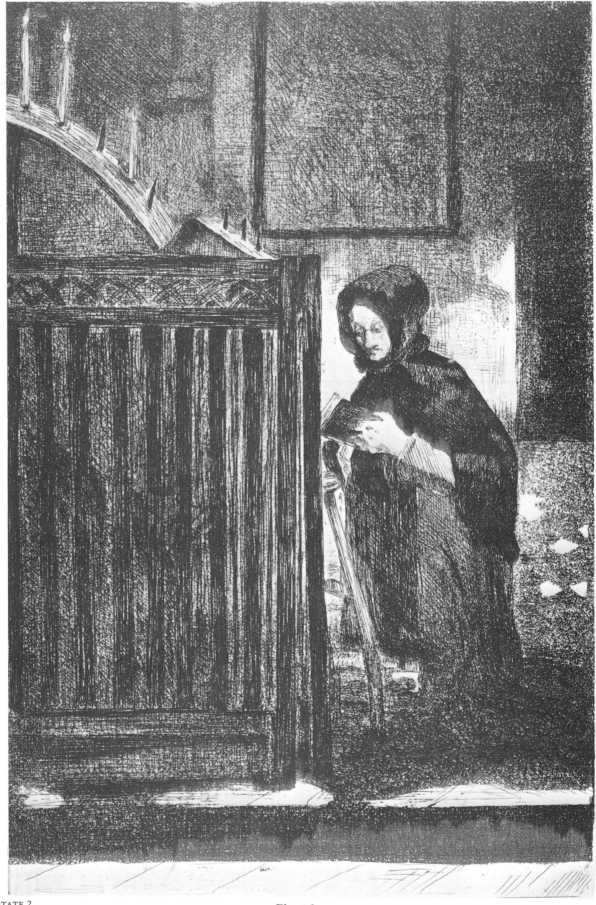

STATE 2 Fig. 16

References: M-N 56; Guérin 19; Rosenthal, 67; Hanson, no. 21, p. 53

1st state (listed as two states by Guérin): Pure etching; whole composition depicted with fine cross-hatchings, some diagonal, some vertical and horizontal.

2nd state: Addition of aquatint reinforces value contrasts. Now the lightest areas are limited to a few spaces in the center of the picture, while the rest of the scene exists in half light.

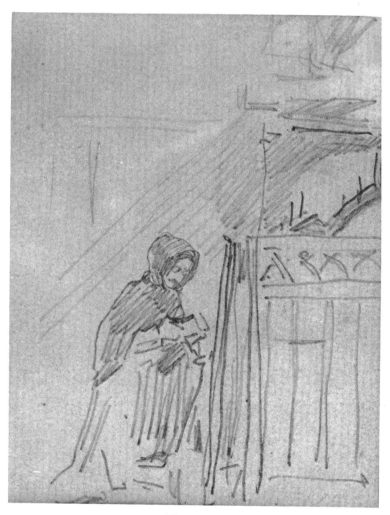

Fig. 17

COMMENTARY: This print was preceded by a pencil drawing (De Leiris 159, Le Garrec collection; Fig. 17). Guérin notes that this etching was influenced by Legros' etching, *The Lectern* (*Le Lutrin,* Malassis-Thibaudeau 61), but actually it is more like his etching of *The Communion in the Church of Saint Médard* (Malassis-Thibaudeau 34). The conception has much in common with the works of many etchers of the period, even with Whistler's, especially *La vieille aux loques* (K. 21). It is also still in the mood of some of Manet's earliest paintings, such as the *Head of an Old Woman* (J. W. B. 13, Collection Sachs). As in the painting of the *Absinthe Drinker* of 1858-59 (J. W. B. 24, Copenhagen, Ny Carlsberg Glyptotek), Manet emphasizes the picturesque figure set against and within an atmospherically suggestive ambient.

The composition emphasizes the major rectangular divisions of the surface and the silhouette of the grille and the figure, reinforcing the two-dimensional design. The handling in the etching seems more controlled and deliberate than in *The Little Cavaliers* of 1860, thus leading to the slightly later dating. The strokes in the 1st state, before the addition of aquatint, are very carefully drawn so as to enhance the effect of surface pattern. This effect is finally reinforced in the 2nd state by the addition of aquatint, which further reduces the significance of the lines themselves.

9.

THE BEAR TRAINER {Le montreur d'ours} (Fig. 18)

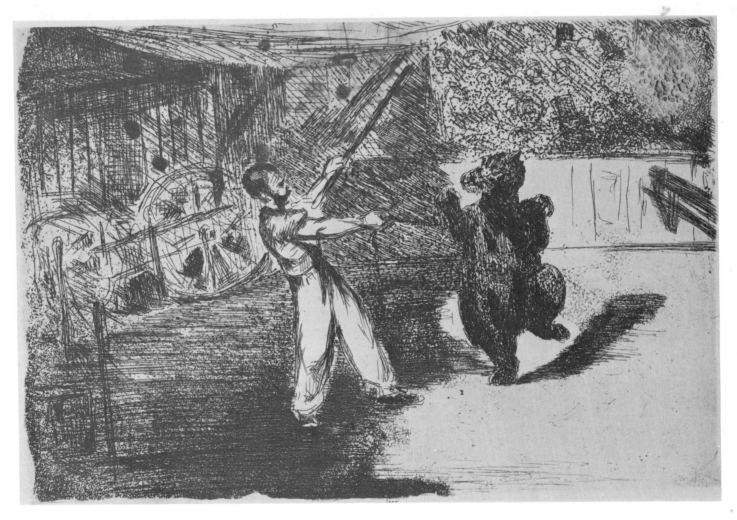

Fig. 18

Etching and aquatint: one state, trial proofs only
Unsigned: undated
Dimensions: 188 x 269 mm.
Date: 1861
Editions: none
References: M-N 65; Guérin 41; Rosenthal, 41

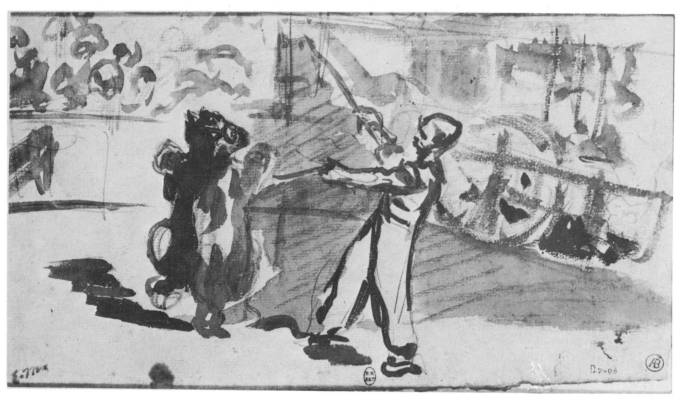

Fig. 19

COMMENTARY: This etching was taken from a drawing which has an appearance of having been done on the spot (De Leiris 216, Cabinet des Estampes, Bibliothèque Nationale, Paris; Fig. 19). It has traditionally been dated 1865 on the asumption that it must have been inspired by Manet's trip to Spain in that year. Guérin gives no reasons for his dating, but one must assume that it is because of a general similarity to Manet's paintings of bull-fight scenes which were executed after the Spanish visit. De Leiris dates the drawing from which this print was taken as 1865, apparently on the basis of a general similarity to works by Goya. However, in actual fact, both the drawing and the print are less like Manet's works of 1865 than they are like works done in 1860 and 1861, both in subject matter and in the handling of medium. The complexity of space and movement makes them seem closer in spirit to early drawings, such as that of tumblers in the Bibliothèque Nationale, than to later works. The compositional motif or pose of the central figure appears again in the pose of *Mlle. Victorine in the Costume of an "Espada"* of 1862.

10.

MAN WITH A DOG ON HIS KNEES
{Homme au chapeau de paille, un chien sur les genoux] (Fig. 20)

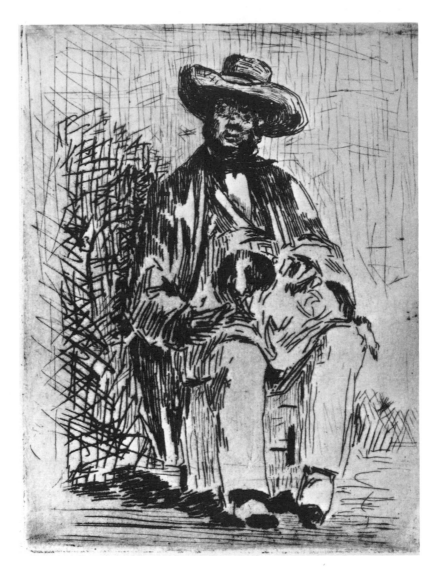

Fig. 20

Etching: one state, trial proofs only
Unsigned; undated
Dimensions: 138 x 103 mm.
Date: 1861
Editions: none
References: M-N 68; Guérin 3; Hanson, no. 19, p. 53

COMMENTARY: This is an abandoned etching, known in only one trial proof which is in the Avery Collection, Prints Division of the New York Public Library. Its breadth and freedom of handling clearly show the influence of Alphonse Legros on Manet's work at the time. It is also in many respects similar in handling to *The Reader* (cat. 13). However, the plate is rather unusual in Manet's work of this period because of its small scale.

11.

THE BOY WITH A DOG [L'enfant et le chien]ᴾ (Figs. 21, 22, 23)

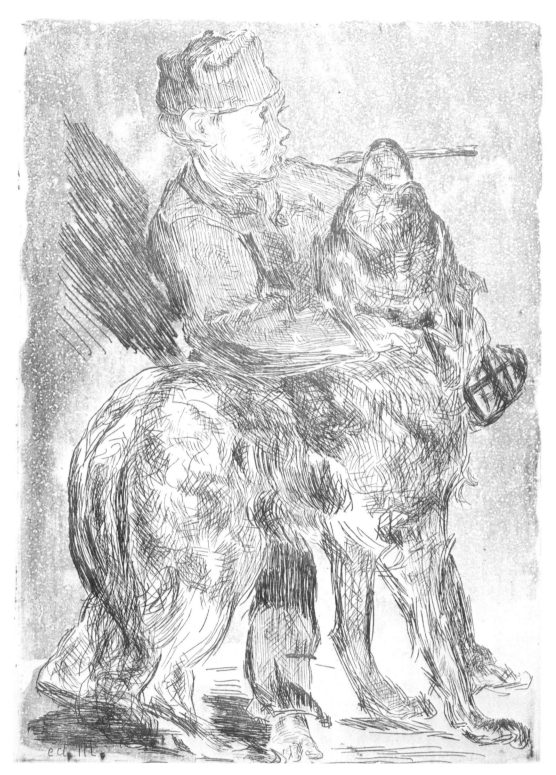

STATE 1

Fig. 21

Etching and aquatint: three states
Signed lower left: "éd. M.;" undated
Dimensions: 202 x 142 mm.
Date: 1861

[45]

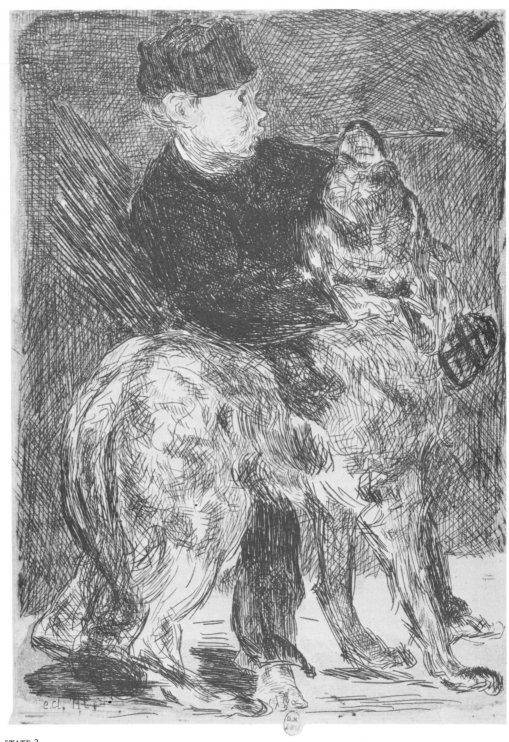

STATE 2

Fig. 22

Editions: 1862 portfolio; 1890 portfolio; 1894 Dumont; 1905 Strölin
References: M-N 10; Guérin 17; Rosenthal, 60, 70; Hanson, no. 20, p. 53
1st state (not listed by Guérin): The boy and the dog are lightly sketched
in, but there are no strokes on the background. There is a light coat of
aquatint on the background so that the figures are quite distinct from
what is behind them.

[46]

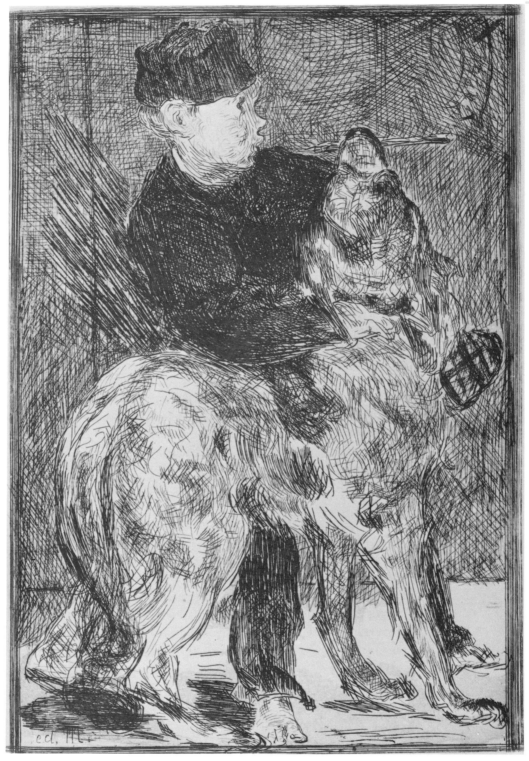

STATE 3

Fig. 23

2nd state (cited as the first state by Guérin): Strokes added to the background
as well as further strokes added to the figures.

3rd state: An etched frame has been added. Also, a few strokes define an
unidentifiable shape in the upper right corner.

COMMENTARY: This is the only etching included in the 1862 portfolio which was not derived from an oil painting. The image was preceded by a sepia and pen drawing in which the pose is very simply indicated (De Leiris 157, formerly Collection Curt Gläser, Berlin). The model was a boy named Alexandre, who had posed for the artist in 1858 or 1859 and later committed suicide in Manet's studio. An oil painting for which he posed, *The Boy with Cherries* (Lisbon, Gulbenkian Foundation; J. W. B. 33), was exhibited in September, 1861, at Martinet's.

The boy's tragic death forms the content of a prose poem by Baudelaire from the collection, *Le Spleen de Paris*. This piece, entitled *La corde,* was dedicated by the writer to Manet. It is generally thought that Baudelaire wrote the piece before the Christmas of 1861 (*Oeuvres complètes,* VI, 223). Manet's translation of the sepia drawing of the boy onto the etching plate may be related to Baudelaire's poem or to the suicide itself.

In terms of its handling, the print shows some advance over the earlier etchings of 1861. Individual strokes as toning agents rather than as calligraphic accents are still important, as in *The Candle Seller* and the second portrait of Manet's father, but there is more linear freedom than in either of these etchings, and the value range is more restricted. Varied hatchings are the most important accents. The distinction between masses and areas is more subtly achieved than in the earlier works.

12.

THE SPANISH SINGER [Le guitarrero]ᴾ (Figs. 24, 25, 26, 27)

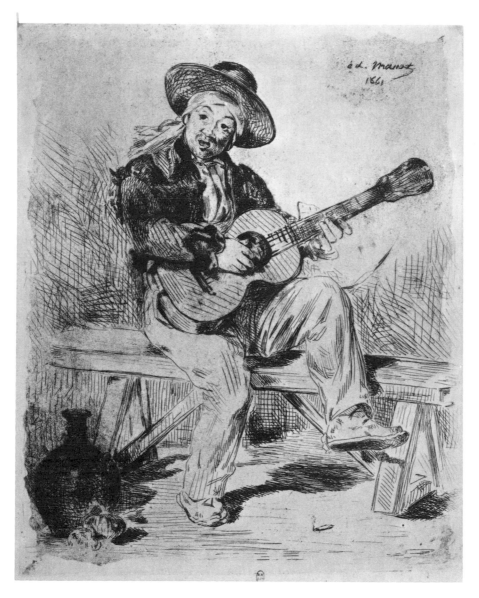

Fig. 24

Etching: five states
Signed upper right: "éd. Manet;" dated in second state: 1861
Dimensions: 297 x 244 mm. (plate)
Date: mid-1861
Editions: 1862 portfolio; 1874 portfolio; 1890 portfolio; 1894 Dumont;
 1905 Strölin; also an edition for *L'Artiste,* folded in the middle, date
 unknown.
References: M-N 4; Guérin 16; Rosenthal, 62; Hanson, no. 47, p. 69; Isaacson,
 no. 9, pp. 27-28

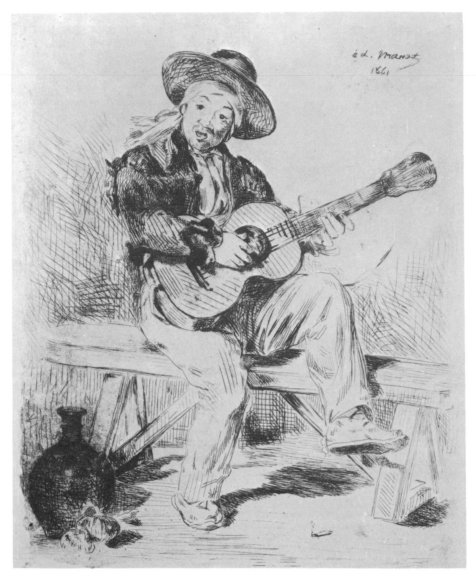

STATE 2

Fig. 25

1st state: Pure etching; no signature. The form is broadly indicated with simple lines and widely spaced hatchings. Some cross-hatching is used in the hat, jacket and face of the figure and in the jug to the left at his feet. The background around the figure has some long strokes of hatching.

2nd state: Signed and dated in upper right corner: "éd. Manet 1861." Additional strokes darken areas which were already darkened: the hat, bolero, guitar, and jug in the lower left. Aquatint softens the form of the jug and darkens the area between it and the bench.

3rd state: The signature has been eliminated; additional darkening of bolero and hat, as well as of the background around the bench.

4th state: The signature is replaced where it was in 2nd state, but with no change in drawing.

5th state: Addition of vertical hatchings in upper part of background. Also, below drawing, but on plate, the addition of the printer's name: "Imp. Delâtre, Paris."

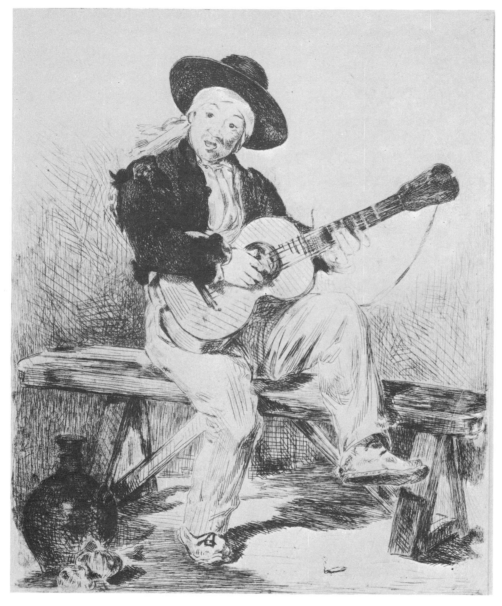

Fig. 26

COMMENTARY: This etching was taken from the oil version of the subject (J. W. B. 40; New York, Metropolitan Museum) by means of a watercolor version (De Leiris 161, Collection Emery Reves; Fig. 28). In addition, there is a tracing of the image (De Leiris 160) which may have been done from the watercolor as a further aid in transcribing the work to the copper plate.

There is some disagreement as to the identification of the singer in this work. Following the traditional assumption, Guérin says that it was Jérôme Bosch, the guitar player of whom Manet made a portrait for the cover of a piece of sheet music (see cat. 29).

However, it is likely that Bosch posed for neither the oil painting nor the etching. The way in which the guitar is being held seems unconvincing, and he would have had to be left-handed as he is shown in the oil painting (see J. Richardson, *Manet,* London/New York, 1958, 118). Richardson feels that the sitter was probably some unidentified picturesque model whom Manet saw in the street and called into his studio to pose. Wildenstein (J. W. B. 40) has suggested that the head is that of Jérôme Bosch, but that someone else posed for the lower part of the body. Certainly, when one compares this representation of a guitar player with the lithograph of

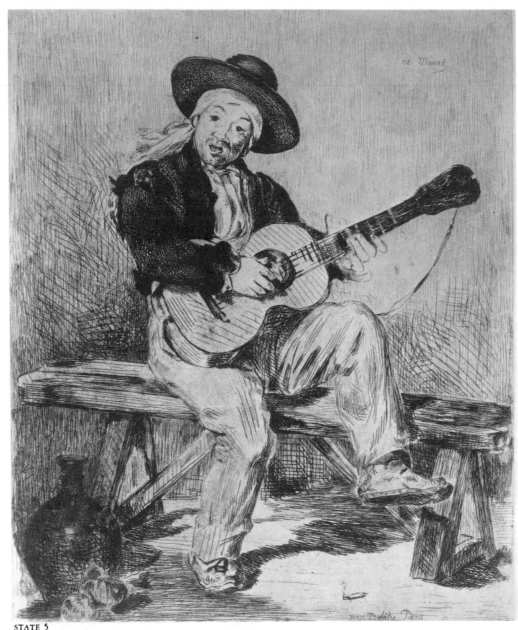

STATE 5

Fig. 27

Jérome Bosch, one feels that the hands are not those of an accomplished musician. Also, the features do not seem to be quite like those of the man in the lithograph. Hence, Richardson's suggestion seems just.

The technique of this print shows a further refinement of the style first evidenced in *The Boy and a Dog*. The bold calligraphy of *The Little Cavaliers* of the preceding year is present, but vigorously defined areas also play a significant role. The methods used to describe the features of the sitter anticipate effects achieved later in oil paintings. Shading in the face is confined to the right side of the cheek; the eyes, nose and mouth are briefly indicated with very short lines. This almost shorthand method of defining features was used only

rarely by Manet in 1860 and 1861, a notable example of such usage being the portrait of Mme. Brunet (J. W. B. 39), which because of its simplicity and awkwardness was refused by the family of the sitter. The method is found more often in paintings done after the middle of 1862, such as *The Street Singer* (Museum of Fine Arts, Boston; J. W. B. 45), of which Paul Mantz wrote: "Form is lost in his large portraits of women, and especially in *The Street Singer*, where, through a peculiarity which bothers us intensely, the eyebrows have been moved from their horizontal position to a vertical one parallel to the nose, like two dark commas." (George Heard Hamilton, *Manet and His Critics*, New Haven, 1954, 40)

[52]

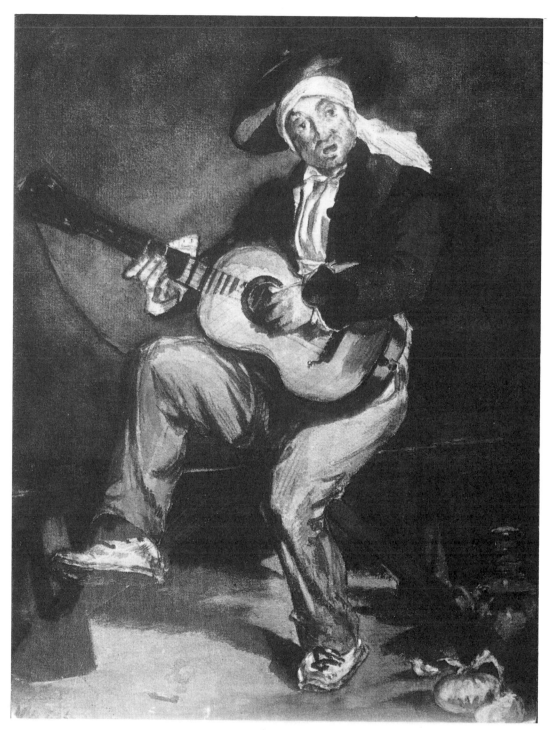

Fig. 28

13.

THE READER [Le liseur] (Figs. 29, 30)

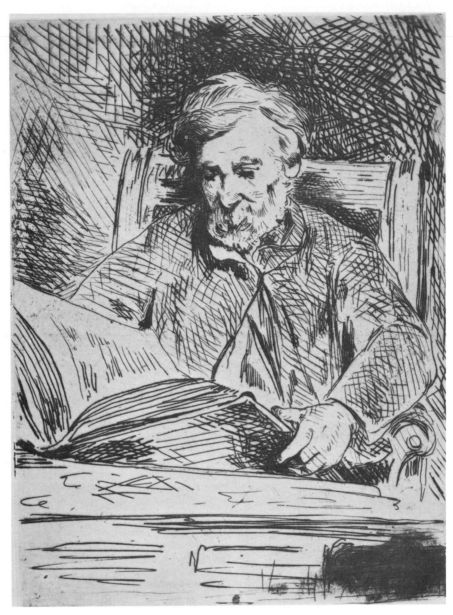

Fig. 29

Etching: two states
Unsigned; undated
Dimensions: 161 x 120 mm.
Date: 1861
Editions: none
References: M-N 57; Guérin 18; Rosenthal, 52-53; Hanson, no. 23, p. 53
1st state: The form is depicted with widely spaced, rather light lines. The
 whole effect is very light.
2nd state: The whole plate has been made very dark with dense and boldly
 drawn cross-hatchings. Only the pages of the book and the man's
 face and hand remain light. The rest of the print is very dark.

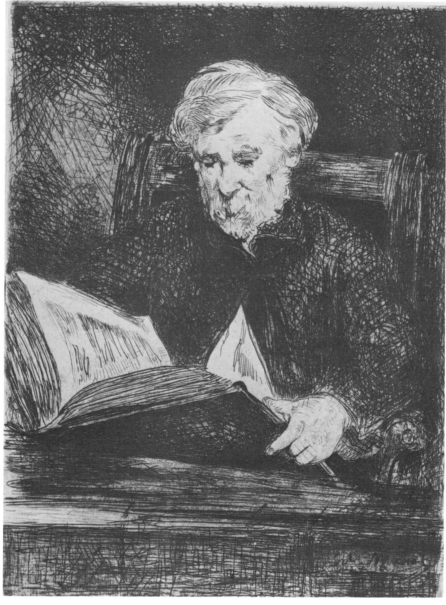

Fig. 30

COMMENTARY: This print shows in reverse the same figure that Manet painted in oils in 1861, using as a model the painter Gall (St. Louis, City Art Museum; J. W. B. 41). The painting was exhibited at Martinet's in September, 1861, along with *The Boy with Cherries.*

Like many of his other early etchings, *The Reader* owes much to the study of Baroque art. In this case, the source seems most clearly to have been Rembrandt, perhaps such a figure as the portrait of Jan Cornelis Sylvius of 1634 (Hind 111). It is also related to etchings by contemporary artists such as Whistler (for instance, *The Music Room,* K. 33). The manipulation of lines to create rich and vibrant dark areas by allowing the white of the paper to mingle with deeply bitten cross-hatchings is characteristic of the technique of both artists.

This etching represents an even bolder transcription of a contemporary oil than does *The Spanish Singer* (cat. 12). In the first state, deeply bitten, straight lines define the main shapes and dark areas of the picture. In the final state, the whole surface, with the exception of the face, hand, and book, has been worked over with additional strokes so as to duplicate the dark atmosphere of the oil. However, unlike the dark surface effect of the earlier *The Candle Seller,* which has a similar value range, the lines here remain quite visible and bold, not obliterated with cross-hatching or aquatint.

14.

THE INFANTA MARGUERITA [Infante Marguerite] (Fig. 31)

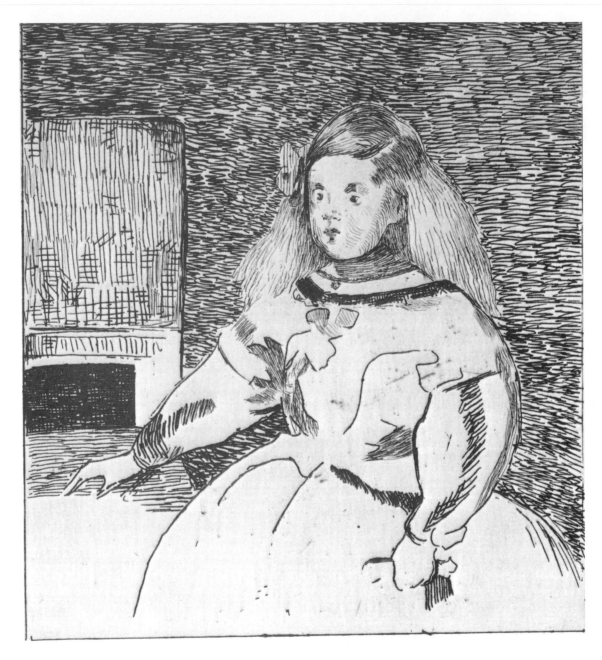

Fig. 31

Etching: one state
Unsigned; undated
Dimensions: 230 x 190 mm. (plate); 162 x 148 mm. (composition)
Date: 1861
Editions: 1874 portfolio; 1890 portfolio; 1894 Dumont; 1905 Strölin
References: M-N 14; Guérin 6; Tabarant, 37; Hanson, no. 5, p. 41; Isaacson,
 no. 2, p. 25

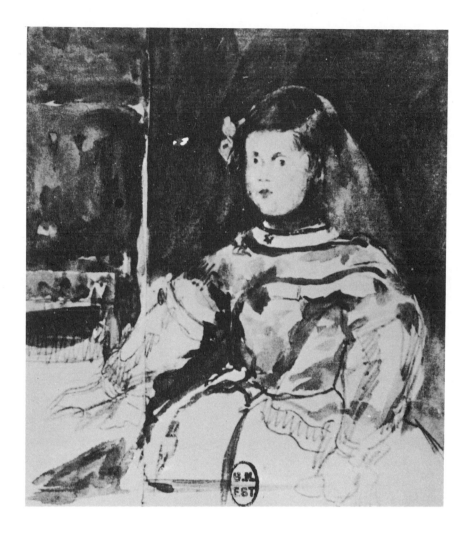

Fig. 32

COMMENTARY: According to Tabarant, Manet painted a copy of the portrait of the Infanta which was attributed to Velazquez, but this work seems to have disappeared. A watercolor version of this image exists in the collection of M. de Lostalot (De Leiris 142; fig. 32) which may well have formed the basis for this etching.

Manet here shows his admiration for the etched works of Goya, for he employs various devices used by the Spanish artist, such as zigzag hatchings in the background and small areas of parallel lines with no actual contours to indicate shadows.

Manet may have abandoned this plate after one state because of the very deep biting of the lines which gives a harsh tone to the whole image. Nevertheless, it was included in Manet's 1874 portfolio of etchings, or at least it has been assumed that it was included (Rosenthal, 31, note 1).

15.

PHILIP IV [Philippe IV] (Figs. 33, 34, 35, 36, 37)

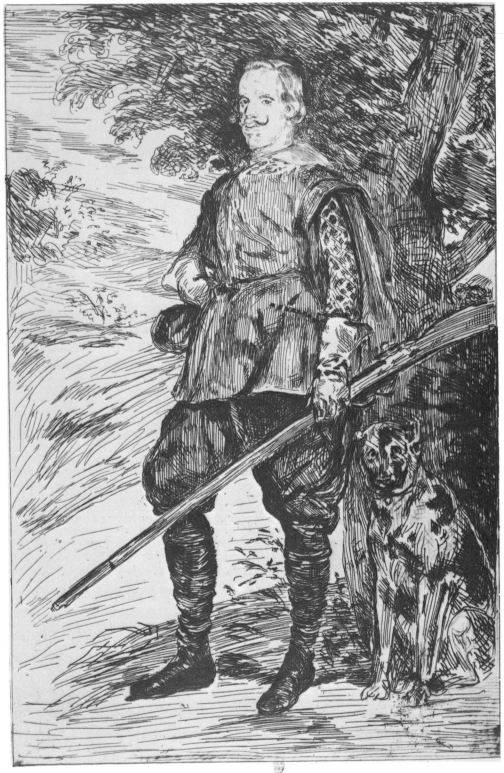

Fig. 33

Etching and aquatint: seven states
Signed in various ways in different states; undated
Dimensions: 350 x 238 mm. (plate); 313 x 197 mm. (composition)

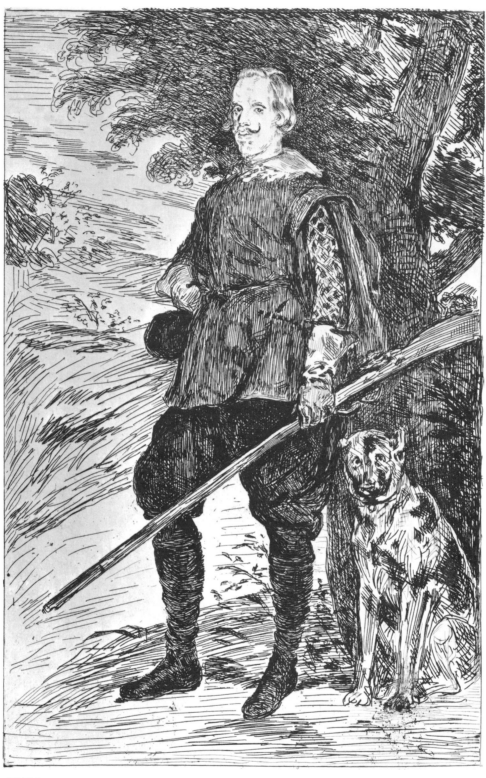

STATE 2

Fig. 34

Date: 1862 for first five states; after 1862 for states 6 and 7
Editions: 1862 portfolio
Exhibited: 1863 Salon des Réfusés; 1867 one-man show
References: M-N 6; Guérin 7; Rosenthal, 54; Hanson, no. 6, p. 41; Isaacson, no. 3, p. 25

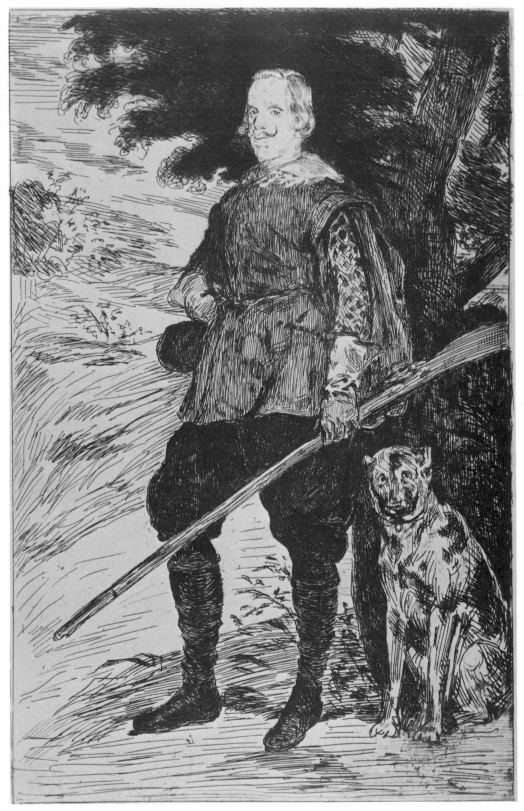

STATE 3

Fig. 35

1st state: Pure etching; the form is boldly drawn with long, parallel hatchings.
 The right foot of the dog is not completed and there are little spots
 below it. This state is not signed.

2nd state: The whole plate is reworked to reinforce the darks, particularly
 in the figure and the tree behind it. The dog's right foot is still in-

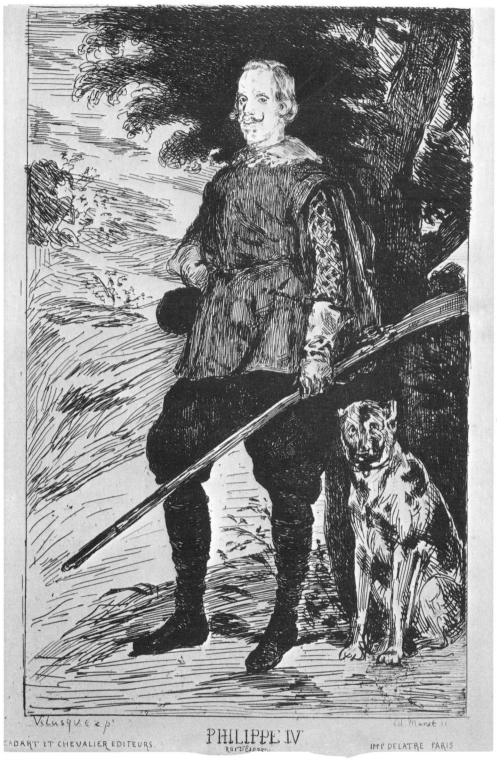

Velasquez p! ed. Manet sc.

PHILIPPE IV

ROI D'ESPAGNE

CADART ET CHEVALIER EDITEURS. IMP DELATRE PARIS

STATE 5 Fig. 36

complete and the spots remain on the ground beneath it. This state
is unsigned also.

3rd state: The man's trousers and the tree behind his head are further
darkened with the addition of strokes. The dog's foot is made more
precise, but the spots on the ground still remain. This state is unsigned.

4th state: Addition of signature, outside of the frame at the left: "Velasquez
pt;" and at the right: "éd. Manet sc."

[61]

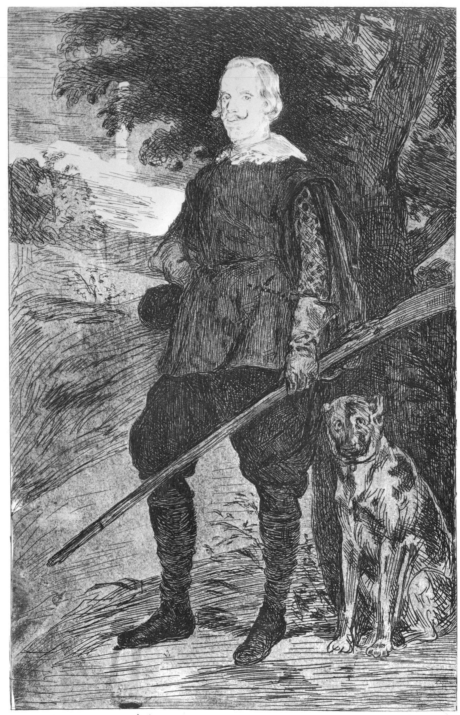

éd. Manet d'après Vélasquez

STATE 7 **Fig. 37**

5th state: Change in the writing, still by Manet himself. In the center, on two
 lines, "Philippe IV roi d'Espagne;" on the edge of the drawing at the
 left: "Velasquez pt;" at the right: "éd. Manet sc." Added at the left
 is the name of publisher: "Cadart et Chevalier éditeurs;" and of the
 printer at the right: "Imp. Delâtre, Paris." This state was published
 in the 1862 portfolio.

6th state: All the earlier writing has been eliminated; in its place, at the left,
 Manet wrote: "éd. Manet, d'après Velasquez."

7th state: The drawing is the same as in the 6th state, but the entire surface
is covered, with the exception of a small area in the upper left and in
the man's hair and collar, with a dense coat of aquatint. This heavy
coating of the plate must have taken place after 1862, perhaps when
Manet was preparing plates for his 1874 portfolio. The reason for
the plate's never having been published in this final state is not hard
to surmise; Manet probably felt that the aquatint had detracted irrep-
arably from the vigor and impressiveness of the man's figure.

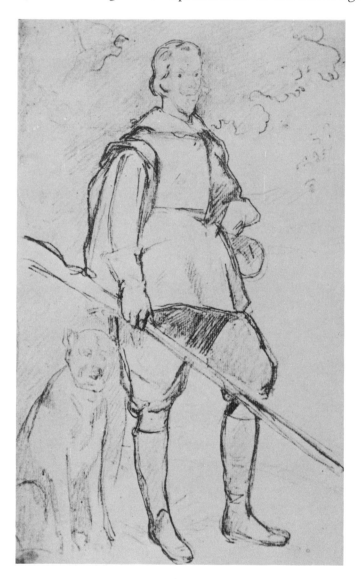

Fig. 38

COMMENTARY: This etching was carried out by
means of an intermediary drawing which is a copy
of the portrait of Philip in the Louvre (De Leiris
151, present location unknown; Fig. 38). The fact
that the oil *Portrait of Philip IV* did not enter the
Louvre until 1862 probably determines the *terminus
a quo* for dating the etching, although it is possible
that Manet might have seen the portrait when it was
still in private hands.

Stylistically, the etching retains, as does *The In-
fanta Marguerita,* several graphic devices of calli-
graphic and tonal variety derived from Goya's etched
copies after Velazquez. However, Manet seems here
to handle such devices with greater subtlety than
in the previous print. In addition, we find here
for the first time in his work certain of the
Spanish master's usages which he was to employ
consistently hereafter. In the first three states, the

figure of Philip is not completely enclosed with a preliminary contour line, as was the case with figures in earlier etchings; instead, Manet indicated the shape with parallel strokes which alone define the leg. There is also a marked contrast between a rather uniform treatment of dark areas and a free, calligraphic treatment of light areas. Both of these techniques are used by Goya, but they are exaggerated in Manet's etching. The darkest areas, the pants and boots of the king and the foliage behind his head, are darkened so much with cross-hatchings that individual strokes are barely distinguishable. The middle value area of Philip's coat is composed of parallel, vertical lines which also give a uniform texture and tone. The lightest areas, on the other hand, the dog and Philip's face and hair, are covered with fine, short strokes of varying directions, while in the background at the left, lightly bitten, long lines are combined with a few short "squiggles" to suggest hills and shrubs seen through air.

Thus, although the etching displays some of the same painterly qualities seen in *The Little Cavaliers* of 1860, which also had its source in Velazquez, the greater freedom and economy of handling in the portrait, as well as its greater assurance and spontaneity, indicate that it was done sometime after *The Guitar Player* and *The Reader*.

THE ABSINTHE DRINKER {Le buveur d'absinthe}　(Figs. 39, 40, 41)

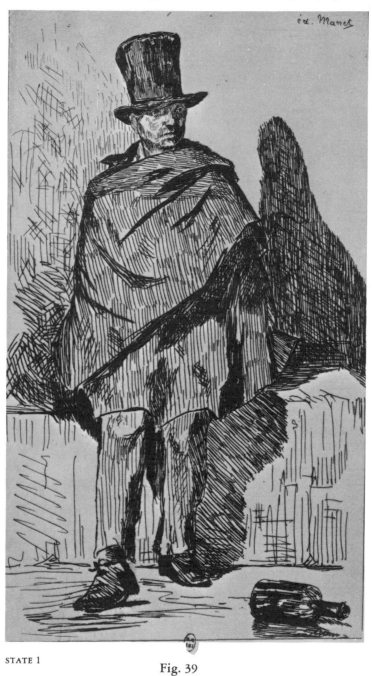

STATE 1

Fig. 39

Etching and aquatint: three states

Signed top right: "éd. Manet;" undated

Dimensions: 286 x 161 mm. (plate); 246 x 144 mm. (composition)

Date: early 1862 for first 2 states; 3rd state at a later, undetermined time

Editions: 1862 portfolio, 2nd state; Porcabeuf, 3rd state

References: M-N 8; Guérin 9; Rosenthal, 61; Hanson, no. 9, p. 45; Isaacson,
　　　no. 10, p. 28

1st state: The form is simply blocked out in pure etching with primarily
　　　parallel, widely spaced hatchings.

Signed upper right: "éd. Manet."

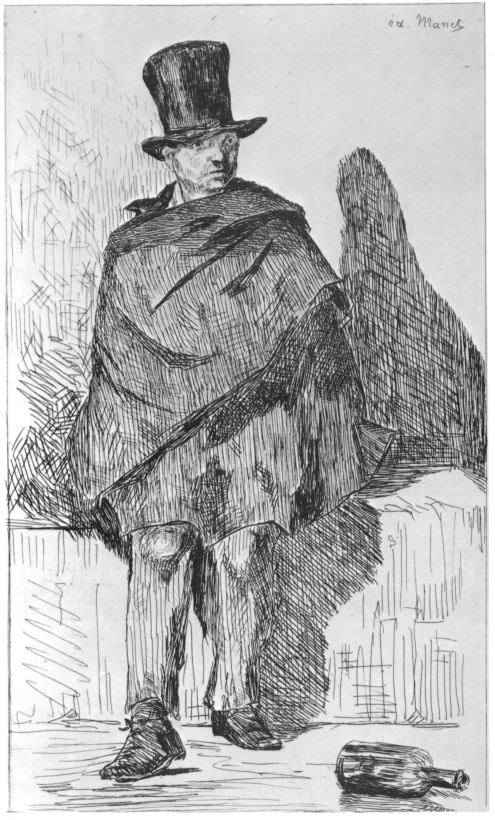

STATE 2

Fig. 40

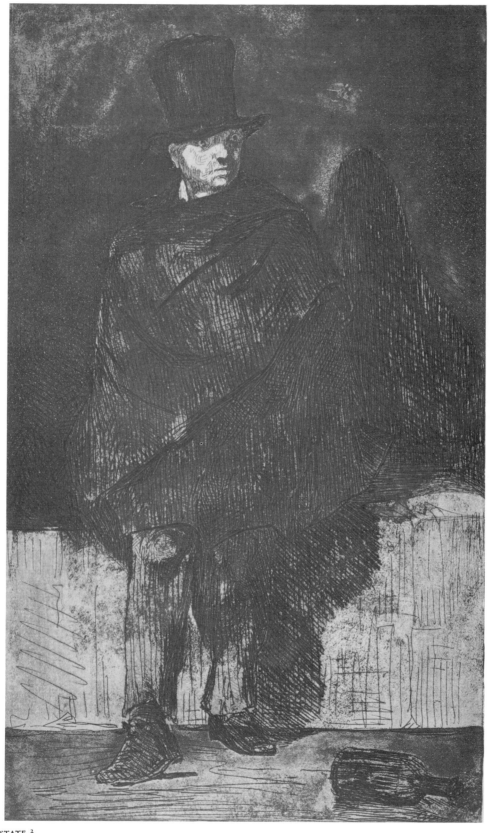

STATE 3

Fig. 41

2nd state: The hat and cloak are darkened with additional strokes of parallel hatching. Also the shadow to the right of the figure has been darkened with additional strokes. This is still pure etching only.

3rd state: The plate is covered with a dense coat of aquatint. This must have been done after October, 1862, for the plate appeared in the 2nd state in the 1862 portfolio. As with the plate of *Philip IV* (cat. 15), the overbiting of the aquatint probably explains why the plate was not included in later editions.

COMMENTARY: This etching reproduces the oil painting of the same subject in Copenhagen, Ny Carlsberg Glyptotek (J. W. B. 24), done in the winter of 1858-59. The etching does not date, however, from this early period but seems to come from the winter of 1861-62, when Manet was involved in re-using the figure of the old man in his painting *The Old Musician*. The accomplished handling of the etching medium certainly testifies to Manet's having acquired a good deal of technical skill by the time the print was executed. Guérin thinks the etching was executed in 1860, but even if it had been done at this point, it would have had a retrospective character. Since none of the etchings of 1860 or early 1861 repeats motifs which Manet had carried out originally a year earlier, and since the reverse is true of the winter of 1861-62, which was a definitely retrospective season in Manet's work, it seems much more likely that the etching comes from the later period.

Three drawings of the *Absinthe Drinker* are known. One is a watercolor in the Rosenwald Collection in the National Gallery, Washington, D. C. (De Leiris 147). The second is a drawing reproduced in *L'Art à Paris* in 1867 (De Leiris 148), which shows only the head and shoulders of the figure. The third is a wash drawing in the Hill-Stead Museum, Farmington, Connecticut (De Leiris 147a; Fig. 42). It is most likely that this third drawing is the one which was used as the study for the etching, for it includes the bottle at the man's feet (which is not true of the Rosenwald drawing) and it is almost exactly the same size as the etched version.

In the state of this etching included in the 1862 portfolio, this is the boldest graphic work which Manet had executed to this time, repeating much of the vigor and contrast seen in the preliminary wash drawing. The shading is effected throughout with parallel strokes closely spaced to render variations in value. Some areas of cross-hatching appear in the folds of the cloak, but these are kept to a minimum so as not to destroy the unity of the

cloak's shape. Diagonal strokes appear in the shadow cast by the man's body on the wall at the right and left of the figure, contrasting with the primarily vertical hatchings in the figure and aiding in the differentiation between figure and ground. Value gradations are not complex or many, making the print immediately striking as an image and almost as effective as a drawing.

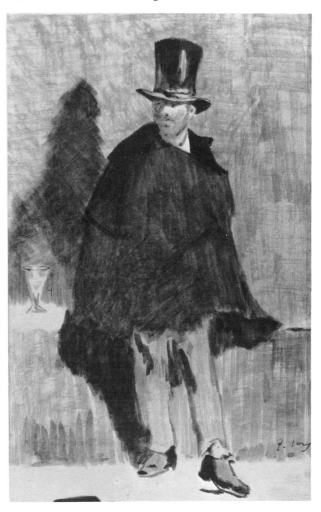

Fig. 42

17.

THE LITTLE GYPSIES [Les petits gitanos] (Fig. 43)

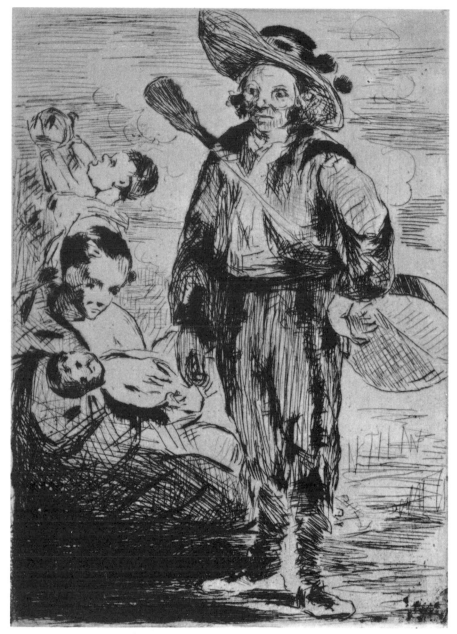

Fig. 43

Etching and dry point: one state, trial proofs only
Unsigned; undated
Dimensions: 197 x 139 mm.
Date: early 1862
Editions: none
References: M-N 61; Guérin 20; Hanson, no. 31, p. 59; Isaacson, no. 12, p. 29

COMMENTARY: This plate is probably a very inferior trial for the print taken from Manet's oil of *The Gypsies,* but its attribution to Manet cannot be doubted. Manet seems to have had difficulty in drawing a motif directly on a plate in reverse of the image before him, which is what he was doing here, for the images as printed face the same way as in the oil painting. It is also clear that here he was concerned with working out a more satisfactory grouping of the three figures than he had achieved in the oil version. Nevertheless, it is not difficult to see why he abandoned this plate.

18.

THE GYPSIES {Les gitanos} (Figs. 44, 45)

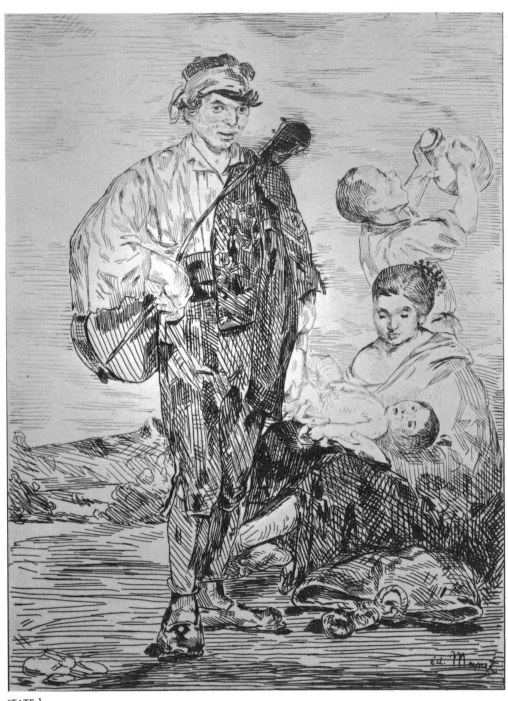

STATE 1 Fig. 44

Etching: two states
Signed lower right: "éd. Manet;" undated
Dimensions: 316 x 236 mm. (plate); 284 x 206 mm. (composition)
Date: early 1862
Editions: 1862 Soc.d.A.; 1874 portfolio; 1890 portfolio; 1894 Dumont; 1905
 Strölin
Exhibited: 1867 one-man show

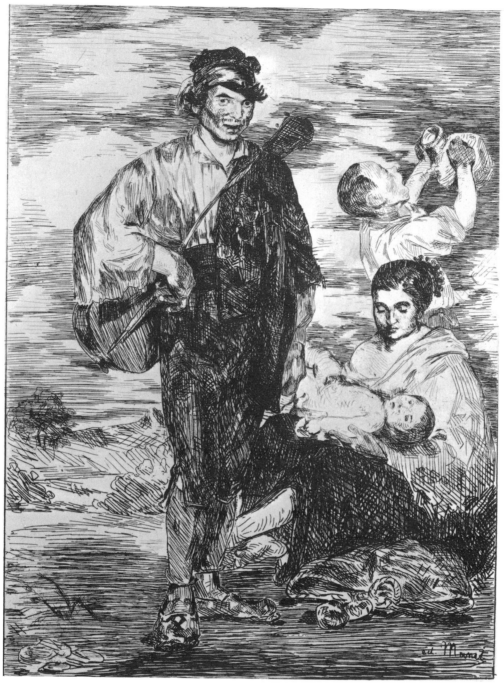

Fig. 45

References: M-N 2; Guérin 21; Rosenthal, 63; Hanson, no. 32, p. 59; Isaac-
 son, no. 13, pp. 29-30
1st state: All the forms blocked in with boldly drawn and deeply bitten
 hatchings. Lines for the most part widely spaced.
2nd state: The whole plate is reworked with additional lines of hatching to
 reinforce the darks. Contrasts of values are strong. There were two
 different printings of the plate in this state. The first, when it was
 one of the prints in the Société des Aquafortistes' first folio issued
 on September 1, 1862, has the title "Les Gitanos" in the center

beneath the print; at the left: "Manet sculpt;" at the right: "Imp. Delâtre, rue des Feuillantines, Paris." Some examples were printed on Holland, some on China, paper. Some also bear in embossed letters the name of the publishers "Cadart et Chevalier, 66, rue de Richelieu," while others have "Cadart et Luquet, éditeurs, 70, rue de Richelieu." A second printing, with all the letters effaced, was carried out at a later, undetermined time.

COMMENTARY: This etching reproduces the painting which Manet executed in 1862 and which exists today only in fragments representing the individual figures (J. W. B. 59, 60, 71). We know that the oil painting must have been very similar to the etching in its composition and figure types, for a cartoonist recorded the appearance of the oil in a page of *Le Journal Amusant* when the one-man show of Manet's work was in progress at the Pont de L'Alma (see Mina Curtiss, "Manet Caricatures," *Massachusetts Review* [Autumn, 1966], between pp. 724 and 753, unpaged [p. 21]).

The etching, particularly in its first state, shows evidence of having been recorded on the plate initially by means of a tracing, perhaps even from a photograph of the oil, for each figure is surrounded by an unbroken contour.

Technically, this is by far the boldest etching which Manet ever executed in a finished form. All of the lines are deeply bitten, even though they vary in width. The hatching is open, permitting a lively play of light throughout the surface. The linear vocabulary is largely restricted to straight lines of varying lengths and widths, but lines are not subordinated to areas very much. Contrast of stroke, therefore, is not so striking as in other prints, such as *Philip IV*. The effect of the etching is much more integrated than in the earlier prints even though linear activity is more pronounced than in painterly etchings such as *The Little Cavaliers*.

19.

THE LITTLE GIRL {La petite fille}[P] (Figs. 46, 47)

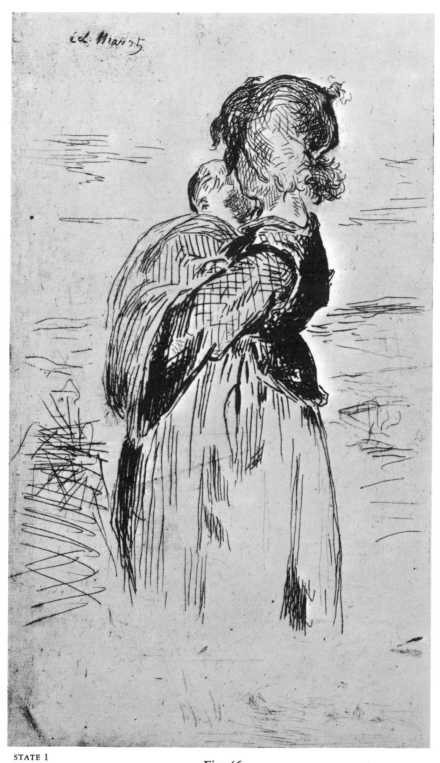

Fig. 46

Etching and drypoint: two states
Signed upper left: 'éd. Manet;'' undated
Dimensions: 206 x 117 mm.
Date: 1862

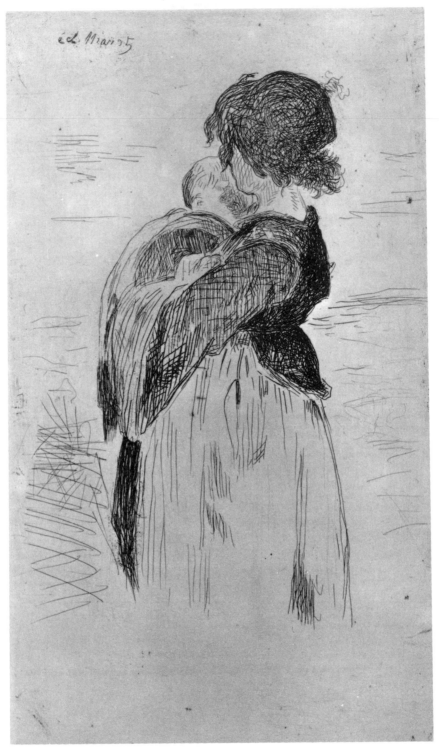

STATE 2

Fig. 47

Editions: 1862 portfolio; 1874 portfolio; 1890 portfolio; 1894 Dumont; 1905
 Strölin
References: M-N 12; Guérin 25; Rosenthal, 142-143; Hanson, no. 10, p. 45;
 Isaacson, no. 11, p. 28
1st state: Forms simply blocked in with widely spaced, parallel hatchings,
 except in back, where some darker, denser hatching is used. Dry-
 point quite evident in dark areas.
2nd state: Additional strokes in sleeves of blouse and head to strengthen
 contrasts.

COMMENTARY: This etching reproduces the figure seen in the left side of *The Old Musician* (J. W. B. 44; National Gallery of Art, Washington, D. C.). The figure is not shown in full length as she appears in the painting, but is cut off at the knees. Thus, she is portrayed less as a concrete figure than as an evocative symbol. The pure suggestivity of the half-length image is enhanced by the anonymity with which she is presented; her face is hidden from the spectator.

The print is much sketchier than any finished print which Manet had executed to this point. The lines are fine and narrow, making the print less forceful in its impact than *The Gypsies*. Variations in value are achieved by a network of fine lines, densely hatched in darkest areas, very widely spaced in lighter sections. Freely rendered strokes are found as in the earlier prints, but there is much less variety of width and depth of biting. The wispy, almost sentimental treatment of the figure suggests that Manet had looked at early etchings by Whistler, particularly *Fumette* (K. 13), which was published as part of the French Set in 1858.

20.

THE TOILETTE {La toilette}ᴾ (Figs. 48, 49)

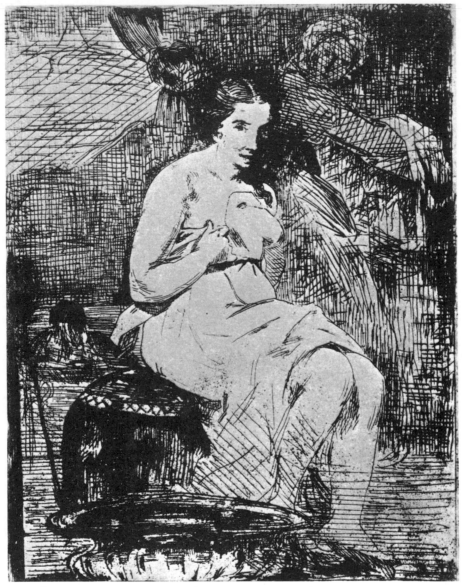

STATE 1

Fig. 48

Etching: two states

Signed lower right in second state: "M.;" undated

Dimensions: 284 x 223 mm.

Date: summer, 1862

Editions: 1862 portfolio; 1874 portfolio; 1890 portfolio; 1894 Dumont;
 1905 Strölin

References: M-N 9; Guérin 26; Rosenthal, 67; Hanson, no. 16, p. 49

1st state: Form simply and boldly blocked in with pure etching. The figure
 of the woman is left white for the most part; the background is
 shaded with long, widely spaced hatchings. This state is not signed.

2nd state: The whole background is darkened; only the figure remains white.
 Signature "M." added.

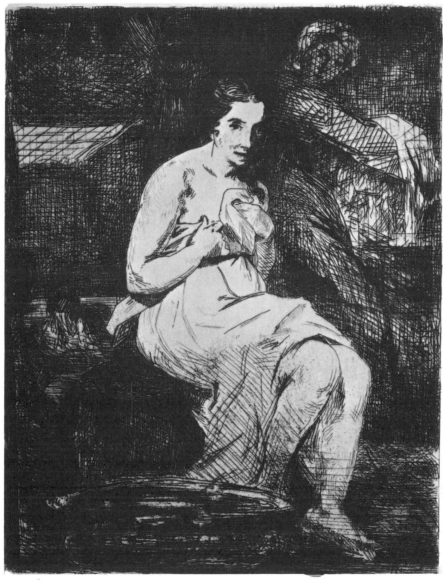

STATE 2

Fig. 49

COMMENTARY: The theme of this etching, a nude woman with an attendant figure, is similar to several paintings on which Manet had worked in 1860 and to which he returned in the summer of 1862 — the *Nymphe surprise series* (J. W. B. 53, 54, 55), the two oils of *The Bath* (or *The Picnic on the Grass*; J. W. B. 78 and 79), and *Olympia* (J. W. B. 82). However, although the work is similar in theme to other paintings and drawings, the composition is an independently executed one in the etching medium. The motif was first worked out in a bold chalk drawing (De Leiris 185; Courtauld Institute of Art, University of London; Fig. 50). The composition has been reproduced almost verbatim from

the drawing, but the background space has been more fully described to provide an environment behind the figure.

It might seem, as is true with *The Reader,* that *The Toilette* has some affinity with Rembrandt's etchings of nudes. The theme of the nude caught in the midst of bathing is seen in Rembrandt's etching of *Diana* of 1631 (Hind 42) and in two later prints of women bathing (Hind 297 and 298). Manet's bold drawing and use of sharp contrasts is also somewhat reminiscent of Rembrandt's handling in the late plate of a *Woman bathing at a brook* (Hind 298), but again, as in earlier comparisons made with the Dutch artist's work, the similarities

[77]

Fig. 50

do not extend to the structural definition by line.

The handling of the medium is very bold and vigorous, similar to that in *The Gypsies*. Various types of hatching, all done with strongly bitten, straight lines which move diagonally, vertically and horizontally across the plate, are used to convey an atmosphere. In addition, in the nude, Manet has exaggerated the shadow and light contrasts by elimi-nating half tones much as he did in the oils of *The Picnic* and *Olympia*. In order to reinforce the flat white areas of the nude's body as almost independent shapes, he covered the rest of the plate with deeply bitten, long lines, mostly cross-hatchings, which serve to darken these areas, and also to preserve the desired spontaneity and vitality.

21.

PROFILE PORTRAIT OF CHARLES BAUDELAIRE[P] (Fig. 51)

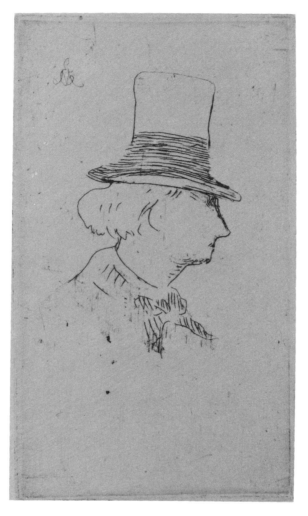

Fig. 51

Etching: one state
Signed with monogram at upper left; undated
Dimensions: 130 x 74 mm.
Date: 1862
Editions: 1890 portfolio; 1894 Dumont; 1905 Strölin; 1910 Duret
References: M-N 40; Guérin 30; Sandblad, 66; Rosenthal, 73; Hanson, no.
 36, p. 61

COMMENTARY: This is one of two portraits of Baudelaire etched by Manet during Baudelaire's lifetime. This one was clearly inspired by the portrait in *Concert in the Tuileries* (National Gallery, London) painted in 1862. Sandblad believes (pp. 64-67) that this version was etched in 1862 at the time of painting *Concert in the Tuileries,* but that the final published version of the profile (cat. 59) was not undertaken until 1869, when a posthumous biography of Baudelaire was being published. His argument seems to have merit.

THE STREET SINGER [Le chanteur des rues] (Fig. 52)

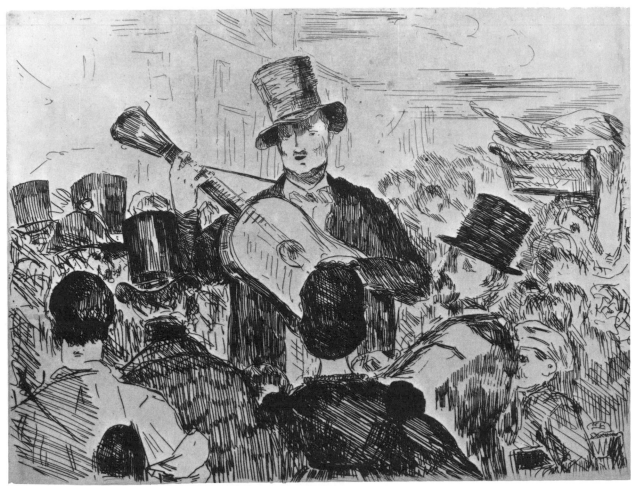

Fig. 52

Etching: one state, trial proofs only
Unsigned; undated
Dimensions: 210 x 280 mm.
Date: mid-1862
Editions: none
References: M-N 69; Guérin 2; Hanson, no. 35, p. 61

COMMENTARY: The obviously naïve quality of the drawing in this print might be explained by supposing that Manet, like many other young artists of the time, notably Whistler, Fantin-Latour, and Legros, was attempting an image drawn directly on the plate without the aid of an intermediary drawing. The practice of drawing from memory was advocated by Fantin's teacher, Lecoq de Boisbaudron, whose method encouraged artists to seek the most individual and memorable traits in visual experience by such means (see M. C. Salaman, *Alphonse Legros,* London, 1926, 3). The result here bears some relationship to a curious example of Legros' work, dating from 1861, a poster advertising a series of verses by F. Desnoyers, *The Theater of Polichinelle* (Bér-

aldi 157; illustrated in *Etchings, Drypoints and Lithographs in the Collection of Frank E. Bliss,* London, 1923, privately printed, Pl. XLVI; see also M. Fried, "Manet's Sources — Aspects of His Art, 1859-1865," *Artforum* [March, 1969], 37-40). The resemblance lies in the deliberate gaucherie of the drawing and the idea of showing the backs of members of the audience witnessing a performance.

That this etching was abandoned without further work on the plate suggests that Manet was not prepared to follow out the implications of its handling. The lack of outline, the use of parallel strokes alone to define form, was used to provide a feeling of outdoor light, but Manet's sense of design prevented him from developing the theme further.

23.

THE BALLOON [Le ballon] (Fig. 53)

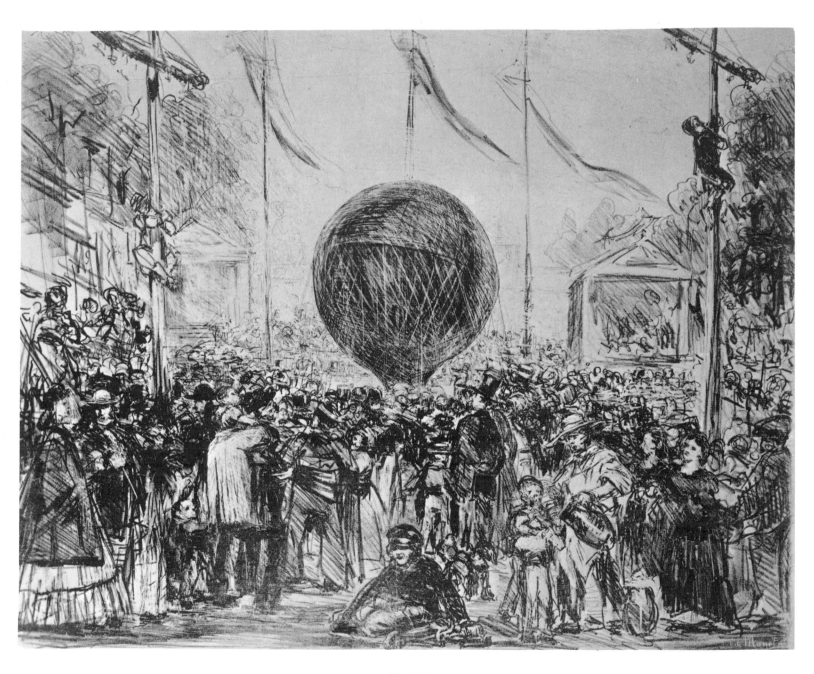

Fig. 53

Lithograph; trial proofs only
Signed lower right: "éd. Manet 1862"
Dimensions: 395 x 510 mm.
Date: mid-1862
Editions: none
References: M-N 76; Guérin 68; Rosenthal, 143; *Minneapolis Institute Bulletin,* March 8, 1947, 50; Hanson, no. 40, p. 63

COMMENTARY: In 1862, Cadart, in an effort to spark a revival of lithography as a fine art, sent three stones to each of five artists, including Ribot, Legros, Bracquemond, Fantin-Latour, and Manet. Ribot, Legros, Bracquemond, and Manet all apparently used only one of the stones for a print; Fantin-Latour used all three. Manet's print was rejected by the printers at Lemercier and Co., who were horrified at his result. The lithogaphs executed by the other four artists are much more assured and finished-looking than Manet's. The works include: Ribot, *La Lecture;* Legros, *Les carriers de Montrouge;* Bracquemond, *Les cavaliers;* and Fantin-Latour, *Tannhäuser, L'amour désarmé, L'education de l'amour,* and *Les brodeuses,* a reproduction of his own oil painting of his sisters of 1858 (see Germain Hédiard, *Fantin-Latour; Catalogue de l'oeuvre graphique du maitre,* Paris, 1906, 15-16).

Manet may have selected a balloon ascent as the subject for his print because it differed from what the others were doing and also because it was in keeping with the "popular amusement" function of lithography at that time.

Balloon ascents were acknowledged by all to be an outstanding form of popular amusement in the middle of the century, even in the circle with which Manet was associated. The photographer Nadar, who was the friend and champion of modern art, took flight himself in 1863 in the largest balloon ever built, The Giant, and published a racy account of his adventures (see Fulgence Marion, *Wonderful Balloon Ascents . . . ,* London, 1870, first published in Paris, 1865). Manet's print could well be an illustration for the following passage written in 1848 for *Le Journal* by Théophile Gautier:

Tout en regardant avec les autres, un monde de pensées tourbillonnait dans notre tête; le ballon, à qui l'on a voulu faire jouer un role utile dans la bataille de Fleurus et au siège de Toulon, n'a guère jusqu'à présent été considéré que comme une expérience de physique amusante; on le fait figurer dans les fêtes et les solemnités, car la foule, qui a le sentiment des grandes choses, plus que les académiciens et les corps savants, éprouve pour les ascensions un attrait qui n'a pas diminué depuis les premiers essais de Montgolfier. C'est un instinct profondement humain que celui qui nous pousse à suivre dans l'air, jusqu'à ce qu'on perde de vue, ce globe gonflé de fumée qui porte les destinées de l'avenir. (*Fusains et eix-fortes,* Paris, 1880, 256)

It is obvious that Manet's creation of a crude, bold drawing was deliberate, for he had earlier exhibited a very much more competent handling of the medium in his caricature of Emile Ollivier (cat. 1). *The Balloon,* thus, is similar to the etching of the *Street Singer* and to the contemporary oil painting, *Concert in the Tuileries,* in its deliberate naïveté and childlikeness. As in the oil, the composition is simple and traditional in its architectonic, semicircular scaffolding (see Sandblad, 32, for a discussion of this feature of the oil painting), but the actual application of the crayon is untraditionally random and formless. None of the shapes is delineated in detail; there is no one object on which attention is focused, with the exception, perhaps, of the balloon itself. At the edges of the print, free scribbly strokes fill up space and enliven the surface, but these strokes are not associated with any specific shapes. In several places Manet even increased the effect of diffuseness by scratching into the crayon marks with a sharp tool.

THE BOY WITH A SWORD {L'enfant à l'épée} (Fig. 54)

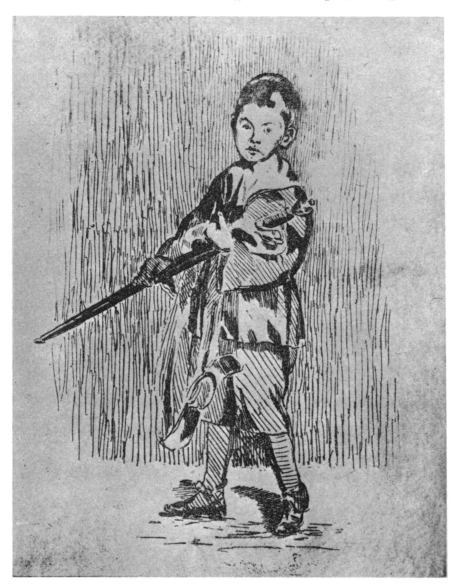

Fig. 54

Etching: one state, trial proofs only
Unsigned; undated
Dimensions: 275 x 216 mm.
Date: 1862
Editions: none
References: M-N 53; Guérin 11

COMMENTARY: This is the first plate which Manet executed from his own oil painting of 1861 (J. W. B. 42; Metropolitan Museum, New York). It was abandoned after only one trial proof had been taken. However, this proof may have provided the tracing which was used in executing the second plate (De Leiris 156).

Baudelaire, in his article of 1862, "Peintres et aquafortistes," in *Le Boulevard* of September, 1862, says that Legros helped Manet with the first plate of this subject. There is no reason to doubt this testimony, even though it might seem that by this time Manet had no need of his assistance. However, if Legros did aid Manet at this time, Manet did not take his help very seriously, for this is the first of four versions of the motif. It is possible, also, that at this very time, Manet and Legros were closer to each other than they had been previously, perhaps because of their common interest in the foundation of the Société des Aquafortistes.

THE BOY WITH A SWORD [L'enfant à l'épée] (Fig. 55)

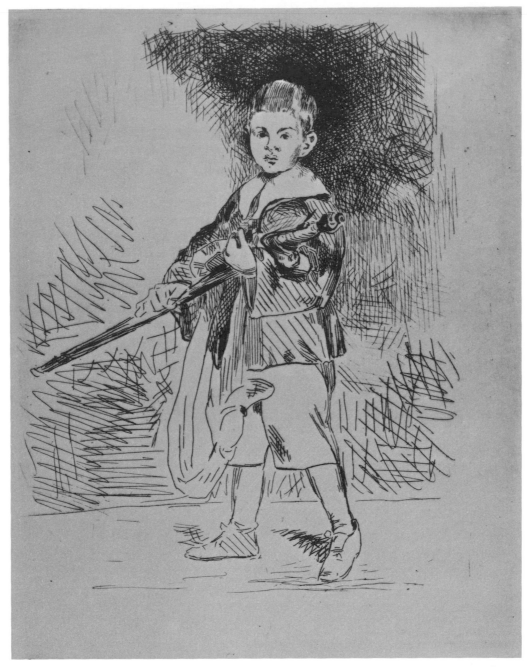

Fig. 55

Etching: one state, trial proofs only
Unsigned; undated
Dimensions: 280 x 218 mm.

Date: 1862
Editions: none
References: M-N 54; Guérin 12

COMMENTARY: This is the second version of the motif, also abandoned after a few trial proofs were printed. It is clear from an examination of the image that a tracing was used to arrive at the major outlines of the boy, probably the tracing mentioned above (De Leiris 156).

In this plate Manet used the same linear variety and reticence of modeling and value range which he used in *The Little Girl*. Within the simply drawn silhouette of the figure, the values are established broadly with widely spaced, diagonal hatchings. The wall behind the figure is covered with long, freely drawn lines to activate its surface, while behind the boy's head, the background is darkened with a hatching of fine vertical and diagonal lines.

THE BOY WITH A SWORD {L'enfant à l'épée} (Figs. 56, 57, 58, 59)

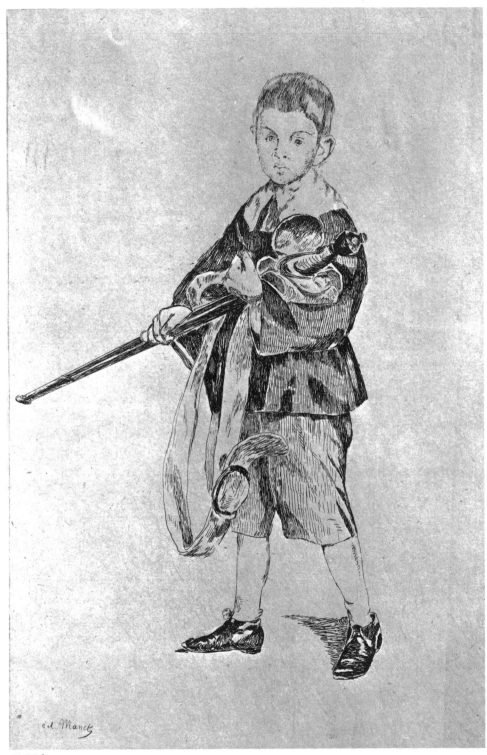

STATE 1 **Fig. 56**

Etching and aquatint: four states
Signed lower left: "éd. Manet;" undated
Dimensions: 315 x 238 mm. (plate); 260 x 174 mm. (composition)
Date: 1862

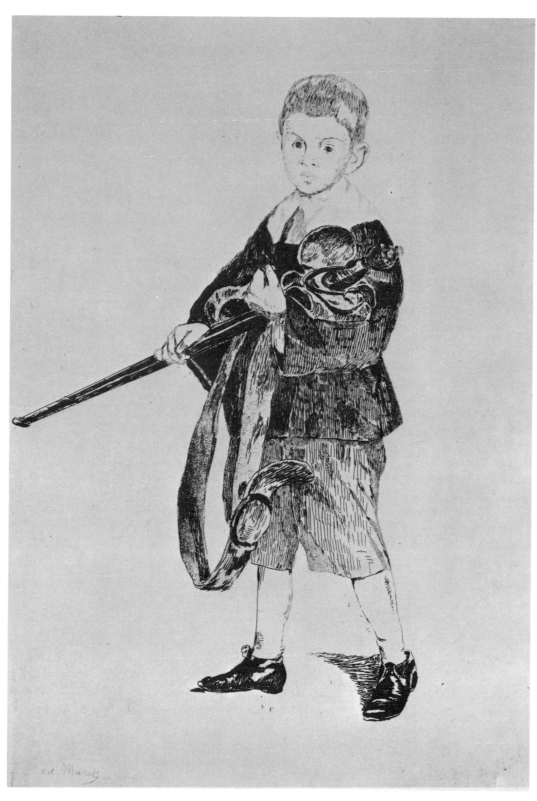

STATE 2

Fig. 57

Editions: none

References: M-N 52; Guérin 13; Rosenthal, 52; Hanson, no. 27, p. 57; Isaacson, no. 6, p. 26

1st state: Pure etching; very light biting. The figure is formed largely of simple, fine hatchings, mostly parallel. Signed.

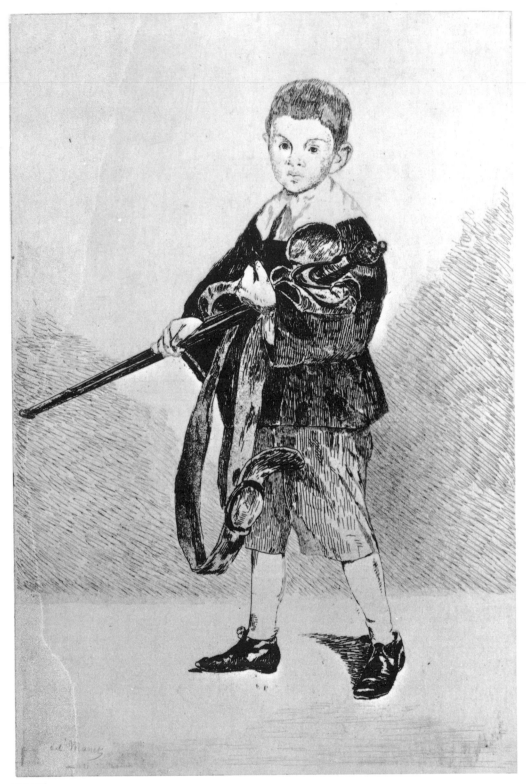

STATE 3

Fig. 58

 2nd state: The background remains untouched, but the whole figure is darkened with additional lines.

 3rd state: Some light zigzag hatching has been added to the lower part of the wall behind the figure, as well as a light coat of aquatint. There are also a few fine horizontal lines in front of the figure on the ground.

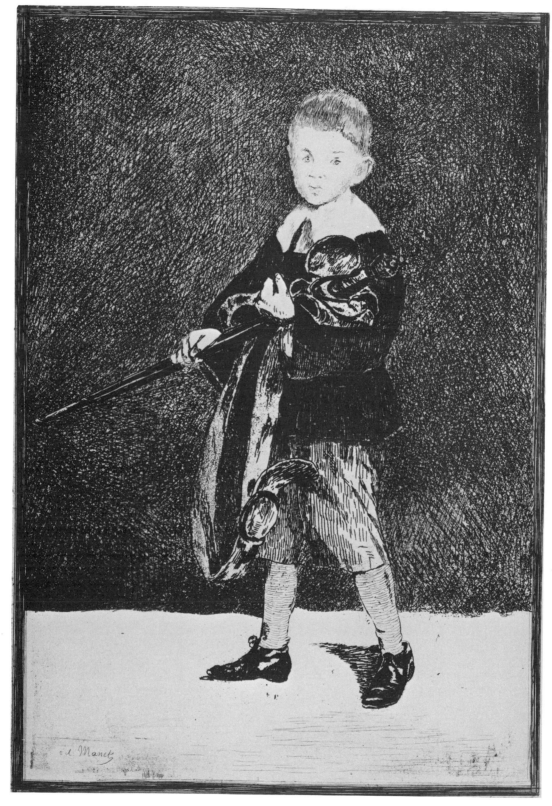

STATE 4 Fig. 59

4th state: The whole image has been changed by the darkening of the
background with fine hatching and aquatint. The boy's head and eyes
have been made lighter, so that they emerge against this dark back-
ground. Also, the etched frame has been widened and darkened to
make it more emphatic.

[89]

COMMENTARY: Apparently, Manet originally intended the etching to be issued in its third state, for the Avery Collection in the Prints Division of the New York Public Library possesses a proof of this state on which is written "bon à tirer, E. Manet" and "25 épreuves, sur papier pareil." The pulling of these twenty-five proofs may well have taken place, for this state of the etching is found in several print collections in Europe and America. The fourth state is much more rare.

Manet intended to include this etching in his 1862 portfolio (see cat. 39), but abandoned the idea at the last minute. It is possible that the etching was eliminated from the portfolio after the etching plate was reworked in its fourth state, at which point the effect no longer seemed satisfactory to the artist.

The quality of this version explains why Manet abandoned the first two attempts (cat. 24, 25). Freedom and variety of line have been eliminated in favor of a more controlled and firmly modeled conception. Major value areas have been used to elucidate structure and clarify design. In the successive states of the print, Manet increasingly obliterated traces of line, so that tone dominates the image.

THE BOY WITH A SWORD [L'enfant à l'épée] (Fig. 60)

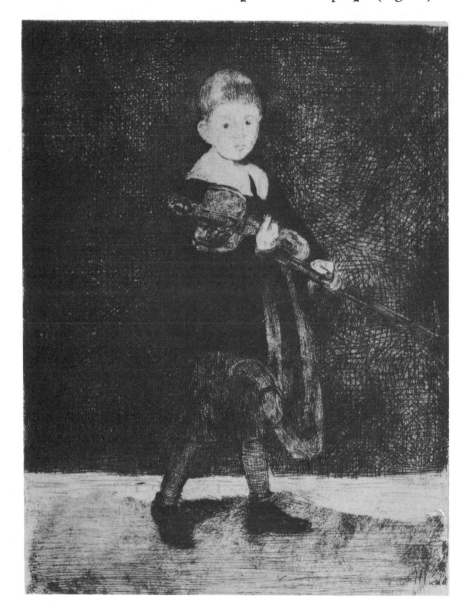

Fig. 60

Etching and aquatint: one state, trial proofs only
Signed and dated lower right: "éd. Manet 1862"
Dimensions: 378 x 209 mm. (plate); 258 x 195 mm. (composition)
Date: 1862
Editions: none
References: M-N 55; Guérin 14

COMMENTARY: This version must be Manet's final execution of the motif. There may well be other states for this print which have not been found, for Manet never carried a print to this degree of finish in one step. It was probably undertaken after the failure of the fourth state of the preceding version to express his intentions in reproducing his own oil. In this version, the boy is facing toward the right, the same direction as is the figure in the oil. This suggests that Manet used a tracing from one of the earlier versions to transfer the image to the plate.

28.

THE BOY CARRYING A TRAY [L'enfant portant un plateau]
(Figs. 61, 62, 63)

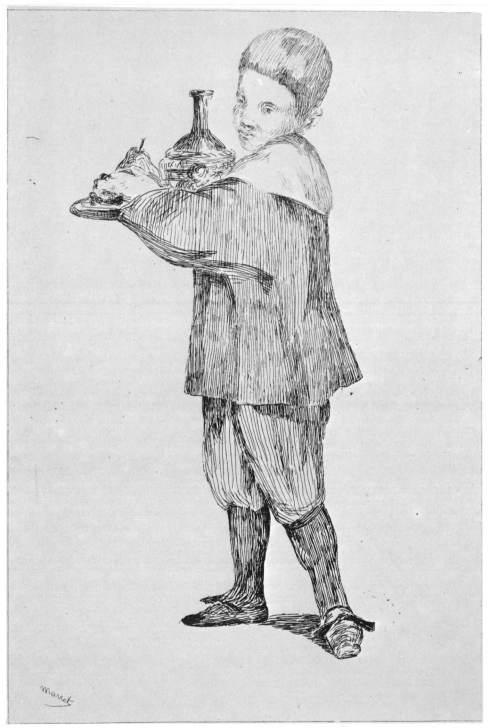

STATE 1

Fig. 61

Etching and aquatint: three states
Signed lower left: "Manet;" undated
Dimensions: 236 x 156 mm. (plate); 220 x 146 mm. (composition)
Date: 1862

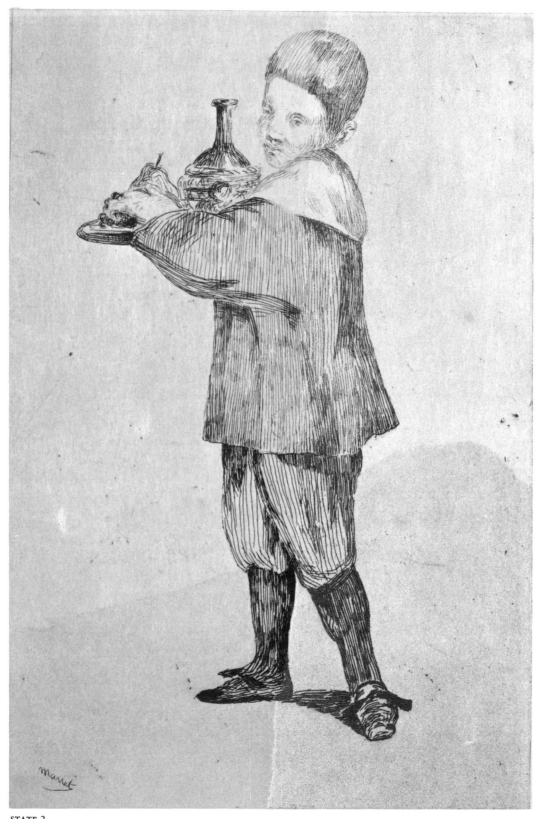

STATE 2

Fig. 62

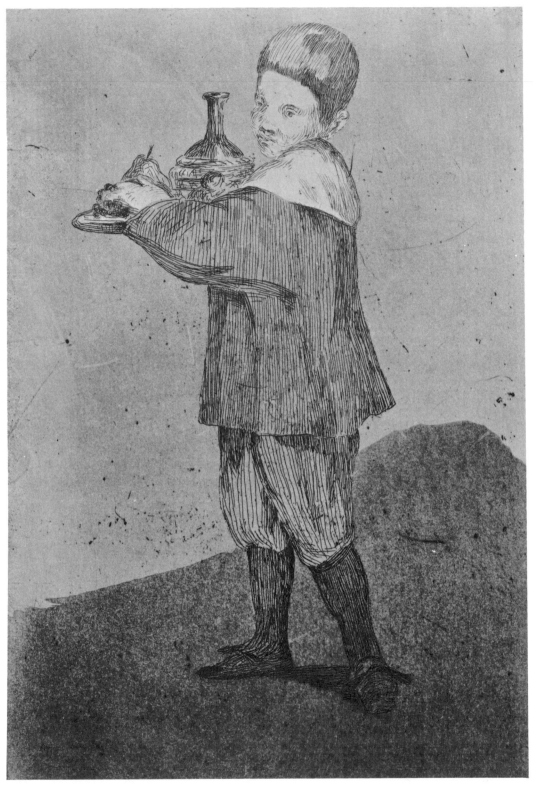

STATE 3

Fig. 63

Editions: Porcabeuf
References: M-N 66; Guérin 15; Rosenthal, 64; Hanson, no. 25, p. 55
1st state: Pure etching; the figure of the boy is formed by simple, parallel
hatchings and rather fine lines, especially those in the upper part of
his body and head.

[94]

2nd state: A coat of aquatint has been added to the lower part of the background to form a dark mass or shadow.

3rd state: (not described by Guérin) Almost the whole surface is covered with aquatint of varying degrees of gray. Only the boy's face, hands and collar remain without shading.

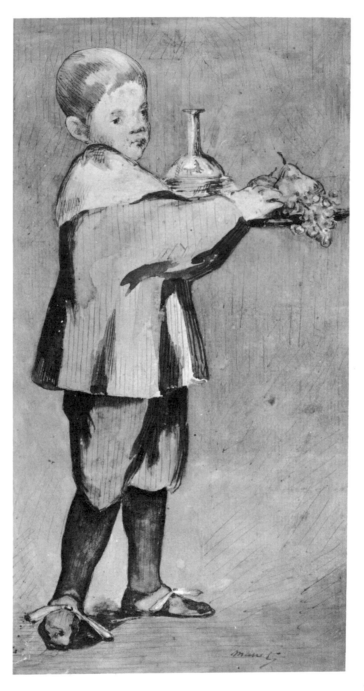

Fig. 64

COMMENTARY: The motif here was taken initially from an oil painting which Manet executed about 1861 entitled *Spanish Cavaliers* (J. W. B. 10; Art Museum, Lyons) and was worked out in detail in a watercolor (De Leiris 155; Phillips Gallery, Washington, D. C.; Fig. 64). Manet later used the same figure with changes in the clothing in the background of *The Balcony* of 1868 (J. W. B. 150; Louvre Museum, Paris). It is possible that this etching was done as late as 1869, but the figure resembles much more closely the boy in the painting of 1861 than it does the boy in the later work. The technique also bears a close resemblance to that used in *The Boy with a Sword* (cat. 26).

MOORISH LAMENT {Plainte moresque] (Fig. 65)

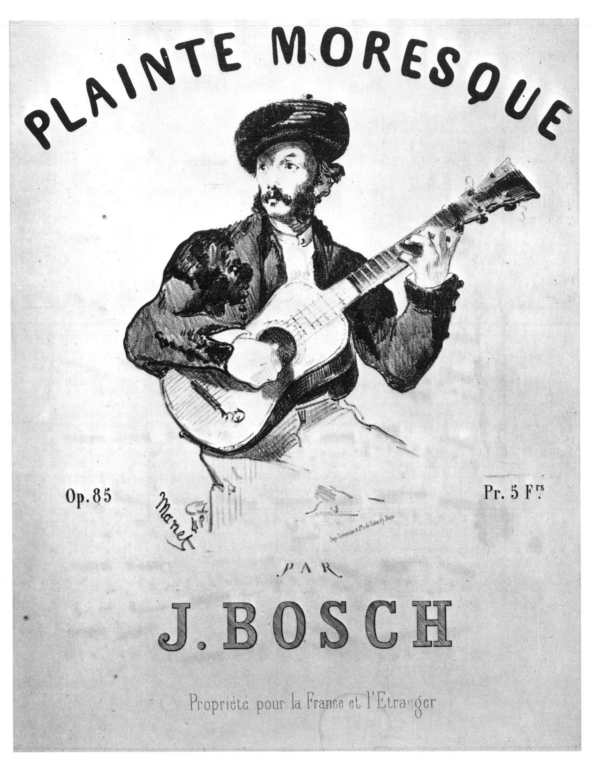

Fig. 65

Lithograph: two printings
Signed lower left: "Manet;" undated
Dimensions: 197 x 178 mm.
Date: 1862

Editions: 1862 Bosch

References: M-N 78; Guérin 70; Rosenthal, 85; Hanson, no. 48, p. 69; Isaacson, no. 20a, p. 33

1st printing: without letters; only one example known.

2nd printing: with title (as illustrated) at bottom, "tiré par l'imprimerie Lemercier et Cie., rue de Seine, 57, Paris."

COMMENTARY: This lithograph, which ornaments the cover of a piece of sheet music entitled "Plainte moresque," seems to represent the composer of the piece, the Spanish guitarist Jérôme Bosch. Although the pose of the guitarist resembles that used in *The Spanish Singer* of the preceding year, there are enough differences between the images to enable us to conclude that this figure was drawn anew from life. The man here is just playing the guitar, not singing. The hands which do the playing are much more convincingly portrayed than are those in *The Spanish Singer*.

Technically, this print resembles the caricature of *Emile Ollivier* of 1860 (cat. 1) more closely than it does the almost contemporary lithograph of *The Balloon*. The outline of the figure is clear and continuous. The crayon strokes fill in the outline with diagonal shading, as in the caricature. The elimination of all but the essential areas of value contrast is another feature linking this work to the caricature. Because of these similarities to the work of 1860, it is possible that it was done before *The Balloon*.

30.

THE URCHIN {Le gamin} (Fig. 66)

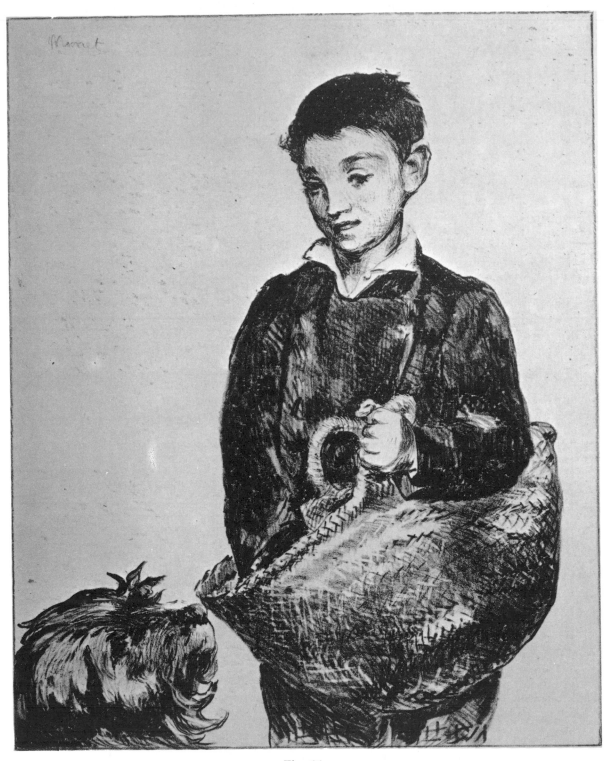

Fig. 66

Lithograph: two printings
Unsigned; undated
Dimensions: 287 x 227 mm.
Date: 1862
Editions: 100 examples, date unknown

References: M-N 86; Guérin 71; Rosenthal, 85; Hanson, no. 29, p. 57;
Isaacson, no. 8, p. 27
1st printing: without title, rare.
2nd printing: with letters, at bottom center, "Le Gamin;" at bottom left,
"tiré à cent exemplaires;" at bottom right, "Imp. Lemercier et Cie,
Paris."

COMMENTARY: This version of Manet's oil painting of the same subject (J. W. B. 73) is much more like the oil than is the etched version of the subject (cat. 31). For this reason, it is probable that it was done before the etching. Here, the boy's legs are not separated as they are in the etching. Also, the dog's head does not overlap the basket. The fur on the dog's head here forms a jagged silhouette as it does in the oil. It is possible that in executing the lithograph the drawing was transferred to the stone by means of a tracing taken from a photograph of the oil, for there is a definite contour line visible around the two figures.

Technically, this print forms a transition between *Moorish Lament* (cat. 29) and *Lola de Valence* (cat. 32). The silhouette of the boy is emphasized, as is true in the portrait of Jérôme Bosch, but within the clearly defined outline, we see the greater linear and tonal variety and extensive use of scratching which are found in the later *Lola de Valence*. At the same time, these variations are not handled with as much subtlety as in the print of *Lola*. Hence, we may conclude that *The Urchin* lithograph does, indeed, form a transitional step between Manet's almost caricatural, early manner and his later, more developed atmospheric technique.

THE URCHIN [Le gamin]ᴾ (Figs. 67, 68)

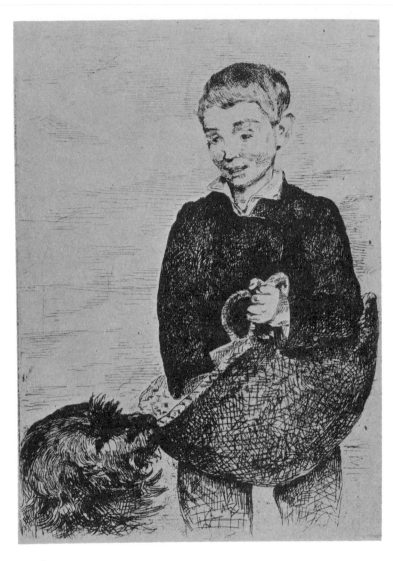

STATE 1

Fig. 67

Etching: two states

Signed in 2nd state, upper left: "éd. Manet;" undated

Dimensions: 203 x 146 mm.

Date: 1862

Editions: 1862 portfolio; 1874 portfolio; 1890 portfolio; 1894 Dumont; 1905 Strölin

References: M-N 11; Guérin 27; Rosenthal, 60, 64; Adhémar, *Nouvelles,* 231; Hanson, no. 28, p. 57; Isaacson, no. 7, p. 27

1st state: The figure is handled with great detail in fine, multiple hatchings. Unsigned.

2nd state: Signature is added upper left; also, additional hatching darkens hair of boy.

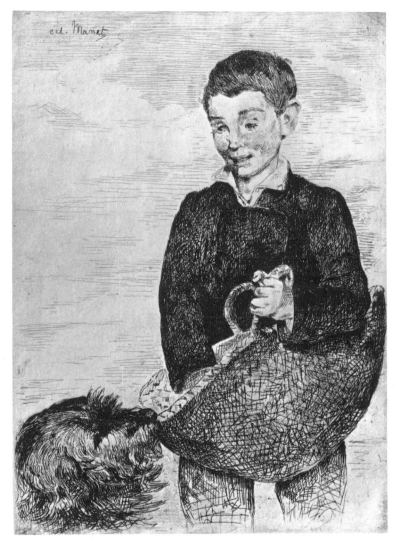

STATE 2

Fig. 68

COMMENTARY: This etching appeared in the 1862 portfolio of Manet's etchings on the same sheet with *The Little Girl* (cat. 19). The motif has been altered from the motif seen in the earlier version (cat. 30). The boy's legs are separated, so that light appears between them. The dog's head overlaps the basket a bit instead of remaining separate from it. The buttons on the boy's coat have been eliminated, perhaps to reinforce the value of the boy's coat as a solid area. The background suggests a sky covered with clouds.

In some respects, this is Manet's finest early etch-ing (see letter quoted in Adhémar: Manet thought so). It is quite similar to *The Boy with a Sword*. The image is more important than is linear virtuosity, forming a delightfully reticent statement. The tonality is remarkably light, despite the density of hatchings in the coat and hair, presenting a lacy and delicate impression. Unlike the handling of *The Gypsies*, done in the winter of 1861-1862, linear boldness here has been suppressed in favor of tonal subtlety, marking a significant change in Manet's handling at this period.

LOLA DE VALENCE (Fig. 69)

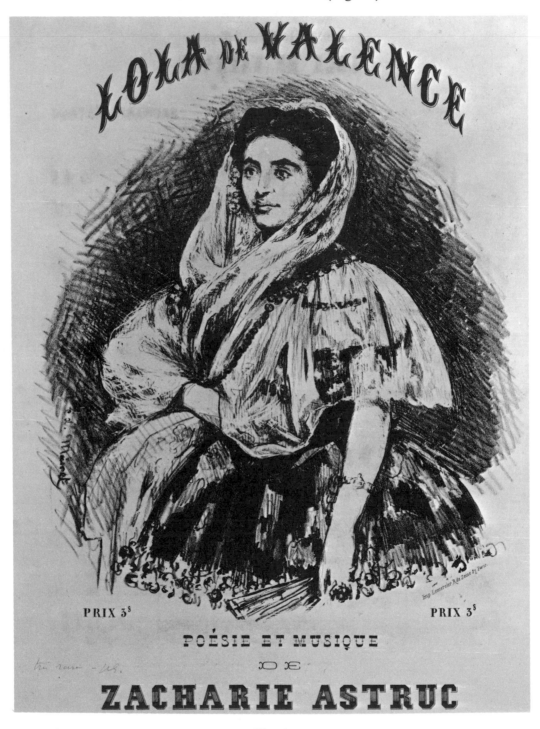

Fig. 69

Lithograph
Signed lower left: "Manet;" undated
Dimensions: 230 x 210 mm.
Date: 1862, after August 12
Editions: 1862 Lola
References: M-N 77; Guérin 69; Rosenthal, 84; Hanson, no. 46, p. 67;
 Isaacson, no. 20, p. 33

COMMENTARY: Lola de Valence was the leading female dancer in Mariano Camprubi's troupe of Spanish dancers, which opened its season in Paris on August 12, 1862. This print represents a direct transcription of the upper part of the Spanish dancer as Manet depicted her in the famous oil painting in the Louvre (J. W. B. 46). The total effect of the image resembles a black and white photograph of the oil very strikingly.

Technically, the print is handled in a free manner, using many different kinds of stroke. In some places, in the shawl over the dancer's head and in the sleeves of her blouse, crayon was scratched off to create light patches. The very boldly drawn lines in the background, densely spaced near the figure, thinning out toward the edges, lend vivacity to the image.

33.

LOLA DE VALENCE[p] (Figs. 70, 71, 72)

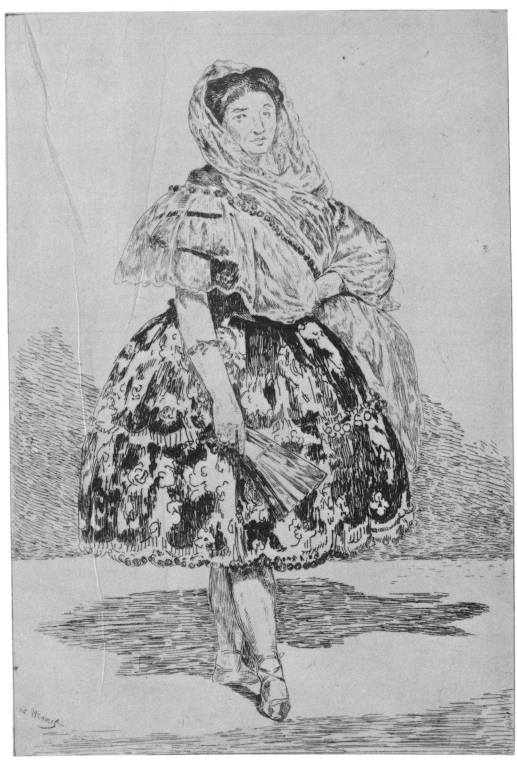

Fig. 70

Etching and aquatint: three states
Signed lower left: "éd. Manet;" undated
Dimensions: 257 x 175 mm. (plate); 230 x 157 mm. (composition)
Date: between August 12 and early September, 1862

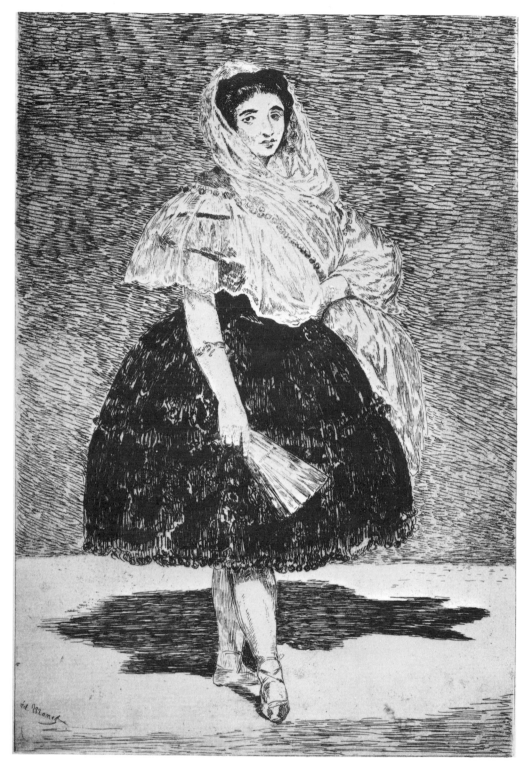

STATE 2

Fig. 71

Editions: 1863 Lola; 1874 portfolio; 1890 portfolio; 1894 Dumont; 1905
 Strölin
References: M-N 3; Guérin 23; Rosenthal, 55-57; Hanson, no. 45, pp. 65-66;
 Isaacson, no. 19, pp. 32-33
1st state: Pure etching, background untouched except at lower part, where
 there are some zigzag hatchings. Figure clearly described.
2nd state: background covered with fine zigzag hatchings and coat of
 aquatint. Skirt darkened with additional hatchings. Features more
 prominent. Shadow on floor darkened.

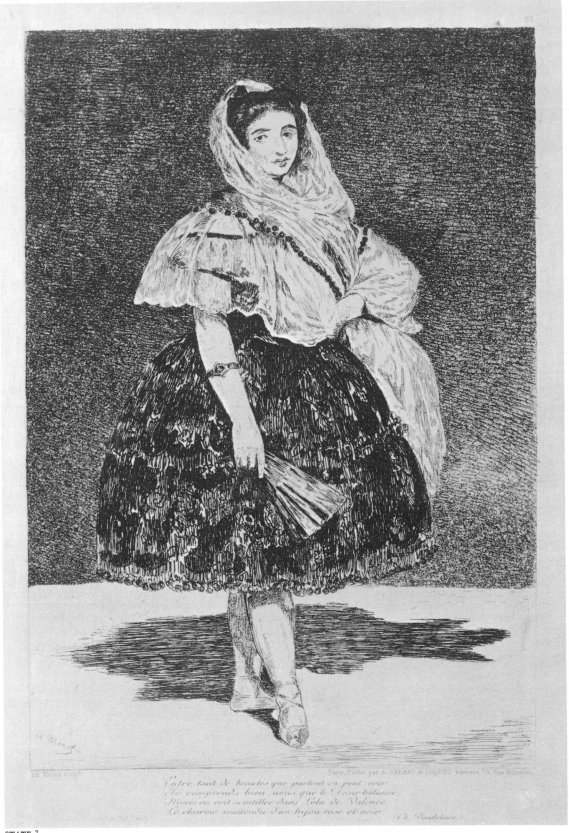

STATE 3

Fig. 72

3rd state: A few additional strokes and aquatint on background. Image cut
off at bottom to allow for insertion of four lines of poetry by
Baudelaire.

COMMENTARY: This print was to have been included in the portfolio of 1862 (see cat. 39), but was withdrawn and issued independently as a publication of the Société des Aquafortistes in October, 1863, with Baudelaire's verses appended. There were two different printings of this plate by the Société des Aquafortistes in 1863. In the first printing, in addition to the verses, we find:

in lower left: "Ed. Manet sculpt" on one line,
 and beneath this: "Imp. Delâtre, rue
 Saint-Jacques, 363, Paris"
in lower right: "Paris, publié par A. Cadart
 et Luquet éditeurs, 79, rue de Richelieu"

In certain examples printed on de luxe paper, the addresses are not inked, but this does not mean a different printing. The example of this printing in the Davison Art Center, Wesleyan University, contains all the letters and, in addition, at the upper right, in red, the number 67.

The second printing lacks the words "Ed. Manet sculpt." In subsequent printings of this plate, all the letters, with the exception of the verses, were eliminated.

According to De Leiris (p. 57), the ink and watercolor drawing in the Cabinet des Dessins in the Louvre (De Leiris 178; Fig. 73) was the preliminary study for this print rather than the watercolor in the Fogg Art Museum (De Leiris 179).

This etching differs somewhat in its proportions from the oil version of which it is a reproduction. In the etching, Lola seems to face the viewer more squarely; her left shoulder is more nearly parallel with the picture plane, which makes the image broader. Although she looks out at the viewer as she does in the painting, the smirk on her lips which is so evident in the oil has been eliminated; her expression here is pensive rather than coy.

In technique, this etching is very similar to *The Boy with a Sword* in its emphasis on area and tone. While the figure is described with many varied strokes, the background is covered with aquatint laid over short horizontal and zigzag hatchings, providing the atmospheric ambient also seen in *The Boy with a Sword:*

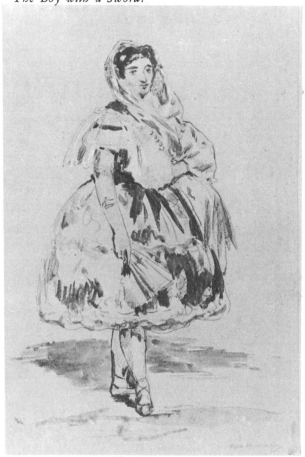

Fig. 73

DON MARIANO CAMPRUBI {Le Baïlarin} (Fig. 74)

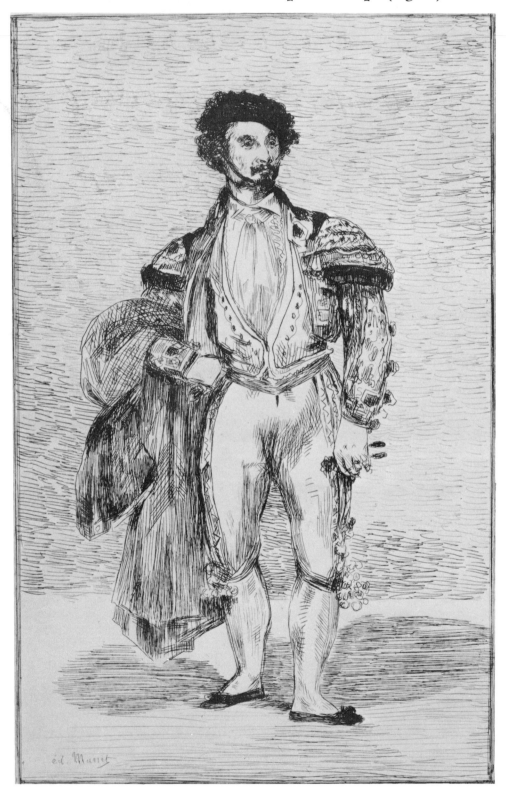

*don Mariano Camprubi
primer bailarin del teatro royal de Madrid*

Fig. 74

Etching: one state

Signed lower left: "éd. Manet" and inscribed below picture, "don Mariano
 Camprubi—primer baïlarin del Teatro royal de Madrid;" undated

Dimensions: 299 x 197 mm. (plate); 225 x 155 mm (composition)

Date: August or September, 1862

Editions: 1890 portfolio; 1894 Dumont; 1905 Strölin

References: M-N 31; Guérin 24; Rosenthal, 27-28; Hanson, no. 43, p. 65;
 Isaacson, no. 18, p. 32

COMMENTARY: Camprubi was the star of the troupe of Spanish dancers, along with Lola de Valence, who came to Paris in August of 1862. Manet represented him several times in various media. This etching is the reproduction of an oil painting (J. W. B. 47; Collection Mr. and Mrs. Donald Stralem) which was executed at the same time as the portrait of Lola in the early autumn of 1862. In some ways, the etching differs from the painting. Like most of Manet's etched copies of paintings, the image is reversed. The "bailarin" here wears a different kind of hat from that which he wears in the painting, which is broader and does not have a chin strap. The figure here also seems more squat in its proportions than in the oil. The costume which he wears here is exactly like that worn by the central male dancer in the painting *The Spanish Ballet* in the Phillips Gallery, Washington, D. C., which was also painted at this time (J. W. B. 48).

Apparently, Manet intended to include this etching in his 1862 portfolio (see cat. 39), but eliminated it at the last moment. A proof of this etching in the Cabinet des Estampes in the Bibliothèque Nationale in Paris is signed "bon à tirer, E. Manet."

It is not known why the print was eliminated from the series.

There is a wash drawing in the Bernstein collection (De Leiris 180) which also depicts this figure. However, this drawing is probably not a study for the etching, for the figure is shown to just below the waist only. Since Manet rarely expanded a motif after reducing its form, it seems unlikely that this drawing preceded either the oil or the etching.

Stylistically, this etching has remarkably little to do with the style of the etching of *Lola de Valence.* The figure here is conceived largely in terms of line rather than of tonal area. The lines are, to be sure, lightly bitten and fine, like those in the etching of Lola, but they are more important as independent accents than as toning agents. A few small areas in the hat and the shadows on top of the sleeve contain dense hatching, but in the rest of the print, the lines are quite far apart, preserving their identity as individual strokes. This very light and sketchy handling of form and line is reminiscent of Goya's handling in certain plates of the *Tauromaquia* (for example, plates 3 and 5).

MLLE. VICTORINE IN THE COSTUME OF AN "ESPADA"
[L'espada] (Figs. 75, 76)

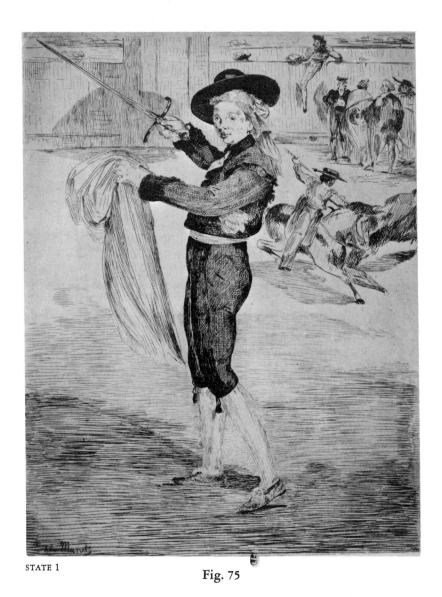

STATE 1

Fig. 75

Etching and aquatint: two states

Signed lower left: "éd. Manet;" undated

Dimensions: 334 x 277 mm. (plate); 306 x 239 mm. (composition)

Date: August or September, 1862

Editions: 1862 portfolio

References: M-N 7; Guérin 32; Hanson, no. 51, p. 71; Isaacson, no. 16, pp. 30-31

1st state: Pure etching. The whole composition is drawn in with lightly bitten lines. Only the area of the hat, coat and pants is cross-hatched and very dark.

2nd state: The whole image of the woman has been darkened with additional hatching, and a coat of aquatint has been applied to the foreground.

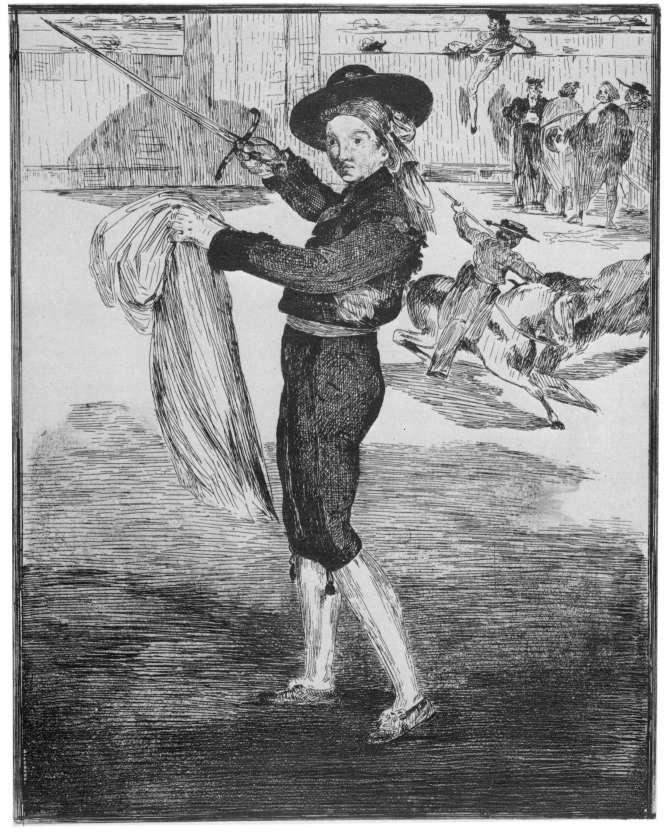

Fig. 76

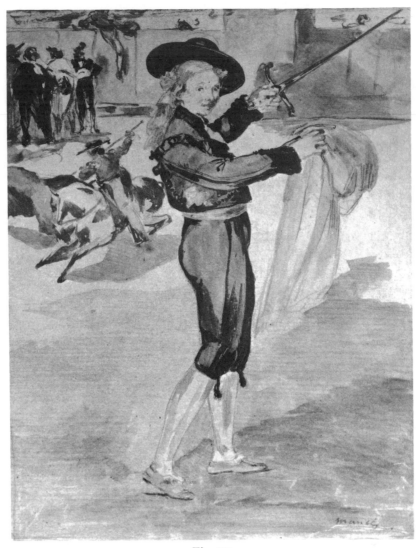

Fig. 77

COMMENTARY: This etching is a transcription of the oil painting of *Mlle. V. as an "espada,"* which is in the Metropolitan Museum in New York (J. W. B. 51). It was transcribed from the oil by means of a watercolor in the Rhode Island School of Design Museum of Art in Providence (De Leiris 181; Fig. 77). De Leiris (p. 12) thinks that Manet may have used a photograph of the oil to arrive at the watercolor, as the watercolor reproduces the image in the oil in reverse. The reversal in the watercolor shows that Manet was anxious to preserve the composition on the oil exactly when he translated it into the etching medium and so he used the reversed image of the watercolor as a means of drawing the figure on the copper plate.

There are some differences between the etching and the oil from which it was taken, but these differences are primarily the result of differences in the media. The figure in the etching looks slimmer because her solidity is not emphasized, as it is in the painting, by solidly applied color. Her costume is not so dense a black as in the oil. However, the major shapes and their relationship to each other are exactly the same as those in the painting.

The compositional problem of reconciling two distinct spatial layers, not new in Manet's art, is presented with great wit and daring. Manet has even had fun with the delusive aspects of jumps in perspective by juxtaposing the rump of the horse in the middle distance and the curve in the woman's back, making the curve act as a boundary for both near and distant shapes. One major distinction between this print and earlier ones is that Manet has not so completely reserved one form of handling for the background and another for the foreground, but has employed the sketchy manner, with its long, fine, unbroken lines, throughout the picture surface. In the first state of the etching, however, the visual distinction between fore- and background was not satisfactory, and he therefore added aquatint to reinforce the distinction.

As was the case in the etching of Camprubi (cat. 34), the handling and even specific motifs owe much to Manet's study of Goya's *Tauromaquia* series. In this etching, the group of figures by the wall in the background is taken almost verbatim from plate 19 of Goya's series, while the group in the center distance of the mounted fighter and bull is quoted from plate 5.

[112]

36.

THE "POSADA" {La posada} (Fig. 78)

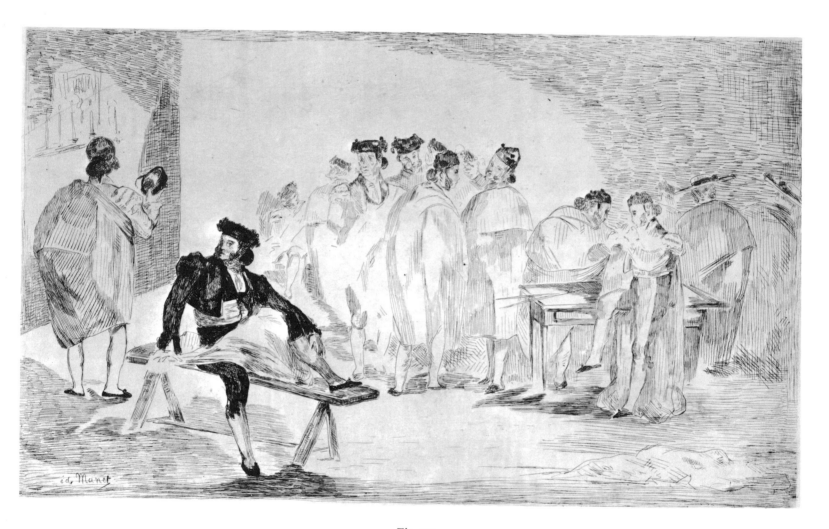

Fig. 78

Etching: one state, trial proofs only
Signed lower left: "éd. Manet;" undated
Dimensions: 246 x 412 mm.

Date: late 1862 or early 1863
Editions: none
References: M-N 71; Guérin 47; Rosenthal, 59; Hanson, no. 49, p. 69;
 Isaacson, no. 20b, pp. 33-34

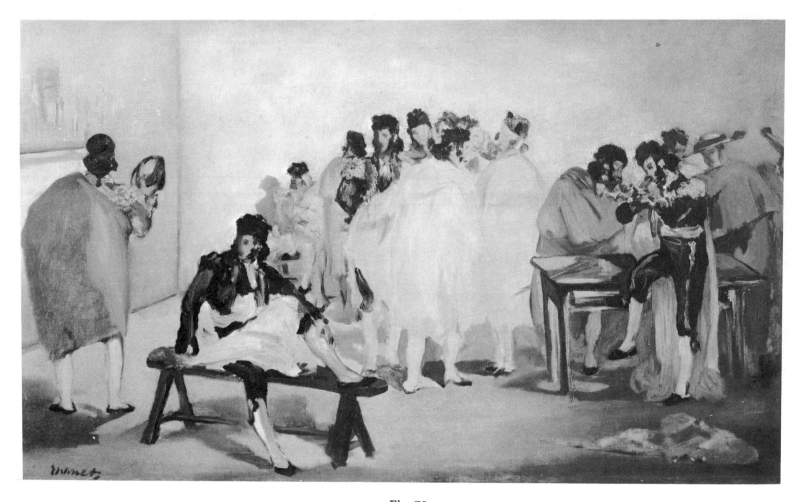

Fig. 79

COMMENTARY: This etching is an exact transcription of an oil in the Hill-Stead Museum in Farmington, Connecticut (J. W. B. 123; Fig. 79). This picture was probably painted in the studio of Alfred Stevens in the autumn of 1862 at the same time as *The Spanish Ballet* in the Phillips Gallery (Hanson, p. 65), for the compositions of the two paintings are very similar. The etching of *The "Posada"* bears a strong resemblance in its technique to *The "Espada"* (cat. 35) and to various prints by Goya (for a discussion of specific sources, see Isaacson, p. 34). The deliberate quotation from Goya's series, both in technique and in composition, suggest strongly that the print and the painting were done in 1862, not, as has been suggested by Guérin and others, in 1865 after Manet's return from Spain.

FRONTISPIECE FOR AN EDITION OF ETCHINGS: A CAT AND PORTFOLIO (Fig. 80)

Fig. 80

Etching: one state

Signed at lower right: "éd. M;" undated

Dimensions: 270 x 190 mm.

Date: 1862

Editions: none

References: M-N 49; Guérin 28; Rosenthal, 29; Theodore Reff, "Manet's Frontispiece Etchings," *Bulletin of the New York Public Library,* LXVI (1962), 143-144; Theodore Reff, "The Symbolism of Manet's Frontispiece Etchings," *Burlington Magazine,* CIV (1962), 182; Hanson, no. 128, p. 145; Michael Fried, "Manet's Sources—Aspects of His Art, 1859-1865," *Artforum,* VII (March, 1969), 37-40

COMMENTARY: This etching probably represents Manet's first attempt at a frontispiece design for his 1862 portfolio. Because it lacks the picturesque or Spanish references which are so prominent in the other versions (cat. 38 and 39), there is a slight possibility that it was not undertaken until 1874 in connection with the second portfolio of etchings. However, this possibility seems very remote because the handling of this etching in its boldness and variety, is much more consistent with Manet's style of the '60's than with that of 1874.

FRONTISPIECE FOR AN EDITION OF ETCHINGS (Fig. 81)

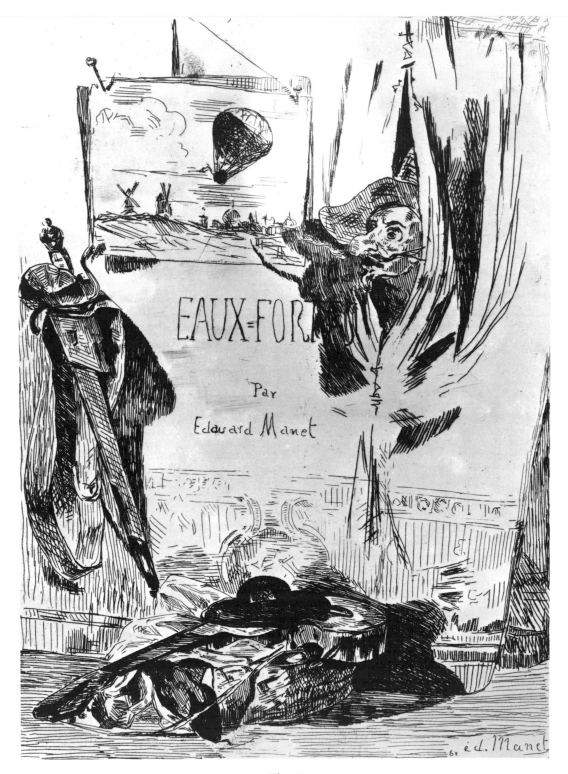

Fig. 81

Etching: one state, 2 trial proofs only known (New York Public Library)
Signed and dated lower right: "62 éd. Manet"
Dimensions: 327 x 240 mm. (plate); 294 x 210 mm. (composition)

Date: August or September, 1862

Editions: none

References: M-N 48; Guérin 29; Rosenthal, 28-29; Theodore Reff, "Manet's Frontispiece Etchings," *Bulletin of the New York Public Library,* LXVI (1962), 143-146; Theodore Reff, "The Symbolism of Manet's Frontispiece Etchings," *Burlington Magazine,* CIV (1962), 182-186; Isaacson, no. 16a, p. 31; Michael Fried, "Manet's Sources—Aspects of His Art, 1859-1865," *Artforum,* VII (March, 1969), 38-40

COMMENTARY: This etching is probably the second attempt at a frontispiece for the 1862 portfolio (see Reff, *NYPL Bull.*). The motifs which Manet has combined here are all derived from his own paintings or prints of the two preceding years: the sword and belt from *The Boy with a Sword,* the sombrero and cape from *Mlle. Victorine in the Costume of an "Espada,"* the guitar from *The Spanish Singer,* and the motif of the balloon from his own lithograph of the *Balloon.* The treatment has an almost histrionic flavor. Polichinelle pokes his head through an opening in the heavy curtain. His silhouette, cast on the curtain at the left, looks like a caricature and may be Manet's way of acknowledging the importance of caricature and the popular comic tradition in his art. It also seems a sort of self-portrait; the artist sees himself in the guise of a performer, an entertainer of the common man. Here Manet indicates his scorn for the "peintre d'histoire," for the image of Polichinelle is derived from the "commedia dell'arte," the world of theater which was directly opposed to the classical. (This is the obvious interpretation of the object's inclusion; for a more personalized approach, see Reff, *Burl. Mag.*) The motif of the still-life at the base of the curtain, with its marked Spanish flavor, was first set down in an oil painting which Manet intended to use as an over-door decoration in his studio (J. W. B. 58; Avignon, Musée Calvet).

The handling of this frontispiece, as well as its objects, is deliberately composite rather than completely unified. The shadows cast by the sword and Spanish still-life lie to the right of the objects, while the shadow cast by Polichinelle lies to his left. The technique is bold and simple, with large areas left untouched. In this respect, it resembles the etching of *The Gypsies* more than the more contemporary prints such as *Lola de Valence* and *The Urchin.* All of the forms are delineated with long, quite boldly drawn, straight lines and a minimum of cross-hatching. It must be remembered, however, that the etching exists only in trial proofs; it must not be judged as a complete work.

Rosenthal suggests that this version was abandoned because of its rather cluttered and banal character. Reff thinks it may have been considered too subtle and obscure to make the point with Manet's audience.

FRONTISPIECE FOR AN EDITION OF ETCHINGS:
HAT AND GUITAR[P] (Figs. 82, 83)

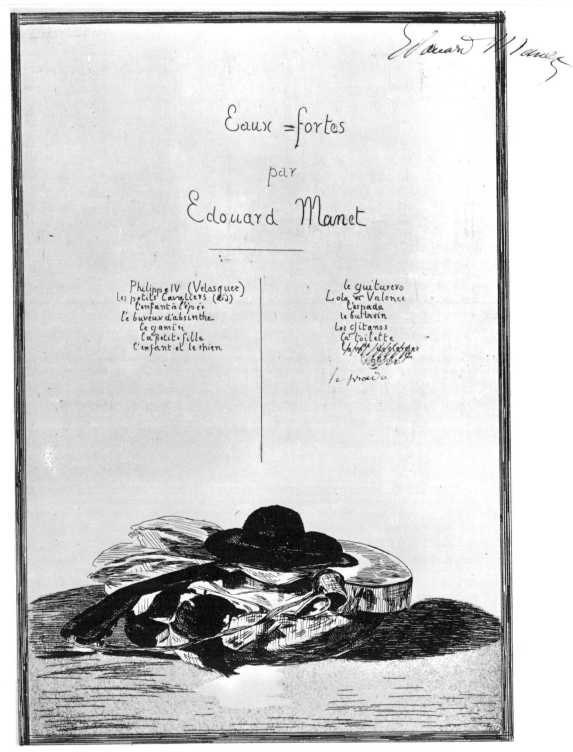

STATE 1 Fig. 82

Etching and aquatint: three states
Unsigned; undated
Dimensions: 438 x 294 mm. (plate in 1st state); 229 x 217 mm. (plate in

1874.

Tiré à 5o Ex.Nᵉˢ

EDOUARD MANET

EAUX-FORTES

Nᵒ 3o

A.CADART.Imprimeur,Paris

STATE 2

Fig. 83

2nd and 3rd states); 332 x 224 mm. (composition in 1st state); 101 x 211 mm. (composition in 2nd and 3rd states)

Date: drawing on plate originally done in September or October, 1862; changes in size of plate done in 1874

Editions: 2nd state used as frontispiece for 1874 portfolio; 3rd state in 1894 Dumont, 1905 Strölin

References: M-N 1; Guérin 62; Rosenthal, 29-30; Theodore Reff, "Manet's Frontispiece Etchings," *Bulletin of the New York Public Library*, LXVI (1962), 146-147; Theodore Reff, "The Symbolism of Manet's Frontispiece Etchings," *Burlington Magazine*, CIV (1962), 182-186; Hanson, no. 131, p. 147; Isaacson, no. 17, p. 32

1st state: The motif of a sombrero, cape and guitar forms a still life at the bottom of the page. It is simply drawn with a few etched lines and then covered with aquatint in the ground, hat, and some of the shadows. Above the still life, hand-written, appear the titles of the works to be included in the portfolio. The following titles appear:

Phillippe IV (Velasquez)	le guitarero
les petits cavaliers (di)	Lola de Valence
L'enfant à l'épée	l'espada
le buveur d'absinthe	le baïlarin
le gamin	les gitanos
la petite fille	la toilette
l'enfant et le chien	la m^{de} de cièrges
	le gamin

The proof of the first state of this etching in the Avery Collection, Prints Division of the New York Public Library, shows corrections in the artist's writings: the last two titles have been crossed out with ink and the title *le prado* substituted.

2nd state: No change in drawing, but the titles have been eliminated and the plate reduced in size. Printed title "Edouard Manet Eaux-Fortes" appears with date and "Tiré à 50 ex N^{és}." This was the form in which the frontispiece was used in 1874.

3rd state: All the letters obliterated. Found in this form in 1894 and 1905 publications.

COMMENTARY: Related to this project is a water-color drawing in the Prints Division of the New York Public Library (De Leiris 219; Fig. 84). Although the still-life motif is the same in all its details as that in the etching, there are some interesting differences in the titles which appear above this motif. In the watercolor, the following titles appear, all in reverse with one exception:

Le guitare	Les petits cavaliers (Velasquez)
Le guitarero (not reversed)	L'enfant et le chien (scratched out)
P Lola de Valence	Phillippe IV
L'espada	l'enfant à l'épée
le Prado	le buveur d'absinthe

It seems likely that this etching was first undertaken as a trial frontispiece for the 1862 portfolio. The first state lists etchings which could have been included in the portfolio of October, 1862. The substitution of the title "le prado" for "la m^{de} de cièrges" and "le gamin" in the proof of the first state mentioned above, and the appearance of the same title "le Prado" on the watercolor may have occurred later. Reff's suggestion (*NYPL Bull.*, 143) that Manet contemplated issuing a portfolio between 1865 and 1867, perhaps in conjunction with his 1867 one-man show at the Pont de l'Alma, has some merit, but too little evidence is available at this point to make it acceptable. (We should point out

in connection with Reff's thesis that the original portfolio of 1862 sold badly, making the possibility of a second publication in the '60's rather unlikely.)

The watercolor drawing has generally been considered a study for the first state of the etching, but it is probably a study for a contemplated later state, before the plate was cut down, one which never was carried out. The list of works which it contains, while not exactly like the contents of either the 1862 or the 1874 portfolio, is closer to those of the earlier portfolio. It contains six works which did appear in the 1862 edition: *Le guitarero, l'espada, Les petits cavaliers, L'enfant et le chien, Le buveur d'absinthe,* and *Philippe IV,* omitting mention only of *La toilette* and the sheet containing *Le gamin* and *La petite fille.*

The real problem with dating the watercolor in 1862 arises from the fact that the title "Le Prado" appears at the bottom of the left column, for it seems, on the basis of what information is available, that this etching, in either version (cats. 44, 45), was not executed until 1865, after Manet's trip to Spain. At the same time, the argument for dating the watercolor in 1874, as a preliminary idea for the later publication, is weakened by the fact that of the list of works which actually were included, only *Lola de Valence, Le Guitarero,* and *Les petits cavaliers* are listed. Despite these discrepancies, however, at the moment it seems most reasonable to conclude that the watercolor does, in fact, represent an initial

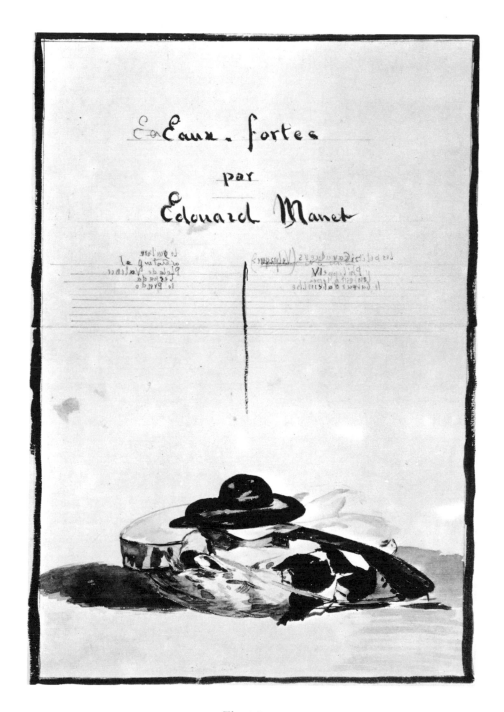

Fig. 84

attempt at working out a frontispiece for the 1874 edition, perhaps using a first state of the etching from which to trace the still-life motif, but changing the list of works quite considerably. There seems to be some evidence that by 1874 Manet was not as involved with the publication of his portfolio of etchings as he had been in 1862 because he was ab-sorbed in more exciting projects and that he may simply have begun with the idea of including only etchings that he had on hand.

There seems to be little argument that the reduction in size of the plate and the substitution of printed letters for the hand-written titles were carried out in 1874, when the second portfolio was issued.

[121]

MARINE[P] (Fig. 85)

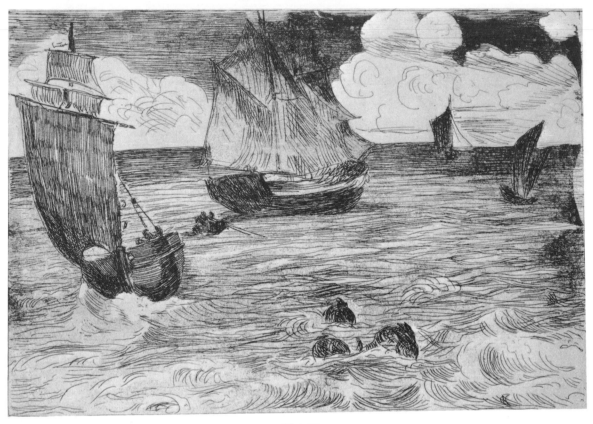

Fig. 85

Etching and aquatint: one state

Unsigned; undated

Dimensions: 140 x 209 mm. (plate); 131 x 180 mm. (composition)

Date: 1864 or 1865

Editions: 1894 Dumont; 1905 Strolin

References: M-N 39; Guérin 35; Rosenthal, 67; Anne C. Hanson, "A Group
of Marine Paintings by Manet," *Art Bulletin,* XLIV (1962), 333-34;
Hanson, no. 66

COMMENTARY: This etching belongs to a series of works which Manet was inspired to execute in the summer of 1864, when the Kearsarge was in the port of Boulogne. Mrs. Hanson, in her discussion of the marine series in the *Art Bulletin* (p. 333, note 22), postulates that the etching may in fact be a transcription of an oil of 1864, now lost, which was entitled "Bateau de pêche arrivant vent arrière," and may thus be the last work in the series. Although the truth of this statement cannot be proved or disproved, it is clear that the print recombines motifs from two of the extant paintings of that summer. The boat to the left of the etching appears at the right of the oil painting, *The Kearsarge at Anchor in Boulogne Harbor* (J. W. B. 88; Collection The Honorable Peter Freylinghuysen, Washington, D.C.). The boat in the center and the curious porpoises in the foreground appear to be taken from the oil entitled *Marine* (Philadelphia Muesum of Art, Hanson, no. 64).

As Mrs. Hanson also points out in her article (p. 333), the compositional arrangement which is seen in this group of works and in the much larger and more imposing painting of the *Kearsarge and Alabama* (Philadelphia Museum of Art; J. W. B. 87), with its emphasis on a high horizon and no overlapping shapes, is peculiar to this group of works and probably occupied Manet's attention only in 1864.

In terms of its handling, this etching is similar to the etching of *The Street Singer* (cat. 22). The shapes are sketchily rendered with parallel hatching. The foreground boats and water are more clearly delineated than are the forms in the background. The activity of stroke is subdued as we look into the background, where the strokes are all horizontal in the water, vertical in the boats.

41.

THE RACES [Les courses] (Fig. 86)

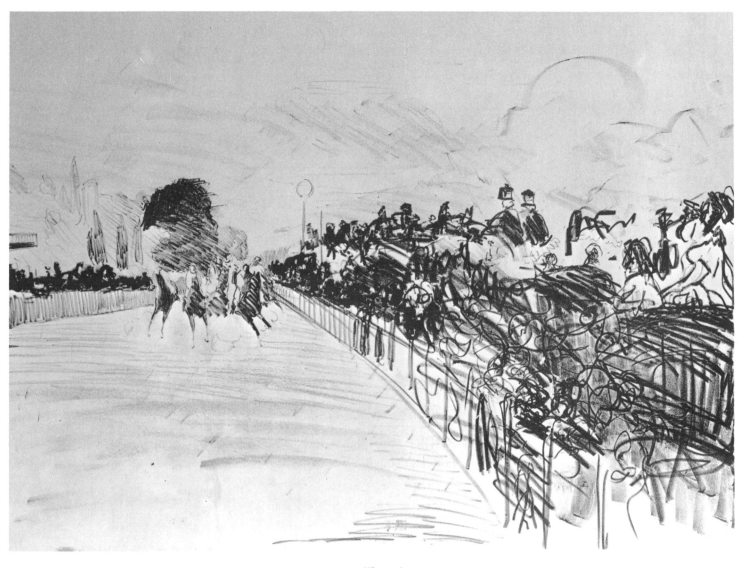

Fig. 86

Lithograph *
Unsigned; undated
Dimensions: 365 x 510 mm.
Date: 1865
Editions: 1884 Memorial
References: M-N 85; Guérin 72; Rosenthal, 90-91, 148-149; Hanson, no.
 69, p. 87; J. Harris, "Manet's Race-Track Paintings," *Art Bulletin,*
 XLVIII (1966), 81

* The "second state" of this lithograph mentioned by Guérin is a spurious work, concocted after, or at the same time as, the posthumous printing of 1884. There is no evidence that any edition of the whole image was printed before Manet's death. The 1884 edition consisted of 100 examples. Therefore, this "second state" can have nothing to do with Manet's personal intervention.

The example of this state which I have examined betrays its suspicious origin in several ways. First, the printed areas run up to the extreme right edge, something which would not be true if Manet himself had arranged for cropping the image for a second state. Secondly, the signature "Manet" in the lower right corner is not like any other signature on Manet's lithographs and must be judged false. An interesting feature of this example is that there is a smudging of the ink in the fence at the extreme left edge. This imperfection leads me to surmise that the false state may have originated as a discarded proof during the 1884 printing which was subsequently "doctored up" by cropping and adding a signature and some slight shading to imply an additional state. Guérin reports that Guérard owned two of these examples; it is even possible that he was responsible for the deception.

COMMENTARY: This lithograph of a scene at the races at Longchamps in the Bois de Boulogne is the third in a series of six versions which Manet executed of this scene (see Harris, *Art Bulletin*, 1966). It is possible that it may never have been carried to completion, as no prints were pulled from the stone until after Manet's death.

Compositionally, it is similar to *Marine* (cat. 40), although the action is more intense. In both scenes, there is a strong central focus toward which attention is directed by a diagonal alignment of foreground shapes. Recession toward the center is more emphatic in the race-track print than in the seascape, for the fences converge at a sharp angle toward the central vanishing point.

The vivacity and activity of the composition is enhanced by the handling of the crayon. The bold draughtsmanship looks much more spontaneous than anything which Manet had done before in the medium. Although some of the shapes, such as the horses and riders, are lightly outlined, the diagonal strokes which darken these shapes do not describe their three-dimensional form, but rather emphasize their insubstantiality, movement, and flatness. The bold drawing evokes a vivid and intense emotional response from the spectator.

42.

PORTRAIT OF FELIX BRACQUEMOND (Fig. 87)

Fig. 87

Etching with pen on plate: one state
Unsigned; undated
Dimensions of drawing: 169 x 112 mm.
Date: 1865
Editions: 1906 Moreau-Nélaton
References: M-N 60; Guérin 42; Rosenthal, 72; Hanson, no. 146, p. 161

COMMENTARY: The dating of this etching seems to depend upon the date of publication of Maxime Lalanne's treatise on the etching technique (Paris, 1866), in which he quotes a method described by Bracquemond for executing a print in this technique (pp. 80-81). However, there is no specific reference to Manet in the passage in the book in which the process is described.

Several examples of trial proofs of this etching exist before letters were added. Also, Guérin notes that he had seen a proof touched with watercolor.

THE WATER DRINKER [Le buveur d'eau]ᴾ (Fig. 88)

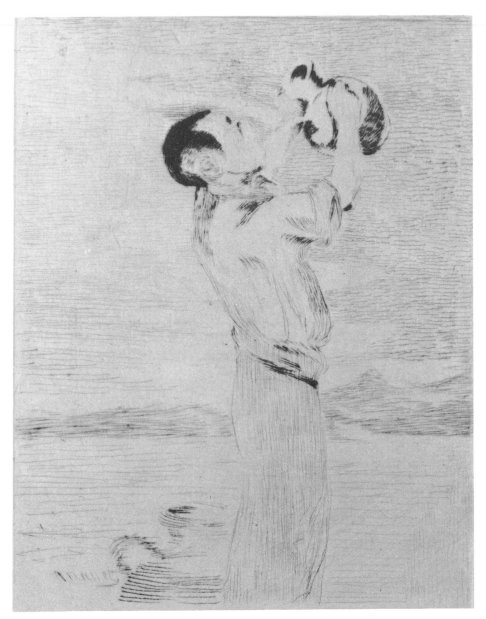

Fig. 88

Etching and drypoint: one state
Signed lower left: "Manet;" undated
Dimensions: 236 x 157 mm. (plate); 180 x 135 mm. (composition)
Date: 1865 (?)
Editions: 1894 Dumont; 1905 Strölin
References: M-N 32; Guérin 22; Hanson, no. 33, p. 59

COMMENTARY: This print may have been done when Manet was involved in preparing some drawings for *L'Autographe au Salon* in 1865. A sheet of drawings printed in photographic facsimile was produced for this publication. There is also a bistre drawing of this figure (De Leiris 177), signed and dated 1865. The style of the print does not conform with that of *The Gypsies*, to which it is thematically related. Since in 1865 Manet was involved in reproducing the image of the boy drinking in various media, it is possible that this plate was etched at the same time. It is somewhat similar stylistically to *The Philosopher* and the first plate of *The Smoker*, both of 1866. It is interesting to note that here Manet shows more of the figure than appears in *The Gypsies* or in the oil fragment (J. W. B. 59 bis).

44.

AT THE PRADO {Au Prado} (Figs. 89, 90)

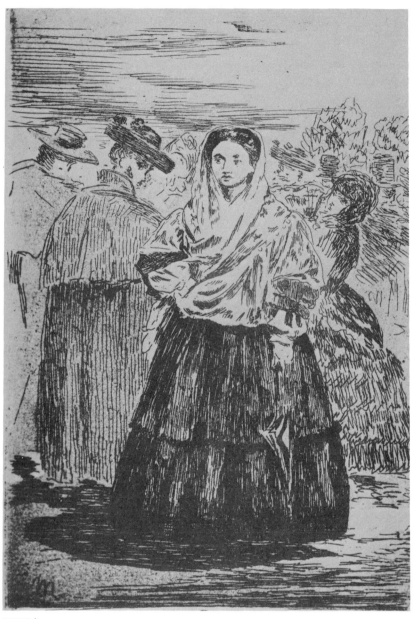

STATE 1

Fig. 89

Etching and aquatint: two states
Signed lower left: "M;" undated; title "Au Prado" beneath drawing
Dimensions: 180 x 118 mm.
Date: autumn, 1865 (?)
Editions: none
References: M-N 63; Guérin 45; Rosenthal, 53; Isaacson, no. 30, pp. 38-39
1st state: The forms are all suggested with long, fine lines of hatching,
 primarily parallel vertical strokes. The shawl which the central figure
 wears is white. There is a light wash of aquatint on the ground to the
 left of the woman and on the cloaks of the two male figures at the
 left.

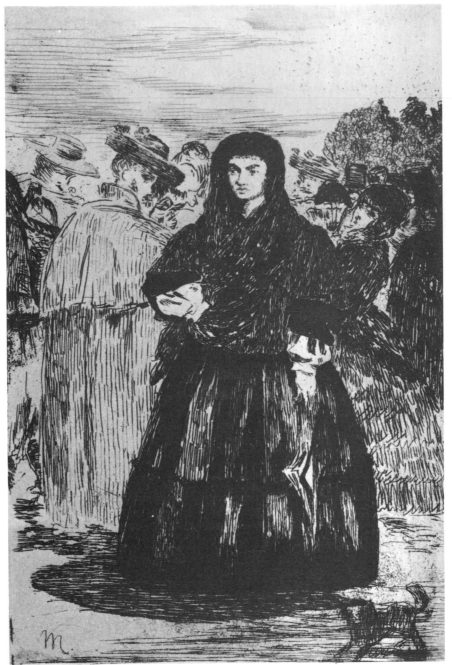

STATE 2

Fig. 90

2nd state: The woman is dressed now entirely in black. The trees on the
right and the women in the background have been darkened. There
is now a dog in the foreground at the right. The aquatint in the
lower left has been almost completely eliminated.

COMMENTARY: This etching is traditionally dated 1865 because of two references in Manet's correspondence of that year to a desire to record the beautiful women of the Prado as they stroll along, heads covered with the mantilla. The first letter, written from Madrid to Fantin-Latour, says merely: "The Prado, a charming walk, is filled with pretty women, all with mantillas, which makes a very unusual picture" (P. Courthion, *Portrait of Manet by Himself and His Contemporaries,* trans. by Michael Ross, London, 1960, 15).

The other letter (dated September 14, 1865), addressed to Baudelaire from Sarthe, where Manet was staying with M. Fournier on his return from Spain, says that he hopes to "mettre sur la toile" both the brilliance of the bullfights and of the Prado, where are found together every evening the most beautiful women in Madrid, "toutes coiffées de la mantille" (Guérin 45).

Since both of these references so specifically describe the subject of this and the following etching, it has been assumed that they were done after the

trip to Madrid. It is, however, worth noting that, although Manet did record his impressions of the bullring in oil paint after his return, he never seems to have been inspired to do so with the subject of the Prado.

Stylistically, this etching seems in some ways to be still closely related to Manet's Spanish-inspired etchings of late 1862, such as The "Espada" (cat. 35), Don Mariano Camprubi (cat. 34), and The "Posada" (cat. 36). Like these works, it was inspired by a close study of Goya's etched works; this time the resemblance is to the Caprichos, especially to Plate 27, Quien mas rendido? The pose of the central figure is very similar to that of Lola de Valence (cat. 33), though the handling of line and tone is decidedly less lacy and delicate. The lack of refinement in the handling may explain why the print was never included in a published edition (see cat. 39).

AT THE PRADO {Au Prado} (Figs. 91, 92)

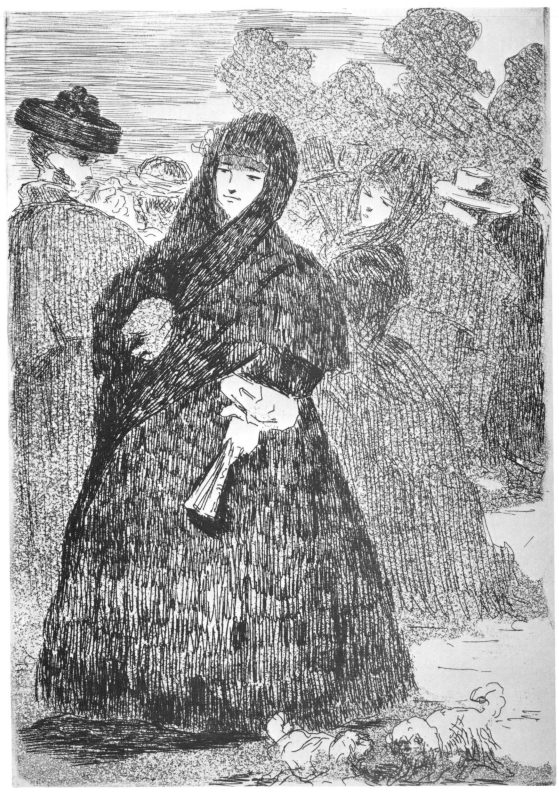

STATE 1 Fig. 91

Etching and aquatint: two states
Unsigned; undated
Dimensions: 221 x 155 mm.
Date: 1865 or 1868

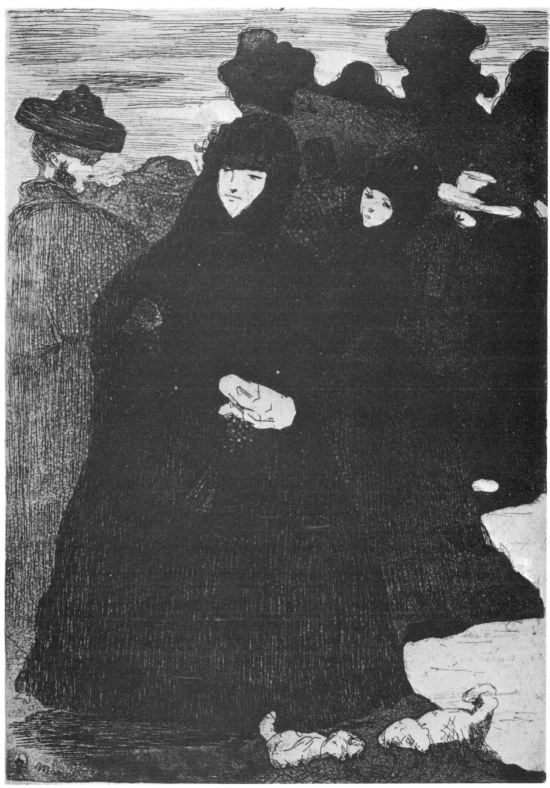

STATE 2

Fig. 92

Editions: Porcabeuf

References: M-N 62; Guérin 46; Rosenthal, 53; Hanson, no. 69, p. 99;
 Isaacson, no. 30, pp. 38-39

1st state: The figures are suggested with a few etched lines and broad areas
 of light aquatint which form the silhouettes of the shapes.

2nd state: The whole composition has been recoated with aquatint so that
 the value contrasts are very strong. There are a few patches of white,
 but the predominant tone is a deep dark.

COMMENTARY: The composition of this version, as of the preceding one, comes from Goya's *Caprichos,* Plate 27, entitled *Quien mas rendido?* This version carries Goya's most boldly stated two-dimensional renderings several steps further. The whole plate is conceived as a flat design. In addition to deeply bitten, parallel hatchings, a heavy coat of aquatint was applied to reinforce the effect of flat cut-outs achieved by the figures' forms.

It is as difficult to date this version of the motif of *Au Prado* as it is to date the preceding work. At first glance, particularly in its second state, its style seems much more closely associated with Manet's etchings of 1868 and 1869. The emphasis upon flat patterns and sharp value contrasts is similar to etchings such as *Exotic Flower* (cat. 57). However, the etching line itself, especially as seen in the first state before the addition of the heavy coat of aquatint, is, in its variety and freedom of handling, closer to the works which Manet executed in 1866, such as *The Philosopher* (cat. 47) and *The Tragic Actor* (cat. 48). Thus, the etching may not have been executed at the same time as the preceding version at all, but several years later.

46.

PORTRAIT OF CHARLES BAUDELAIRE, FULL FACE (Fig. 93)

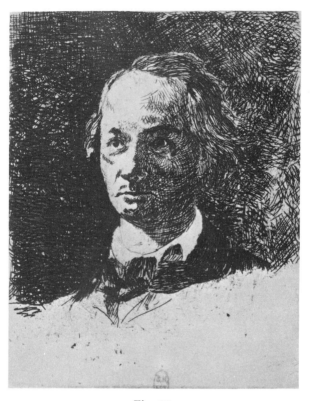

Fig. 93

Etching: one state
Dimensions: 100 x 80 mm.
Date: 1865 or 1869
Editions: none
References: M-N 58; Guérin 36; Sandblad, 64-66; J. Adhémar, "Le portrait
 de Baudelaire gravé par Manet," *Revue des Arts,* II (December, 1952).
 240-242; A. Scharf and A. Jammes, "Le réalisme de la photographie
 et le réaction des peintres," *Art de France,* IV (1964), 176; Hanson,
 no. 38, p. 61

COMMENTARY: This is the first of three portraits of Baudelaire which Manet undertook from a photograph of the writer taken by Nadar (Fig. 94). Although Manet used only the head and collar of the figure for the etching, the shadows indicated on the face follow closely (in reverse, of course) those seen in the photographic version.

Sandblad suggests that Manet etched this first plate in 1865, while Baudelaire was in Brussels. Since this was the year of the *Olympia* scandal and the year of Manet's greatest discouragement,

it may be that he executed the portrait in memory of his friend, who was no longer by his side. Baudelaire did not die, however, until 1867. In an undated letter (quoted in P. Courthion, *Portrait of Manet by Himself and His Contemporaries,* trans. by Michael Ross, London, 1960, 18), presumably of 1869, from Manet to Asselineau, the publisher of Baudelaire's works, we read:

My dear Asselineau,
 You are busy just now, aren't you, on an edition

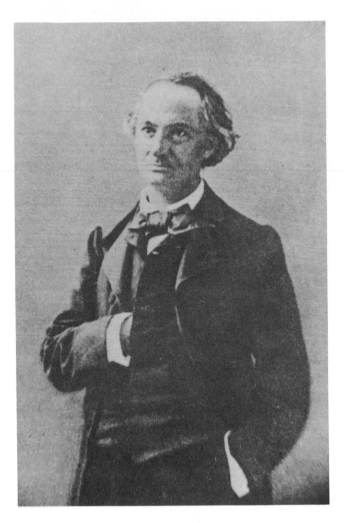

Fig. 94

of the works of Baudelaire? If you are inserting a portrait of him as a frontispiece to *Le Spleen de Paris,* I have a portrait of Baudelaire in outdoor clothes, wearing a hat, which perhaps wouldn't look bad at the beginning of this book. I have yet another and more important one of him, bareheaded, which would look well in a book of poetry. I'm very keen to be given this job.

Naturally in suggesting myself I would *give* you the plates.

Ed. Manet
49 rue de Saint-Petersbourg

This letter certainly indicates that Manet was intending to rework the old images for the biography (see cat. 59, 60, 61 for further discussion of the project).

47.

THE PHILOSOPHER {Le philosophe}[P] (Fig. 95)

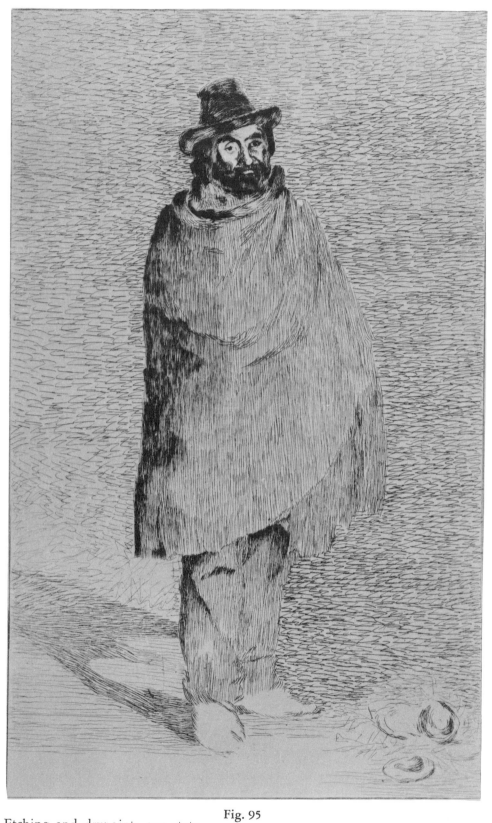

Fig. 95

Etching and drypoint: one state
Unsigned; undated
Dimensions: 314 x 233 mm. (plate); 270 x 160 mm. (composition)

Date: 1866
Editions: 1894 Dumont; 1905 Strölin
References: M-N 35; Guérin 43; Rosenthal, 115-116; Hanson, no. 74, p. 93; Isaacson, no. 28, pp. 37-38

COMMENTARY: This print is a reproduction of an oil painting of 1865 in the Art Institute of Chicago (J. W. B. 111) which was inspired by Manet's Spanish trip in August of that year. The resemblance to Velazquez's painting of *A Philosopher* and to Goya's etched copy of that painting has often been noted and was undoubtedly in Manet's mind when he executed his image (see Isaacson, no. 28). This print repeats the composition of the oil almost exactly except for the reversal of the image.

The simplification and concentration of statement successfully achieved in *The Tragic Actor* (cat. 48) seem not to have come to fruition here, suggesting that the print was executed prior to the other and thus represents the initial experiment with the new approach after the return from Spain. The handling of the background areas exhibits less assurance than seen in *The Tragic Actor,* diminishing the concentration on the figure itself. The lack of forceful handling may well be the reason that Manet abandoned the plate after the first state.

48.

THE TRAGIC ACTOR [L'acteur tragique][P] (Figs. 96, 97)

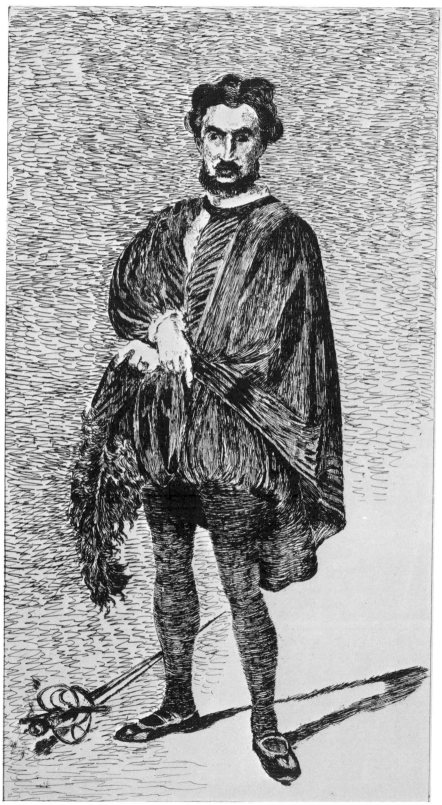

Fig. 96

Etching: two states
Signed lower right in second state: "Manet;" undated
Dimensions: 299 x 160 mm.

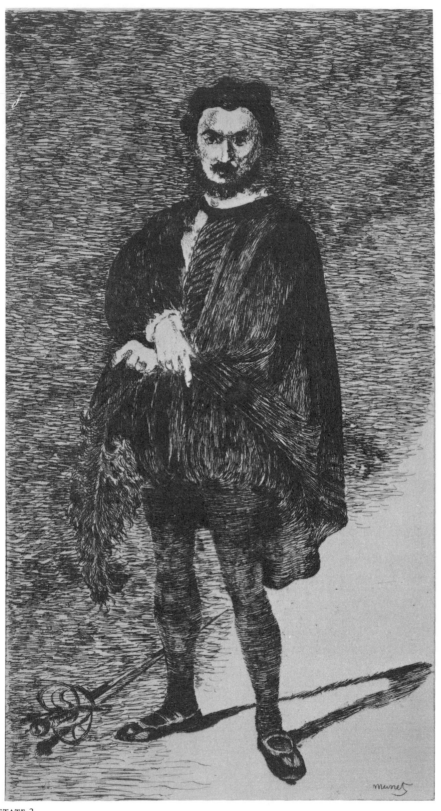

STATE 2

Fig. 97

Date: 1866

Editions: 1890 portfolio; 1894 Dumont; 1950 Strölin

References: M-N 38; Guérin 44; Hanson, no. 77, p. 95; Isaacson, no. 27, p. 37

1st state: The whole image is clearly drawn in; the figure is dark against a

light background which consists of widely spaced, zigzag strokes. There is no signature.

2nd state: The image is much darker, as is the background. There is now a sharp contrast between the ground and the upper part of the background behind the figure, reinforcing the white areas of the face, hands, and collar of the actor's garment. In this state, the etching is signed in the lower right corner.

COMMENTARY: Like the preceding print, this work is copied from an oil painting which Manet executed after his trip to Spain. It depicts the great tragedian, Philibert Rouvière, in the role of Hamlet (J. W. B. 125; National Gallery of Art, Washington, D.C.). Manet was inspired to paint this picture after having seen Velazquez's painting of an actor in the court of Philip IV in the Prado. It is said that Rouvière died before Manet completed the painting and that some of his friends had to pose for the hands and legs to allow him to finish it. It is possible that Rouvière's death was one reason for Manet's undertaking an etched version of his oil painting, but it is more likely that his indignation at the Salon Jury's refusal to include the painting in the Salon of 1866 prompted him to rework the motif in the etched form.

As in the painting, only the most significant areas of dark and light are emphasized. The hatchings are parallel to the outline of each area, creating a uniform density and texture for each portion. Even though the basic elements in the oil version reappear in the etching, certain shifts in emphasis indicate that Manet clarified the structure of the depiction in this second version. A case in point is the treatment of the background. In the oil, a horizontal division between the lighter floor area and the darker background establishes a sort of stage for the actor. In the etching, this suggestion is replaced by a division which runs from the lower left corner to the middle of the right side, establishing a vague differentiation between "floor" and background, but not the definite "stage" seen in the oil. This elimination of the stage space results in a greater concentration on the figure and the sword at his feet.

As compared with Manet's earlier etchings showing a single isolated figure on a stage, such as *The Boy with a Sword* and *Lola de Valence, The Tragic Actor* exhibits a reduction of complexity corresponding to the compositional and expressive changes effected between the oil and the etched copy. In the earlier works, the strokes vary in length, direction and width to produce subtle effects within a wide value range. The subtle aquatint and zigzag-covered backgrounds in the two earlier etchings suggest atmosphere surrounding the figures and to some extent obscure their outlines. By contrast, in *The Tragic Actor,* textural variations and modeling are eliminated in favor of a greater emphasis upon the shape of the figure, with the result that the print is bolder and more direct in its impact than either of the earlier works.

49.

THE SMOKER [Le fumeur]P (Fig. 98)

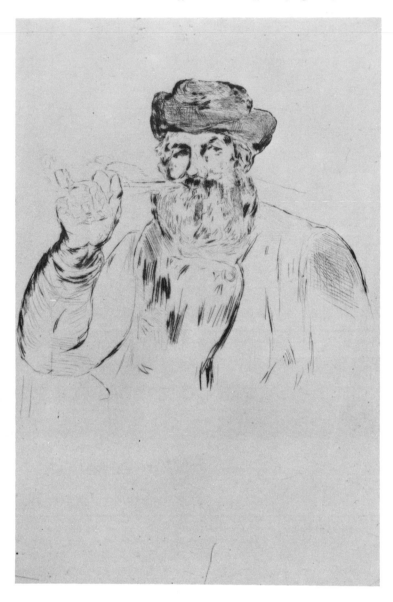

Fig. 98

Etching and drypoint; one state
Unsigned; undated
Dimensions: 237 x 153 mm. (plate)
Date: 1866
Editions: 1894 Dumont; 1905 Strölin
References: M-N 34; Guérin 48; Rosenthal, 145; Hanson, no. 82, p. 101

COMMENTARY: This print was taken from Manet's painting of 1866, a portrait of Joseph Gall smoking (J. W. B. 133), but the image is reversed in the etching. As in many European etchings of this period, the motif is reduced in conception, with the lines blending off into the paper away from the figure's head. The use of drypoint is not often found in Manet's work, but here it is very marked, indicating, perhaps, Manet's desire to achieve an effect similar to that of etchings by Legros and Seymour Haden. It is possible that the plate was abandoned after the only state had been pulled because Manet did not really favor the effect.

THE SMOKER [Le fumeur]ᴾ (Fig. 99)

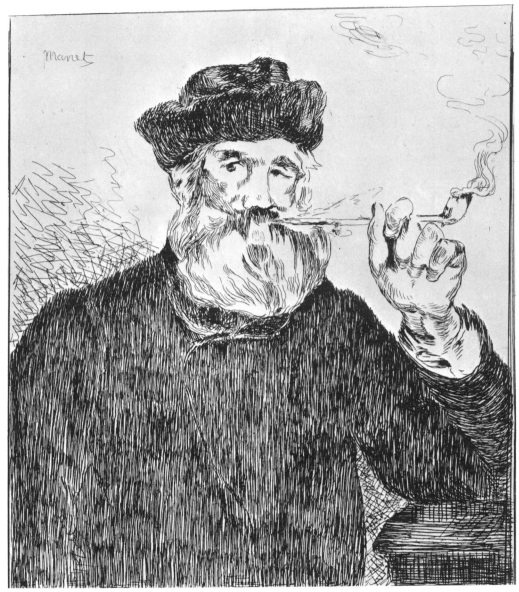

STATE 1

Fig. 99

Etching: two states
Signed upper left: "Manet;" undated
Dimensions: 232 x 155 mm. (plate in 1st state);
 172 x 155 mm. (plate in 2nd state);
 154 x 132 mm. (composition)
Date: 1866
Editions: 1890 portfolio; 1894 Dumont; 1905 Strölin
References: M-N 33; Guérin 49; Rosenthal, 145; Hanson, no. 83, p. 101
1st state: The image is drawn with the etching needle and surrounded with
 a slender etched frame. This state is signed.
2nd state: There is no change in the drawing itself; only the size of the plate
 was reduced.

COMMENTARY: This print is taken from the same painting as cat. 49, but here the figure is shown facing to the right, as he does in the oil. More of the figure is shown in this etching than in the previous one, although the figure is not as complete as in the painting. Manet has cut the figure off just above the waist, whereas in the painting, he is shown in three-quarter length. This is judged to be the second version partly because it faces the same way as the oil, but also because, as has been observed in the case of other etched copies of his own works from this period, Manet aimed at a reduction and clarification of the oil. This version is simpler both in the treatment of the figure, as only the upper part is shown, and in the elimination of the background. Values are kept within a limited range and few variations of stroke are used. To offset what might have been too stark an effect of silhouetting, small areas of zigzag hatching were introduced to the left of the shoulders and between the arm and the table.

DEAD CHRIST WITH ANGELS [Christ aux anges] (Figs. 100, 101)

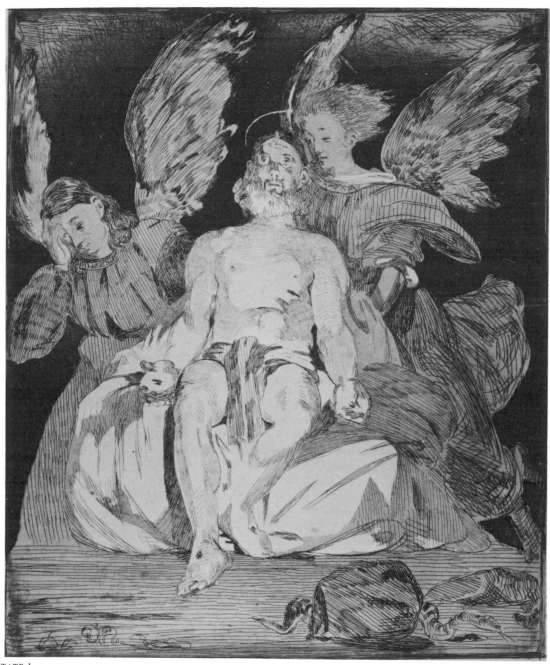

STATE 1

Fig. 100

Etching and aquatint: three states (four states given by Guérin)

Unsigned; undated

Dimensions: 328 x 282 mm.

Date: winter, 1866-67

Editions: none

References: M-N 59; Guérin 34; Rosenthal, 58-59; Hanson, no. 70, pp. 90-91;
Isaacson, no. 26, pp. 36-37

1st state: The major forms are sketched in lightly with long, fine lines. The
background is covered with a clear coat of aquatint which sets off

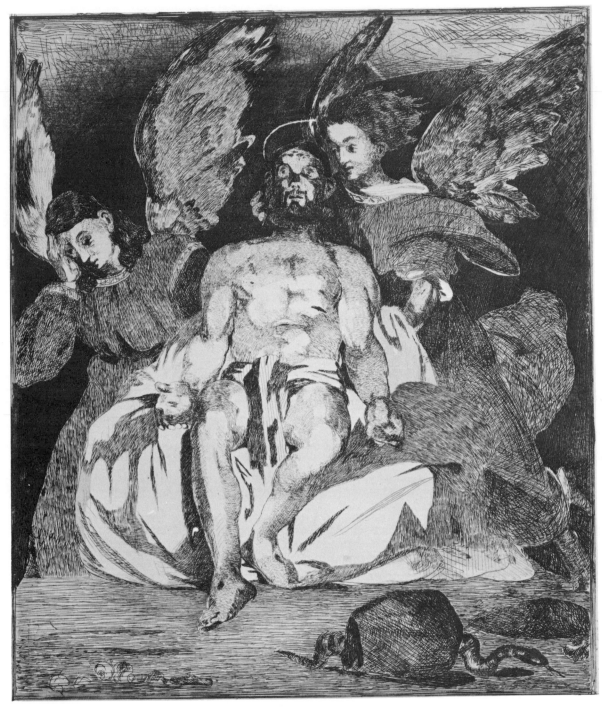

Fig. 101

the figures sharply. There are few areas of modeling within the
figures.

2nd state: (listed by Guérin but not illustrated. Not seen by present author)
Some additional work on the robes of the angels and the body of Christ.

3rd state: The figures are densely covered in shadowed areas with hatchings,
both parallel and cross-hatchings. The resulting effect is a study in
strong value contrasts.

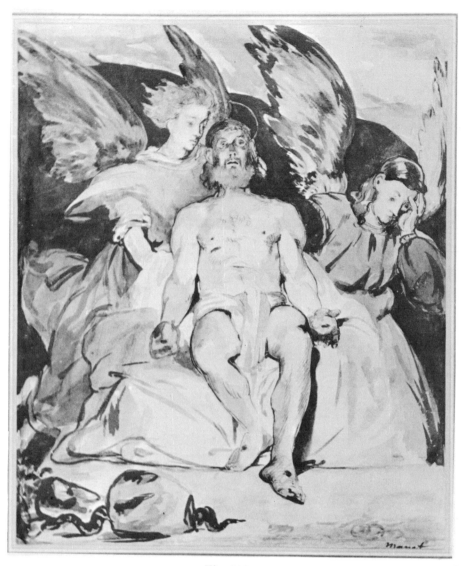

Fig. 102

COMMENTARY: This etching is a transcription of the oil painting now in the Metropolitan Museum in New York, which was exhibited in the Salon of 1864 (J. W. B. 85). After the painting had been installed in the Salon, Baudelaire wrote Manet that the wound in Christ's body was on the wrong side and that he must correct it before opening day. Several scholars have suggested that the watercolor drawing in the Louvre (De Leiris 198; Fig. 102) was Manet's way of correcting the placement of the wound, but the fact of the matter is that it is an intermediary step between the oil painting and the etching, for the dimensions of the two are almost exactly the same, although the entire composition is reversed. After Manet had finished with the water-color drawing, he gave it to Zola; subsequently, Mme. Zola presented it to the Louvre.

Although it is possible that the etching was done in 1864, I think, on the basis of its style, that it is more likely to have been done in the first part of 1867. The painting, *Dead Christ with Angels,* is one which apparently was an especial favorite of

Zola (witness the account of it in his Jan. 1, 1867 *Evènement* article), and it is entirely possible that Manet considered using an etching of this painting to accompany the brochure by Zola which eventually contained only the etched version of *Olympia* (cat. 53).

Stylistically, the work is perfectly consistent with Manet's handling in dated works of late 1866 and early 1867. As in the contemporary etching of *Olympia,* the implications of strong two-dimensional pattern are carried much further than in the oil. At the same time, the print continues to exhibit some features of slightly earlier works such as *The Smoker* and *The Tragic Actor,* i.e., linear variety and vigor, features which were abandoned in Manet's prints after 1867. Thus, the etching, though more two-dimensional in impact than Manet's works of 1864 and 1865, does not exhibit the exaggerated flatness of form and emphasis on surface pattern which are characteristic of the developed etchings of 1868 and 1869.

OLYMPIA[P] (Figs. 103, 104)

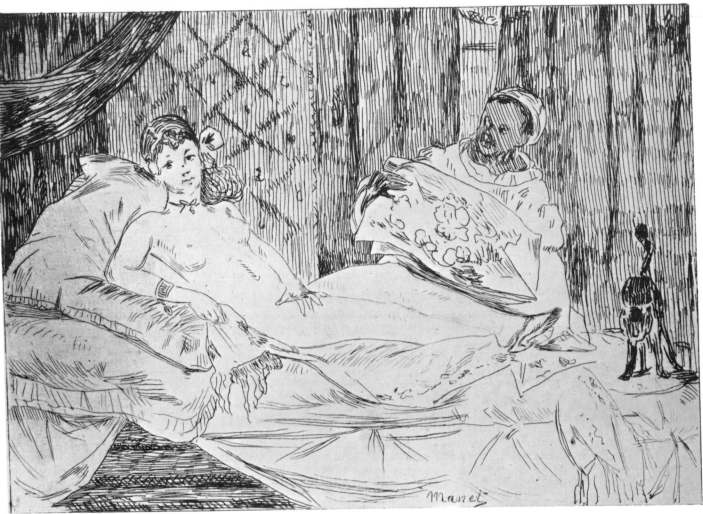

STATE 1

Fig. 103

Etching: three states

Signed on first two states outside of drawing: "Manet del.;" undated

Dimensions: 158 x 240 mm. (plate); 131 x 183 mm. (composition)

Date: between January and May, 1867

Editions: 1890 portfolio; 1894 Dumont; 1905 Strölin

References: M-N 37; Guérin 40; Rosenthal, 57-58, 123-136; Adhémar, *Nouvelles,* 231; Hanson, no. 57, p. 77; Isaacson, no. 22, pp. 34-35

1st state: The major divisions of the composition are lightly delineated. The biting of the parallel hatchings is very light; value contrasts are not emphasized.

2nd state: The whole drawing has been darkened, and the areas of shadow have been made very low in value. The various divisions of the background have been almost completely obliterated by a dense crosshatching. The effect of this state is much closer to that of the oil painting.

3rd state: The only change appears to be that the signature outside of the drawing has been eliminated.

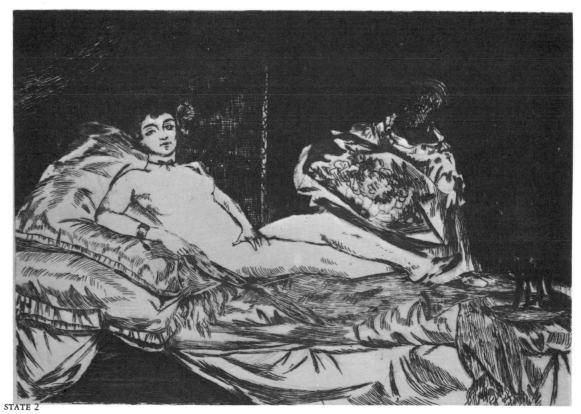

STATE 2

Fig. 104

COMMENTARY: Guérin thinks that this is the second etched version of the infamous painting of 1863, but several facts indicate that it must be the first. In the first place, in its composition and proportions, this version is much more like the oil than is the other etching. Secondly, it seems more reasonable to assume that this is a trial piece for Zola's publication, rather than a later working, for it was the other etching which was published in the brochure in May, 1867.

For some curious reason, Manet introduced a curl in the middle of Olympia's forehead in this etching. This curl appears in the other etching (cat. 53) and in the small replica of Olympia in the upper right corner of Manet's portrait of Zola, executed in 1868 and exhibited in the Salon of that year (J. W. B.

146; Louvre). However, the curl does not appear in the original oil or in the watercolor in the Niarchos Collection (De Leiris 196). This detail is mentioned because it seems to corroborate our contention that the two etchings were done after the watercolor and close in time to the oil portrait of Zola.

Technically, this etching represents a modification of the vigor and plasticity of the oil painting. Manet has retained the effect of flatness by omitting shadows in the rendering of Olympia's form by darkening the background and making it even less differentiated than it appears in the painting. Finally, forms and shaded areas are rendered with a relatively uniform stroke so as to retain the sense of unity.

[147]

53.

OLYMPIA (Figs. 105, 106, 107)

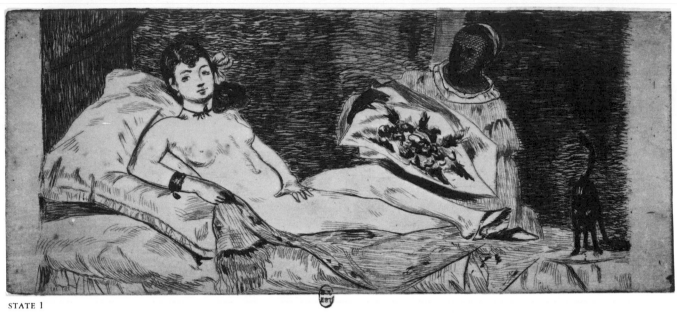

STATE 1

Fig. 105

Etching and aquatint: five states

Unsigned; undated

Dimensions: 88 x 204 mm. in first two states; the width is reduced in the
4th state to 178 mm.

Date: between January and May, 1867

Editions: 1867 Zola; 1894 Dumont; 1902 Duret; 1905 Strölin

References: M-N 17; Guérin 39; Rosenthal, 57-58, 123-136; Hanson, no. 58,
p. 77; Isaacson, no. 23, p. 35

1st state: Major areas have been delineated with a few simple outlines. The
background is covered with zigzag strokes, except for the curtain at
the left, which is shaded with vertical, parallel strokes. There is some
space left untouched at both sides of the plate. The Cabinet des Es-
tampes in the Bibliothèque Nationale has an example of this state
(here illustrated) which is touched with watercolor; a light bluish-
gray wash covers the background, and on the edge of Olympia's right
hand there is a touch of pink. There is also a touch of pink on the
flowers and on the Negress' dress and turban.

2nd state: There are minor changes in the drawing of the figure, in the
contour of the right shoulder, and on the upper edge of the right arm.
The background contains additional hatching.

3rd state: There is no change in the drawing, but the background has been
darkened with aquatint.

4th state: The plate has been reduced in width. No change in the drawing.

5th state: This state is the one that appeared in Zola's pamphlet. The only
changes in the drawing are in the contours of the left hand, which
are reinforced, and in the addition behind the right hand of the tip
of the thumb.

[148]

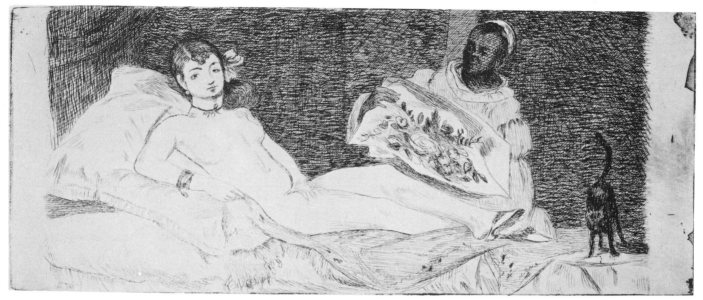

STATE 2

Fig. 106

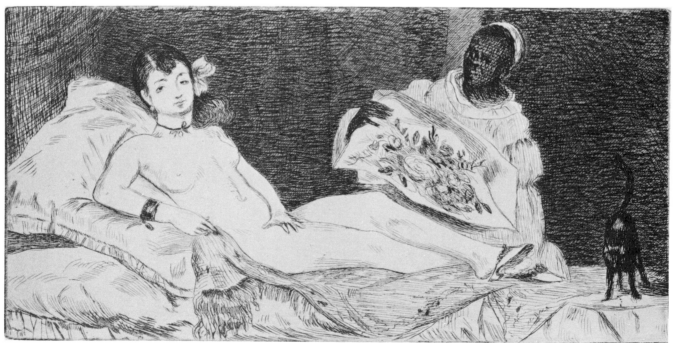

STATE 5

Fig. 107

COMMENTARY: This plate is quite clearly the second etched version of the motif which Manet undertook. For some reason, Guérin lists this as the first version, but the changes in the composition away from those of the oil and of the first plate indicate, in accordance with Manet's usual practice, that this is not true (see cat. 52).

In this version of the subject, Manet reduced the height of the original composition by eliminating the lower part of the picture. Here the bed forms the bottom of the composition and most of the space above the heads of the figures has been cut out. The background is undivided; in each successive state, it is darkened increasingly so as to contrast most effectively with the white figure and bed. The elimination of surrounding space and simplification of values asserts the two-dimensional design even more forcefully than does the oil and presents an even more sharply focused depiction than does the preceding version. This simplification underscores Manet's intention here to reinforce the "message" of his "synthetist" style and produce a much more startling effect than he would ever have tried to create in an oil painting of this period.

The possibility exists that only the first state of this etching was carried out by Manet himself. Mrs. Hanson has directed my attention to a copy of Zola's brochure owned by the Brera Gallery in Milan, whose director, F. Russoli, pointed it out to her, in which the first and second title pages contain corrections of the attribution of the print almost certainly in Manet's writing. The Brera's copy of the pamphlet is inscribed to Signorini and signed by "E. Manet" and, in the same ink and writing, the words "d'Ed. Manet" which follow the description of the etching are crossed out and the letter "B." substituted. Manet may have begun a second version of the image of *Olympia* after the first plate turned out to be a failure (cat. 52), and turned it over to Bracquemond to complete when he ran out of time (he was, after all, getting his one-man show ready). Certainly the initial drawing on the plate bears no recognizable sign of being by Bracquemond, but is probably by Manet himself. (It must be acknowledged, however, that Bracquemond was very adept at imitating the drawing style of others; see, for instance, his etching taken from Courbet's *Les demoiselles du village*.) After the first state little change was made on the plate; significant alterations occur only in the woman's left hand and the background. Since Bracquemond often helped Manet with the aquatint in the subordinate areas of his prints, it is not unduly surprising that he may have been asked to complete the work on this plate. Most unusual, however, is the omission of Manet's signature, especially since the etching was destined for use in Zola's publication. This omission seems to us the most convincing testimony to the possibility that only the original state of the print actually comes from Manet's own hand.

54.

THE EXECUTION OF THE EMPEROR MAXIMILIAN
{L'exécution de Maximilien} (Fig. 108)

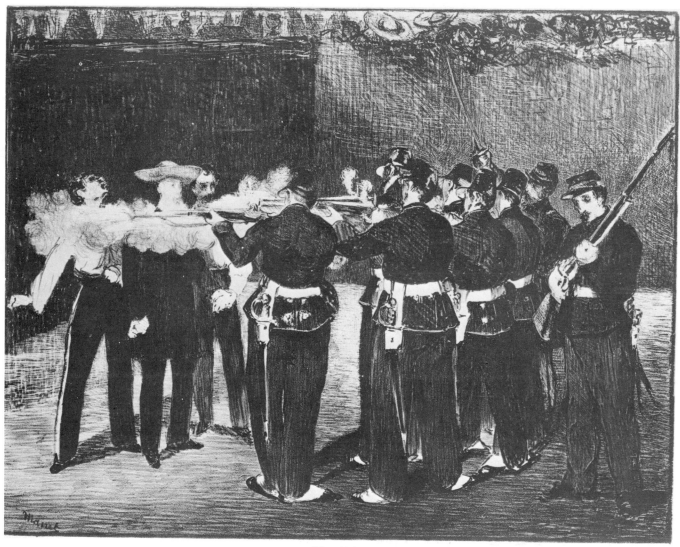

Fig. 108

Lithograph: two printings
Signed lower left: "Manet;" undated
Dimensions: 335 x 431 mm.
Date: late in the year 1867
Editions: 1884 Memorial
References: M-N 79; Guérin 73; Rosenthal, 87; Sandblad, 109-155; Hanson,
 no. 86, pp. 103-105; Isaacson, no. 29, p. 38
1st printing: without letters, only a few trial proofs
2nd printing: with letters as follows (bottom center): "Imp. Lemercier et
 Cie., Paris." Some examples were printed with these letters covered up.

COMMENTARY: This lithograph is one of five versions of the subject of the execution of the Emperor which took place in Mexico on June 19, 1867. There has been some controversy about the order and dating of these versions (for a survey of the various ideas, see Sandblad, 109-155; the review of Sandblad by Martin Davies, "Recent Manet Literature," *Burlington Magazine,* XCVIII [May, 1956], 169-171; and Hanson, pp. 103-105), but the present evidence seems to indicate most convincingly that Manet painted his first oil version (J. W. B. 138; Museum of Fine Arts, Boston) in late July or early August, that he abandoned this version after getting more accurate information about the event from photographs and newspaper reports, and that he then turned, probably in September, to painting a large canvas, which was subsequently damaged and remained rolled up in his studio until after his death (the salvaged fragments are now in the National Gallery, London [J. W. B. 139]). According to Sandblad (p. 153) it was at this point, either late in 1867 or early in 1868, that Manet undertook the lithograph, perhaps in order to spread more widely the ideas contained in his work. It is also possible that he reworked the scene at this point first in a small canvas (J. W. B. 141; Ny Carlsberg Glyptotek, Copenhagen), for this painting is almost exactly the same size and composition as the lithograph. The reasons for giving the oil sketch priority over the lithograph are: 1) that Manet's usual practice was to reproduce in a graphic medium a work already existing in oil painting (not vice versa), and 2) that there exists a tracing of the figure group in reverse of the oil and the lithograph (De Leiris 217; Museum of Fine Arts, Budapest), which may have been used to transfer the motif from the oil sketch to the lithographic stone.

The lithograph and the Copenhagen oil sketch differ from the other versions in placing the event before a wall with spectators hanging over its top, *à la* Goya, and in showing the man with a sword giving the signal for the firing to commence (in the London fragment showing the firing squad, only the sword, not its wielder, is seen). The sword and its wielder are completely absent from the final, large oil version, the painting in Mannheim (J. W. B. 140). However, in this version, Manet retained the idea, first introduced in the Copenhagen oil and in the lithograph, of placing the event in front of a wall. The inscribed date on the Mannheim painting of "19 juin 1867" records, of course, the day of the execution of the Emperor, not the date when the painting was carried out. The final oil may not even have been done until 1869 (this would particularly be the case if the letter from Manet to Burty quoted by Rosenthal and Guérin concerning the confiscation of the lithographic stone is correctly datable 18 February, 1869, for it seems most likely to me that Manet did not undertake the final oil version until publication of the lithograph was definitely prohibited).

As a print, the lithograph shares with Manet's etchings of 1866 and 1867 a style which is a direct simplification and reinterpretation of his style in oils of the same period. He rejects accidental-looking effects and independent calligraphic accents in favor of a clear rendering of the motif. He has eliminated almost all of the subordinate figures and landscape accessories that appear in the oil versions, but has avoided monotony in the background by dividing the wall into two sections which correspond with the two groups of figures in the foreground. These two divisions are lightened and darkened to provide a contrasting foil for the figures.

Technically, the lithograph is more "conservative" than is the nearly contemporary *The Races* (cat. 41). The whole surface is composed of areas of boldly contrasting values, and each shape is presented clearly without distracting details or vivid calligraphy. As in his early lithographs, such as *The Urchin* (cat. 30), Manet has outlined individual figures, which suggests that he used a tracing for the preliminary drawing on the stone. He also made extensive use of scratching into the black areas with a sharp tool as in earlier lithographs to give variety and contrast to the dark values. Only in rendering the spectators hanging over the wall did Manet allow the free, calligraphic manner to appear in this print, and it is here kept to a very minimal role in the composition.

55.

DEAD TOREADOR {Torero mort}
(Figs. 109, 110, 111, 112, 113, 114)

STATE 1

Fig. 109

Etching and aquatint: six states

Signed lower left: "Manet;" undated

Dimensions: 154 x 224 mm. (plate); 95 x 194 mm. (composition)

Date: 1868

Editions: 1874 portfolio; 1890 portfolio; 1894 Dumont; 1905 Strolin

Exhibited: Salon of 1869

References: M-N 13; Guérin 33; Rosenthal, 59-60; Hanson, no. 60, pp. 79-81; Isaacson, no. 25, p. 36

1st state: The figure of the torero is depicted with a combination of deeply bitten and lightly bitten parallel lines, all of which follow the direction of the planes of his body. The background is covered with two different values of aquatint. The ground has a light coat, while the upper part of the background is much darker. The division between the upper and lower parts of the background crosses the composition horizontally at the level of the man's right hand and emerges behind his left foot.

2nd state: Aquatint background is darkened somewhat by additional toning, although distinction between "floor" and "wall" remains. All of the hatched areas contain more work; especially noticeable are increased hatchings in the cape and jacket.

3rd state: The separation between the near and distant background areas has been reinforced by the addition of a very dark strip of aquatint between the "floor" and "wall" areas. There are now three value areas—one,

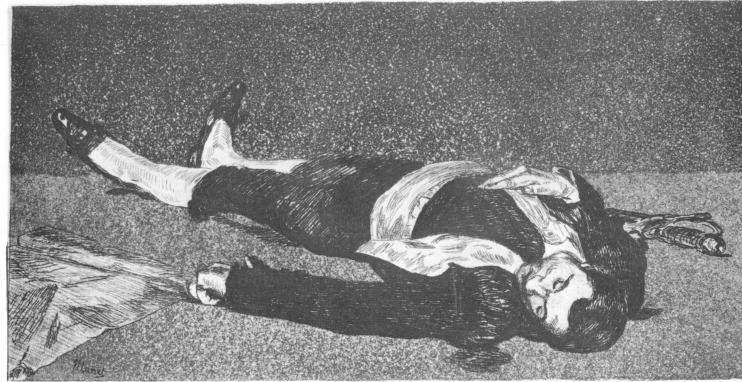

STATE 2

Fig. 110

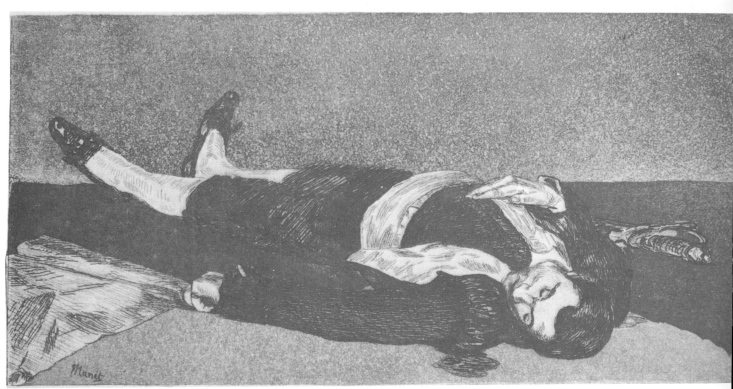

STATE 3

Fig. 111

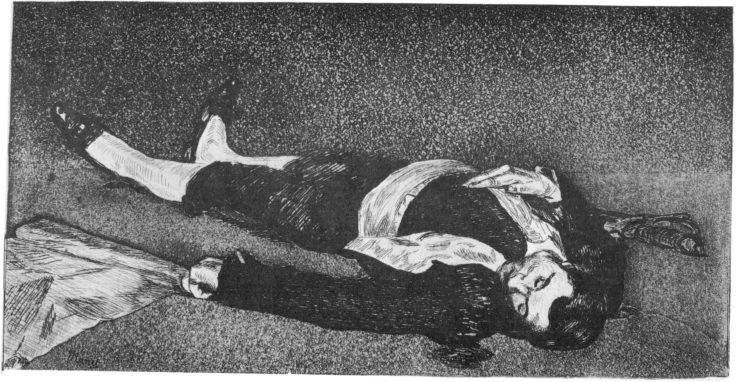

Fig. 112

the nearest, in front of the figure, is the lightest; the second is a very dark gray strip beneath the figure; the third, or wall area, is of a middle value gray.

4th state: The horizontal line separating the ground level from the upper part of the background has been eliminated on the right side of the print so that there is a gradual darkening of the value of the background from beneath the man's head up to the middle of the right side of the etching.

5th state: On the right side of the print, a dark patch separating "floor" and "wall" areas has been reintroduced. The patch, a dark trapezoid to the right of the man's head, separates the much lighter area of the ground from the darker, upper part of the background.

6th state: Again, the horizontal line behind the man has been eliminated and is replaced with a diagonal division between "floor" and "wall" which runs directly beneath the main axis of the prostrate figure. The floor area is still covered with a light grainy aquatint, but the aquatint coat of the background has been covered with a series of zigzag hatchings.

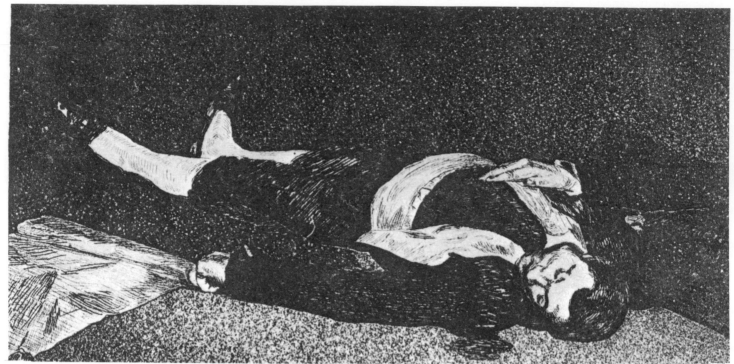

STATE 5

Fig. 113

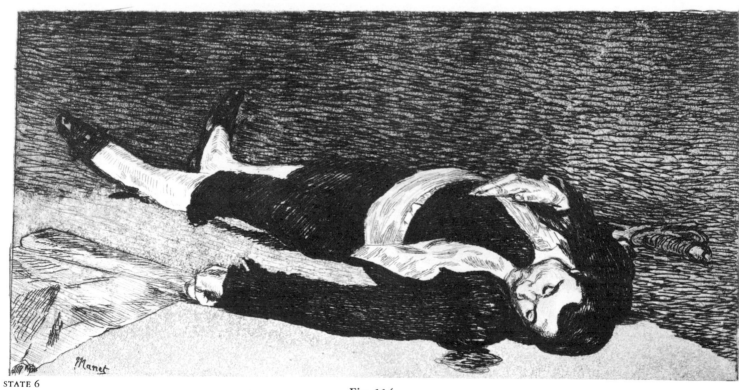

STATE 6

Fig. 114

COMMENTARY: This etching is taken from the oil fragments which Manet salvaged out of his painting of *Episode in a Bull-Fight* (J. W. B. preceding 83), painted and cut up in 1864. The fragment depicting the dead toreador (J. W. B. 83) is in the National Gallery of Art, Washington, D.C. There are minor changes in the composition of the etching as compared with that of the oil fragment. In the etching, the figure is not surrounded by quite so much space as he is in the painting. The cloak at the left has been cut off and there is less space at the right. The effect of these reductions is to place the figure more squarely in the center of the surface.

Guérin thinks that this etching dates from 1864, but several facts seem to militate against this dating. First, in its style, it is much closer to the works of 1868 than it is to those of 1864, particularly to the etching *Exotic Flower* (cat. 57), which is definitely datable to 1868. In fact, *The Dead Toreador* was exhibited with *Exotic Flower* in the Salon of 1869. The fact that it was exhibited at this Salon but was absent from the one-man show of 1867, where several of the "important" (i.e., worked-over) etchings prior to the date did appear, seems to corroborate the dating on stylistic grounds.

The changes which Manet effected in the six states of this etching illustrate convincingly his interest in the late '60's in reinforcing flat tonal effects to create an interesting two-dimensional design without sacrificing entirely an atmospheric quality. The various experiments with the treatment of the background of this etching testify to his concern for obtaining a satisfactory compromise between flatness and fluctuation. Only after five attempts did he achieve the solution which seems to have satisfied him. Here the background and foreground are separated on a diagonal which follows the angle of recession established by the body. The foreground is almost entirely white, with a few traces of aquatint remaining, while to the darker tone have been added zigzag lines to vary the monotony of the aquatint and force the eye to view the surface as an atmospheric ambient.

In its final state, *The Dead Toreador* is not unlike the second version of *Olympia* of 1867 (cat. 53); it is also, as we have already suggested, very similar in its flatness to *Exotic Flower* of 1868. Because it was carried to so many states, indicating that Manet was quite unsure of how to achieve the effects he wanted, it seems not unreasonable to date it after the *Olympia* (1867), but before *Exotic Flower* (1868), by which time he seems to have solved the problem of correlating areas darkened with aquatint and those darkened with parallel etched strokes with great assurance.

ODALISQUE (Fig. 115)

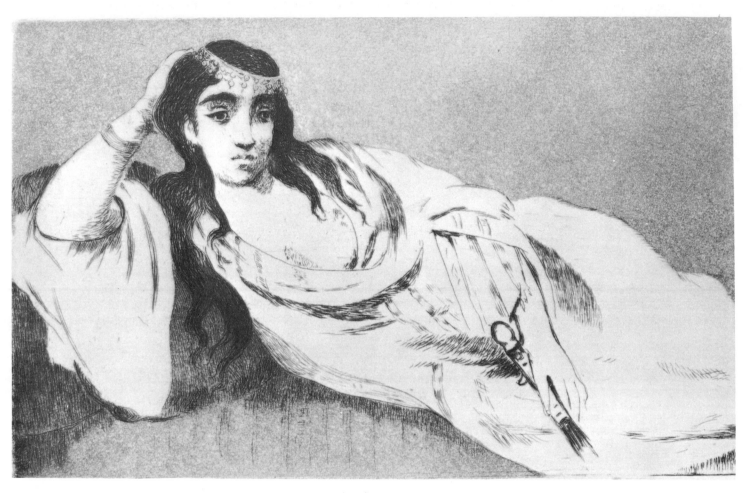

Fig. 115

Etching and aquatint: one state
Unsigned; undated
Dimensions: 126 x 198 mm. (plate); 120 x 191 mm. (composition)
Date: 1868
Editions: 1884 Bazire
References: M-N 20; Guérin 64; Rosenthal, 65-66; Hanson, no. 54, p. 73;
 Isaacson, no. 24, p. 35

COMMENTARY: This figure was taken from a sepia and gouache painting in the Louvre (De Leiris 193; Fig. 116), a painting which may very well have been done in 1862 at the same time as the oil and watercolor versions of *The Young Woman Reclining in a Spanish Costume* (J. W. B. 63; De Leiris 166; both Yale University Art Gallery). It is, in fact, even possible that the same model posed for both pictures, as is suggested by Beatrice Farwell (Hanson, p. 73).

The etching may or may not have been done at the same time as the drawing. Thematically, it certainly fits well with the group of sultry ladies which Manet executed in 1862 and 1863. However, stylistically, the etching does not seem consistent with Manet's efforts of 1862. It is rendered in an accomplished fashion and with a reticence of linear activity which is not found in his other etchings of the early years. The aquatint ground is rather uni-

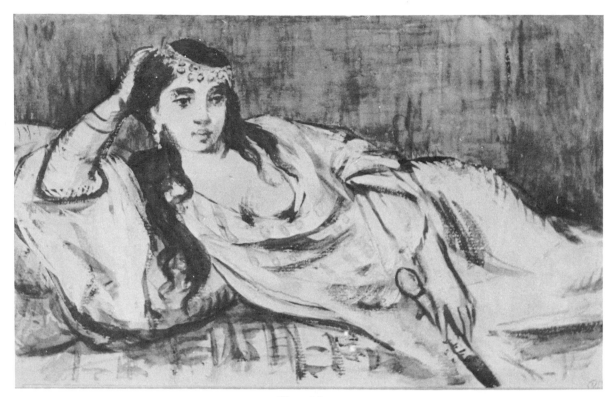

Fig. 116

form, emphasizing the flatness of the figure and presenting an image which gives a very different effect from the watercolor which was the preliminary study. The method of handling is far closer to what Manet was doing in printmaking in 1868 and 1869. For this reason, it seems possible that the etching itself represents a first idea for Manet's commissioned etching, *Exotic Flower* (cat. 57), an idea which was rejected.

It is interesting to speculate on the reasons for the rejection of this image, but it is quite possible that the "odalisque" subject as symbolic of the word "exotique" was considered too trite by 1868, prompting Manet to turn to an image *à la* Goya which seemed less ordinary.

Both the pose and handling of line bear a startling resemblance to a Turkish miniature painting of the 17th century here reproduced (Fig. 117). Such images must have been familiar to artists of the period, as they were often in the hands of col-

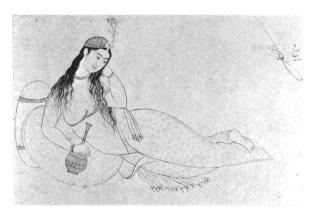

Fig. 117

lectors like Philippe Burty. Could Burty have shown Manet some such drawing at the time of commissioning an etching from him for his deluxe publication?

EXOTIC FLOWER {Fleur exotique} (Figs. 118, 119)

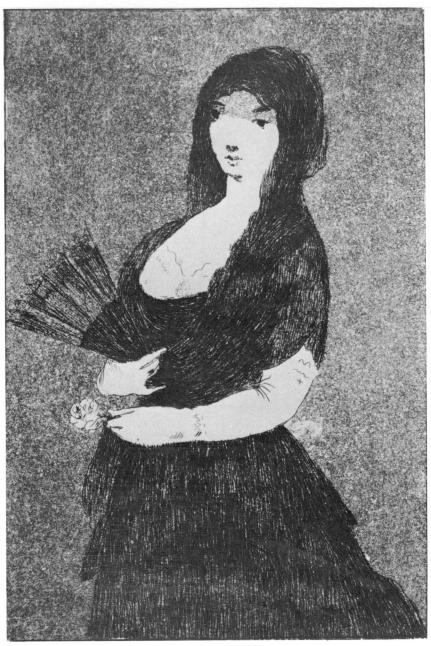

STATE 1

Fig. 118

Etching and aquatint: two states
Signed lower left in second state: "Manet;" undated
Dimensions: 174 x 135 mm. (plate); 161 x 107 mm. (composition)
Date: 1868
Editions: 1869 Lemerre
Exhibited: Salon of 1869
References: M-N 18; Guérin 51; Rosenthal, 38, 40-41; Adhémar, *Nouvelles,*
 231; Hanson, no. 80, p. 99; Harris, 227; Isaacson, no. 31, p. 39
1st state: The woman's dress and mantilla are formed with parallel, vertical
 hatchings, but her face and gloves remain untouched by interior

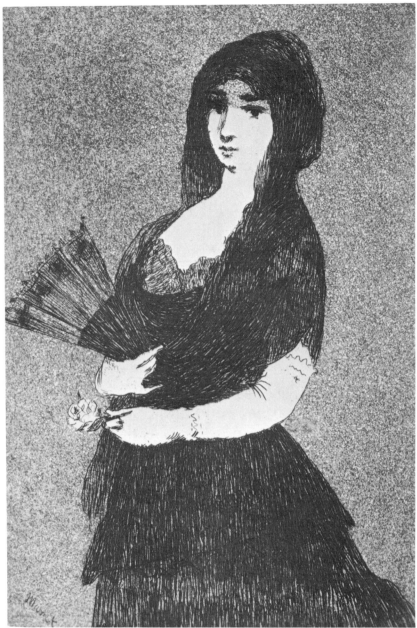

STATE 2

Fig. 119

modeling, except for the very simple suggestion of eyes, nose, and
mouth. The lace at the neck of her dress is white. The background
is covered with a coat of aquatint.

2nd state: The details in the face have been added; the eyes are larger
and darker and a line now joins the nose with the right eyebrow.
The lace at the neck of the dress has been darkened with parallel
strokes. The shape of the headdress has been altered slightly, being a bit
higher in back, to suggest a comb under the mantilla.

COMMENTARY: Manet submitted this etching at the
request of Philippe Burty to accompany a sonnet
entitled "Fleur exotique" to appear in Burty's edi-
iton, *Sonnets et eaux-fortes,* which was published
by Lemerre in 1869. Burty sent Manet the sonnet
with a letter describing progress on his venture (re-

printed in full in Guérin 51, dated June 28, 1868):
"Voici un sonnet qui me paraît cadrer parfaitement
avec ce que nous connaissons de vous." The edition
consisted of 350 examples printed on laid "papier
des Vosges" and 36 deluxe examples which were
not put up for sale. Of these deluxe examples, 12

[161]

were on China paper, while 20 were on China paper mounted on Whatman, printed in double examples: on each sheet, one was printed in black, and one in bistre. Finally, 4 examples were printed on parchment.

It is quite possible that Manet tried out several ideas before settling on this particular image. Both the etching of the *Odalisque* (cat. 56) and the second plate of *At the Prado* (cat. 45) could be trial pieces for the project, discarded when Manet decided he had gone too far in a certain direction. As was suggested above (cat. 56), the *Odalisque* seems a rather hackneyed rendition of the theme, while the second state of *At the Prado* (cat. 45) presents an uncomfortably exaggerated two-dimensional effect. The published version, by combining the technical reticence of the *Odalisque* and the Goyaesque design of *At the Prado,* creates a completely delightful and successful image. The source is plate 15 of Goya's *Caprichos,* but Manet has made his lady much more aloof than did Goya and has eliminated any suggestion of moral tone. Thus, he has created a self-sufficient image which serves to accompany, but hardly to illustrate, the sonnet.

THE CATS' RENDEZVOUS 〔Le rendez-vous des chats〕 (Fig. 120)

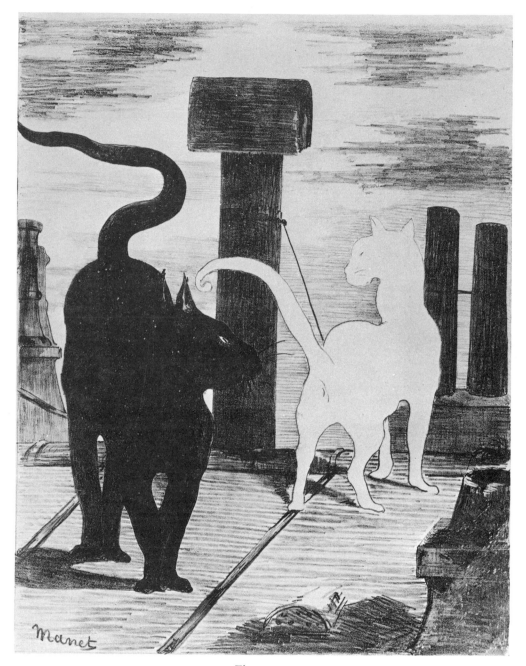

Fig. 120

Lithograph
Signed lower left: "Manet;" undated
Dimensions: 435 x 330 mm.
Date: 1868
Editions: 1869 Champfleury
References: M-N 80; Guérin 74; Rosenthal, 91-92; Adhémar, *Nouvelles,*
232; Hanson, no. 90, p. 111; Harris, 227

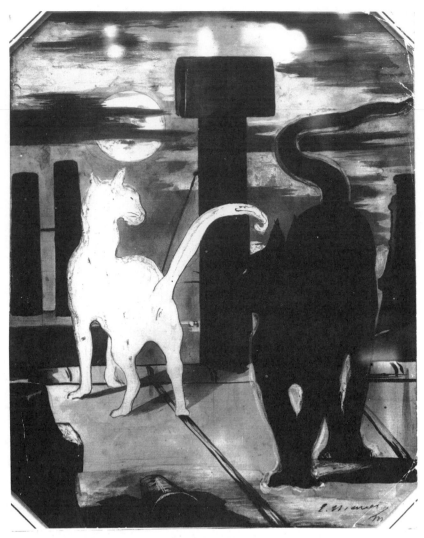

Fig. 121

COMMENTARY: This lithograph must have been executed before October 25, 1868, for it was then reproduced photographically on the back page of the Sunday supplement of *La chronique illustrée* to accompany an article on cats by the Duc d'Alena. The lithograph also served, with the addition of letters, as a poster announcing the publication of a second edition of Champfleury's book, *Les chats: histoire, moeurs, observations, anecdotes* (Deluxe edition, 1870). Guérin suggests that this poster is a reproduction of the original lithograph with letters, not a second state of the work. He says that the poster is almost as rare as the original lithograph. Finally, the lithograph was reproduced in a much reduced wood engraving in the fourth edition of Champfleury's book (opposite p. 258).

According to Duret (1906, 165), Manet mentioned that the chimneys corresponded to the black cat, the moon to the white. He was amused by this fantasy and promised Champfleury that it would draw attention.

Although no specific examples of Japanese woodcuts resemble this lithograph closely, there is no doubt that "l'esprit japonais" invades the work (see Ernst Sheyer, "Far Eastern Art and French Impres-

sionism," *Art Quarterly,* VI [Spring, 1943], 128-129). In addition, the poster quality is strongly marked; it seems as if there can be little doubt that Manet knew when he designed it that it was to be used as an advertisement.

There is a preparatory drawing in gouache and ink for this print (De Leiris 227; formerly Collection Le Garrec; Fig. 121). The two cats appear in the same relative positions as those in the lithograph. Not only is the basic design similar, but the dimensions are almost identical, indicating that Manet may have used a tracing of the drawing to transfer the motif onto the stone.

Technically, the lithograph presents a curious combination of the decorative, two-dimensional, and the more atmospheric, three-dimensional rendering of form. Each cat is drawn with simple outline and there is no modeling within the unbroken contour. The result is that each is a very wittily foreshortened, flattened silhouette. The background, on the other hand, is handled much more atmospherically, perhaps as a means of avoiding an exaggerated flatness, and also perhaps to present in rather deliberately bold form some of the basic concepts of Manet's personal aesthetic.

[164]

PROFILE PORTRAIT OF CHARLES BAUDELAIRE (Figs. 122, 123)

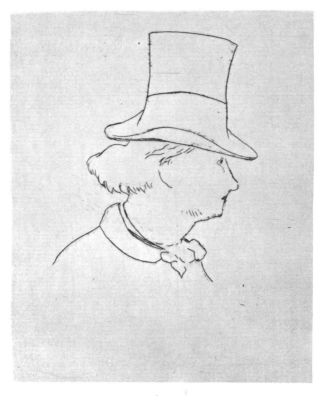

STATE 1

Fig. 122

Etching: two states
Signed upper left in second state with monogram
Dimensions: 108 x 89 mm.
Date: 1869
Editions: 1869 Baudelaire
References: M-N 15; Guérin 31; Rosenthal, 74; Sandblad, 63-66; Hanson, no. 37, p. 61
1st state: The image is drawn with a clean, precise contour. There is no signature.
2nd state: No change in drawing. Addition of monogram signature in upper left corner: an "M" in a box covered with vertical hatchings.

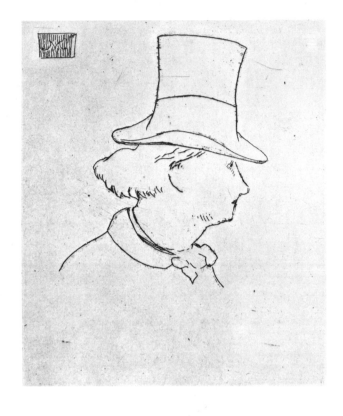

Fig. 123

COMMENTARY: Sandblad believes that this portrait drawing was taken from the 1862 plate at the time of the publication of Asselineau's biography and that the words "Peint et gravé par Manet, 1862" refer to the time when the portrait type was created, not the time of the execution of the etching (see discussion under cat. 21).

A comparison between the 1862 version of this portrait and this version published in 1869 confirms Sandblad's thesis. In the first version, there is a little shading with parallel strokes in the lower part of the hat, the coat collar and tie. These hatchings are completely eliminated in the second version; what remains is a pure outline drawing untouched by shading. In addition, the line used to trace the contour is much more refined, less sketchy, than in the first version. The change in the direction of precision and clarity is entirely consistent with Manet's other efforts of the late '60's. Finally, the addition of the very overtly "Japanese" monogram in the second state adds the ultimate touch consistent with the later dating.

60.

PORTRAIT OF CHARLES BAUDELAIRE, FULL FACE (Fig. 124)

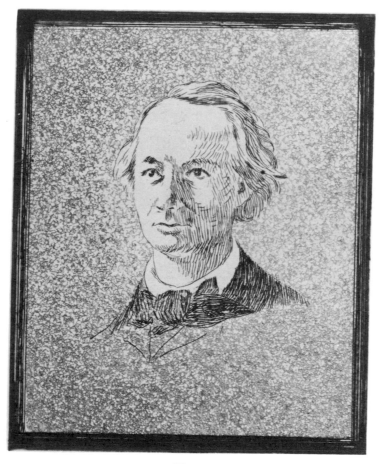

Fig. 124

Etching and aquatint: one state
Unsigned; undated
Dimensions: 113 x 93 mm.
Date: 1869
Editions: none
References: Guérin 37; Sandblad, 64-66

COMMENTARY: The image of the writer is essentially the same as that in cat. 46, which was executed in 1865. It is very likely that the silhouette of the shape was taken from one of the proofs of the first version, for the dimensions of the two prints are almost exactly the same. The image here definitely suggests a posthumous portrait, for the wide and very dark etched frame is a device for framing the portrait of a dead person.

PORTRAIT OF CHARLES BAUDELAIRE, FULL FACE
(Figs. 125, 126, 127, 128)

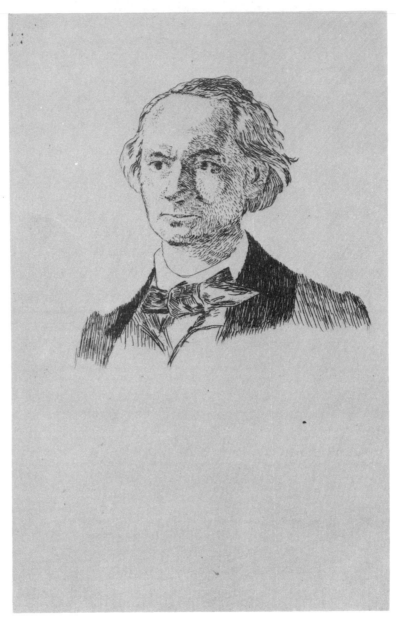

STATE 1 Fig. 125

Etching: four states
Signed in 3rd and 4th states at lower right: "Manet;" undated
Dimensions: 165 x 98 mm. (plate in first three states);
 96 x 82 mm. (plate in 4th state)
Date: 1869
Editions: 1869 Baudelaire
Exhibited: Salon of 1869
References: M-N 16; Guérin 38; Rosenthal, 73; Sandblad, 64-66; Hanson, no.
 39, p. 61
1st state: Only the head of the writer appears here, delineated with fine
 parallel strokes. The background is untouched.

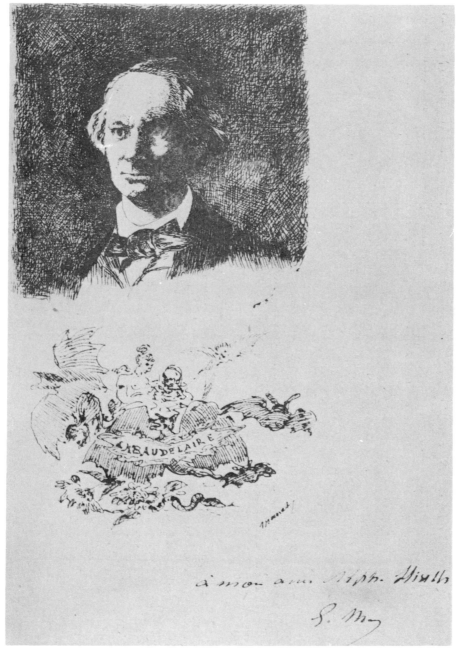

STATE 2

Fig. 126

2nd state: The background has been covered with a dense hatching, while
the whole image is much darkened with the addition of many small
hatchings. The proof of this state, which once belonged to Degas
(here illustrated) contains a pen drawing with a memorial inscription
to Baudelaire.

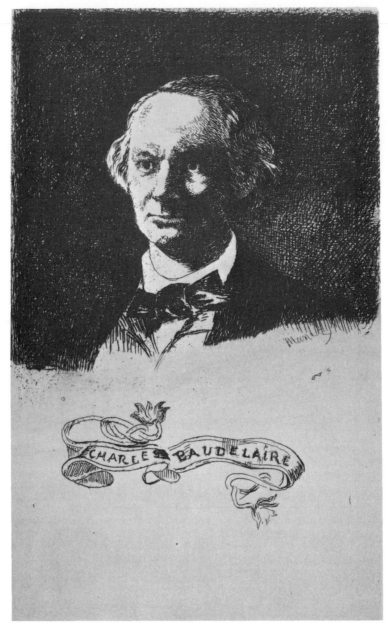

STATE 3

Fig. 127

3rd state: The artist here added on the plate a scroll with Baudelaire's name
and a stylized flower at one end. He also added his signature just
below the dark background area on the right.

4th state: The plate was cut so that the scroll no longer appears. The letters
"Peint et gravé par Manet, 1865" appear in printing at the lower
left.

[170]

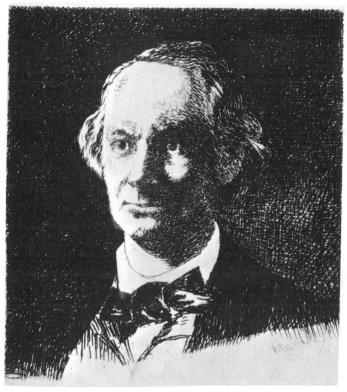

STATE 4

Fig. 128

COMMENTARY: This is the version of the portrait which was published in the 1869 biography. It must have been undertaken after Baudelaire's death, because of the inclusion of the *memento mori* in the 3rd state (see Sandblad).

The handling of this plate corroborates Sandblad's contention that this version was not undertaken until 1869. The devices for achieving tonal variations are similar to those in *The Boy with Soap Bubbles* (cat. 63), but they do not appear in earlier works. In the final version of the plate, the atmospheric quality is achieved with many fine hatchings which are parallel to each other, while the background is covered with a dense network of short cross-hatchings.

62.

THE RABBIT [Le lapin] (Fig. 129)

Fig. 129

Etching and aquatint: one state
Unsigned; undated
Dimensions: 135 x 102 mm.
Date: 1866-1869
Editions: none
References: M-N 64; Guérin 50; Hanson, no. 97, p. 115

COMMENTARY: This etching is taken directly from Manet's oil painting of the *Dead Rabbit* (J. W. B. 129), but the composition is reversed. The oil, probably painted in 1866, was exhibited in Manet's one-man show in 1867 (no. 48). The etching may have been undertaken in 1866, but its style seems later. The etching which it most closely resembles in feeling is *The Boy with Soap Bubbles* (cat. 63), which was done in 1869; like it, *The Rabbit* owes much to Manet's study of Chardin (particularly similar to *The Rabbit* is Chardin's *Hare with a Satchel and Powder-Flask* in the Louvre). Manet's etching also reflects the influence of contemporary printmaking; among Bracquemond's etched works, one finds a print of a dead rabbit (Béraldi 220).

This plate was obviously abandoned because of the failure of the drawing and the aquatint to bite clearly. It is conceived, like the painting which is its source, as a dark picture with light accents emerging from darkness. The subtle variations of lighting which are successfully handled in *The Boy with Soap Bubbles* simply did not materialize satisfactorily in this attempt.

63.

THE BOY WITH SOAP BUBBLES [L'enfant aux bulles de savon][P]
(Figs. 130, 131, 132)

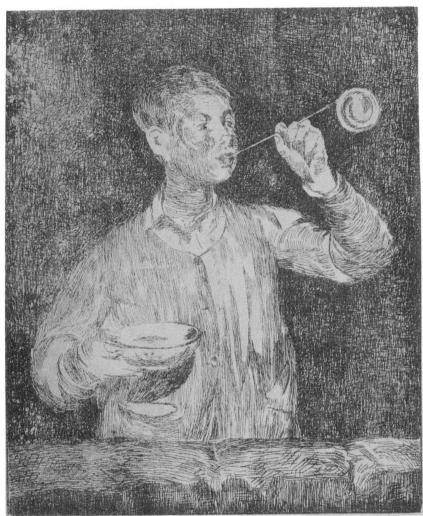

STATE 1 Fig. 130

Etching and aquatint: three states

Unsigned; undated

Dimensions: 249 x 210 mm. (plate); 189 x 162 mm. (composition)

Date: late 1868 or early 1869

Editions: 1890 portfolio; 1894 Dumont; 1905 Strölin

References: M-N 36; Guérin 54; Hanson, no. 98, p. 115

1st state: Very light biting of the whole surface with all basic elements of the picture shown.

2nd state: Whole plate rebitten to reinforce dark areas. Strokes on plate outside of etched frame at four corners, particularly noticeable at upper left corner.

3rd state: Strokes outside of etched frame have been eliminated. The background has light coat of aquatint. There is also aquatint on boy's right hand and in shadow beneath his hand. The Art Institute of Chicago owns a proof of this state, here illustrated, printed in soft

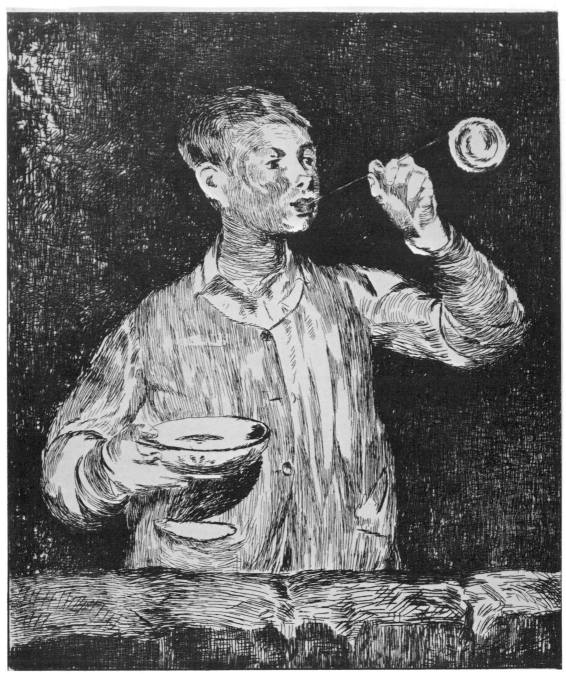

Fig. 131

colors. As the ink was applied *à la poupée,* the colors are soft and
light. The background is brown; the boy's coat and the sill are olive
green; his hands and face are a reddish tone. The bowl contains the
brown background color.

COMMENTARY: The etching is taken from the oil
painting of Léon Leenhof blowing soap bubbles
which was painted in 1868 (J. W. B. 148). The
image is reversed in the print, but otherwise is very
close to the painting. As in the case of *The Rabbit*
(cat. 62), this image is derived from a work by
Chardin, *The Soap Bubbles,* of which there are sev-
eral versions. Manet may have had in mind particu-
larly an engraving of the original version, which
was done in 1739 (Wildenstein, *Chardin,* no. 133).

At first glance, the print resembles more closely
the painterly etchings of 1861 such as *The Boy with*

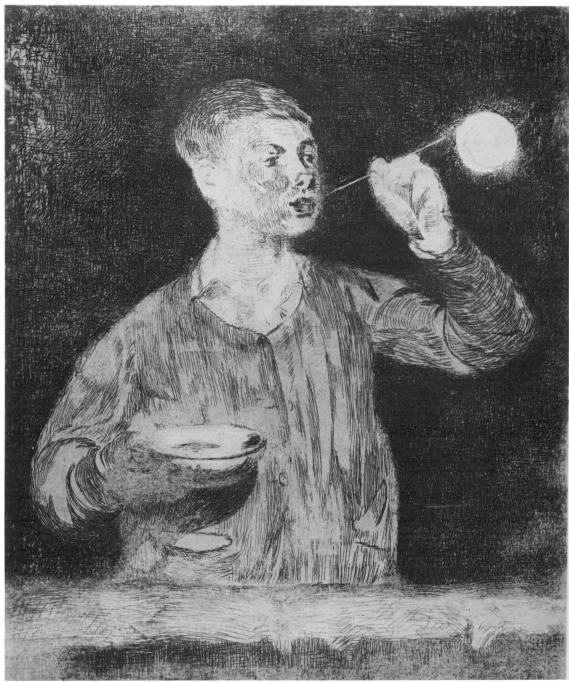

STATE 3

Fig. 132

a *Sword* and *The Urchin* than it does those of the late '60's such as *Exotic Flower* or the *Dead Toreador*. As in the earlier etchings, chiaroscuro and subtle linear variations are used to achieve atmospheric effects, while there seems to be none of the emphasis upon simplified, two-dimensional design that is present in other works of the late '60's. However, actually, the painterly effects in this etching are achieved quite differently. In the first place, lines vary only in direction rather than in depth of biting and length as was true of the early works. There is also a blurring of the distinction between the figure and surroundings by a lack of continuous contour line. In several places the background seems to invade the boy's form. The surface is thus unified as to texture both literally and psychologically.

[175]

64.

THE CATS [Les chats]P (Fig. 133)

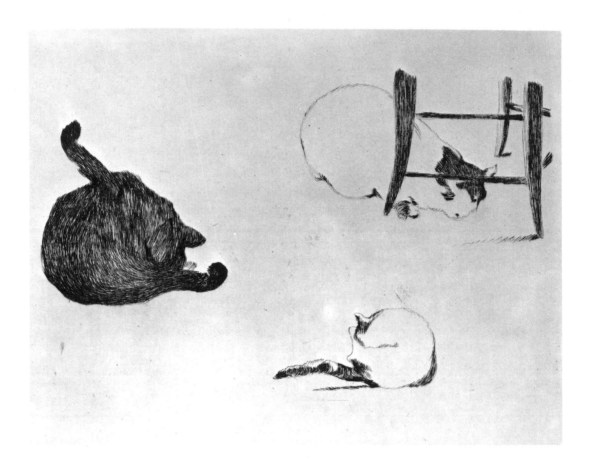

Fig. 133

Etching: one state
Unsigned; undated.
Dimensions: 175 x 218 mm. (plate); 115 x 188 mm. (composition)
Date: 1869
Editions: 1890 portfolio; 1894 Dumont; 1905 Strölin
References: M-N 43; Guérin 52; Rosenthal, 68; Hanson, no. 88, p. 109

Fig. 134

COMMENTARY: This etched sheet may represent an initial working out of ideas for Manet's commission in connection with Champfleury's *Les chats* (see cat. 65). However, for some reason, this plate was never used.

The sheet shows three cats, each isolated from the others, although they are all oriented in the same direction on the page. The cat under the chair was first recorded in a wash drawing in the Cabinet des Estampes of the Bibliothèque Nationale (De Leiris 218; Fig. 134). The black cat at the left of the etching appears in Manet's painting, *Luncheon in the Studio* of 1868 (J. W. B. 149; Neue Pinakothek, Munich).

The isolated motifs used here seem very much like the single images of cats drawn from the sketchbooks of Hokusai and used as little illustrations in the 4th edition of Champfleury's book (see cat. 65). It may be that Manet had in mind some such Japanese reference when he made this etching (see Ernst Sheyer, "Far Eastern Art and French Impressionism," *Art Quarterly,* VI [Spring, 1943], 125, 129).

The handling of this etching is similar in some ways to *Exotic Flower* (cat. 57). The cats' shapes are not outlined, but are separated from the background with a series of short, parallel strokes suggestive of fur. These shapes are of primary importance; there is no modeling within them. The extreme economy of statement is a major debt which Manet owes to Japanese brush drawing.

65.

CAT AND FLOWERS {Le chat et les fleurs} (Figs. 135, 136, 137)

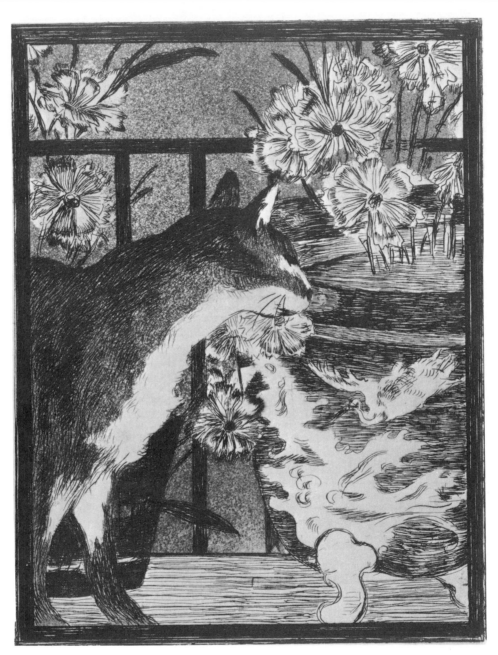

STATE 1 **Fig. 135**

Etching and aquatint: three states

Signed in second state below drawing: "Manet;" undated

Dimensions: 203 x 152 mm. (plate); 165 x 127 mm. (composition)

Date: summer, 1869

Editions: 1870 Champfleury; 1899 Mégnin

References: M-N 19; Guérin 53; Rosenthal, 68; Adhémar, *Nouvelles,* 232;
 Hanson, no. 89, p. 111; Harris, 227-228

1st state: Whole design is worked out, but certain details are not yet included.
 The floor is mostly light, covered with widely spaced, horizontal lines.

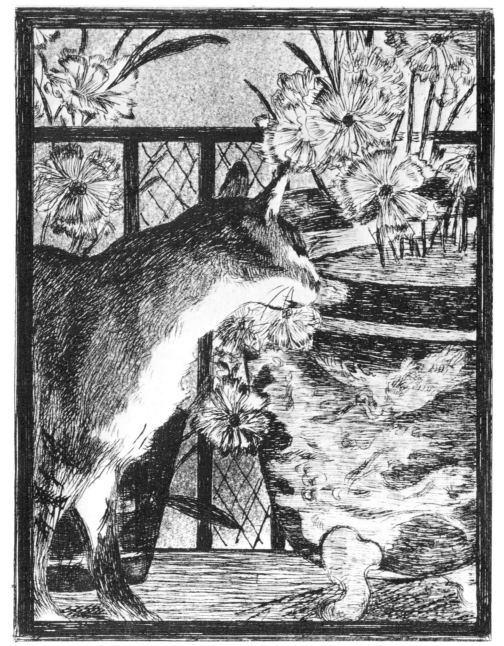

Fig. 136

Portions of the vase are untouched. The spaces between vertical rail-
ings are not filled in. A proof in the Cabinet des Estampes in the
Bibliothèque Nationale contains dark areas of wash on the floor, the
vase, and the flowers.

2nd state: Additional strokes on floor and on light areas of the vase. Signed
lower left outside frame. A proof of this state in the Prints Division
of the New York Public Library shows diagonal lines drawn in
between the railings of the fence in pen and some areas on the body
of the cat darkened with wash.

3rd state: Additional hatching on the floor, on the vase, and between the rail-
ings. The flowers are changed somewhat; some have more shading,
some less. Three different editions of this state were made, each of
which has different lettering. Two editions were issued for Champfleury's
book. On the first of these is printed, below the picture in the center:

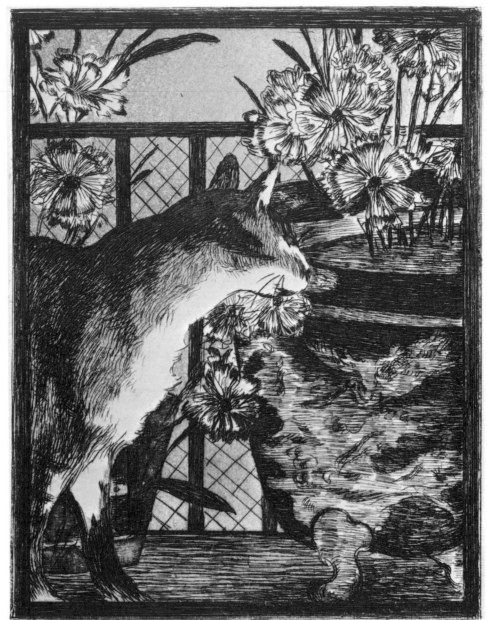

STATE 3

Fig. 137

"Le chat et les fleurs." On the second edition for Champfleury's book above the picture is printed: "Champfleury: Les Chats," and below in the center: "Le Chat et les Fleurs," and beneath this: "Imp. Cadart et Luce," and at the right: "J. Rothschild, éditeur." The third edition was made for Mégnin's book. In some of these prints the title "Champfleury: Les Chats" has been removed; in some, the name of the printer Cadart.

COMMENTARY: This illustration, like the lithograph of the *Cats' Rendezvous* (cat. 58), shows traces of Japanese influence, both in the deliberate flatness of the spatial arrangement and in the actual drawing of individual elements of the design (see Ernst Sheyer, "Far Eastern Art and French Impressionism," *Art Quarterly,* VI [Spring, 1943], 125, 129; W.

Seidlitz, *A History of Japanese Colour Prints,* London, 1910, opp. 60, illustrates a woodcut of a vase of flowers by Haronobu which is very similar to the vase of flowers in Manet's etching).

Along with the decorative pattern effects, however, Manet also employs some rather freely drawn and widely spaced strokes to describe the flowers.

These strokes help to animate the surface and to relieve the monotony of the uniform aquatinting.

Compositionally, this is one of Manet's most subtle combinations of complex and simple. The silhouetting of the flat area of the cat's shape against a "busy" background presents some visual confusion, for the spectator's attention is often distracted from the simple, easily grasped shape of the cat and of the railings to the more intricate lines and rhythms of the flowers and the diamond shapes between the railings. Manet has thus reversed what is a more normal figure-ground relationship (i.e., with the more complex description of form being in the foreground and the simple, more broadly handled forms behind) and prepares the way for a new treatment of pictorial space which was to be further exploited in his paintings of the seventies, such as *The Railroad* (J. W. B. 23), *Skating* (J. W. B. 279), *In the Conservatory* (J. W. B. 296), *Spring* (J. W. B. 470), and *The Bar at the Folies-Bergères* (J. W. B. 467).

AT THE CAFE [Au Café] (Fig. 138)

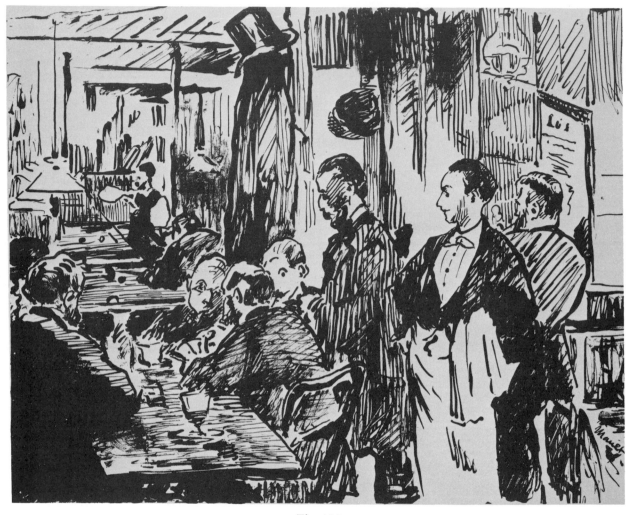

Fig. 138

Transfer lithograph
Signed lower left: "Manet;" undated
Dimensions: 263 x 332 mm.
Date: 1869
Editions: none
References: M-N 88; Guérin 81; Hanson, no. 93, p. 113

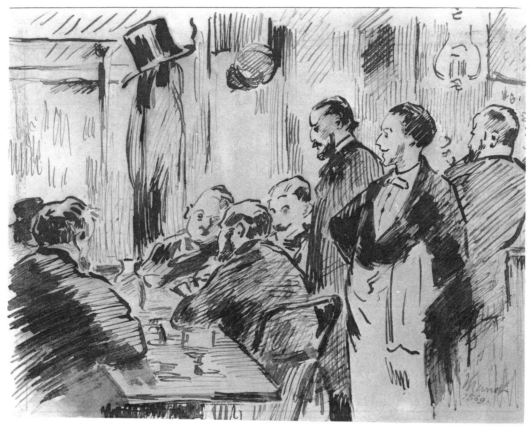

Fig. 139

COMMENTARY: This is the first of two versions of a café scene taken from a drawing in the Fogg Art Museum (De Leiris 238; Fig. 139), which is signed and dated 1869. These two works represent Manet's first attempts at a large-scale work in transfer lithography.

The composition of this print is unusual in some respects for this date in Manet's career, for it exhibits a more diffuse character than the other prints of the late '60's. Although there is a dominant direction in space established on the left back to the billiard table, the directional pull is somewhat offset by a diversion of attention into the space on the right. This scattering of focus is seen in earlier works of the decade, such as the gouache of the *Race-Track at Longchamps* of 1864 in the Fogg Art Museum, and *Concert in the Tuileries* of 1862 in the National Gallery, London, as well as in contemporary works such as *Departure of the Folkestone Boat* (J. W. B. 163; Philadelphia Museum of Art), but it is not seen at all in other graphic works of the period.

67.

AT THE CAFE [Au Café] (Fig. 140)

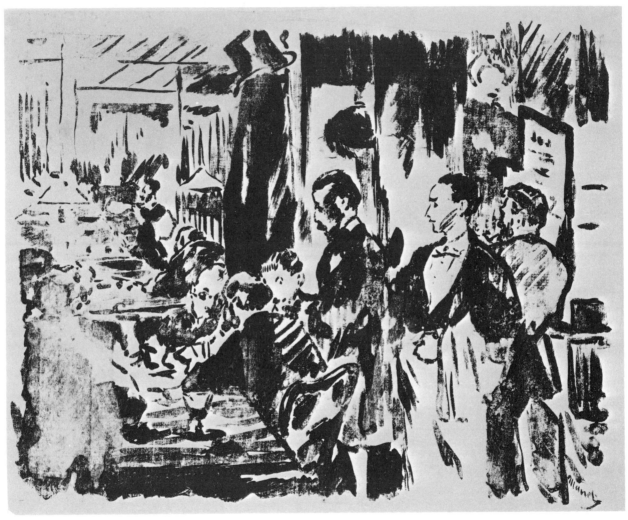

Fig. 140

Transfer lithograph
Signed lower right: "Manet;" undated
Dimensions: 270 x 353 mm.
Date: 1869
Editions: none
References: Guérin 80; Hanson, no. 94, p. 113

COMMENTARY: This is the second version of the lithograph which Manet made using as a study a drawing in the Fogg Art Museum. Here we find that Manet has simpified the description of shapes and modeling of forms as compared with the treatment in the first print. This simplification is char-acteristic of Manet's procedure when dealing with successive versions of the same motif. For an analogous development in treatments of a theme, see J. Harris, "Manet's Race-Track Paintings," *Art Bulletin,* XLVIII (1966), 78-82.

68.

PROFILE OF EVA G. TURNED TO THE LEFT^P (Fig. 141)

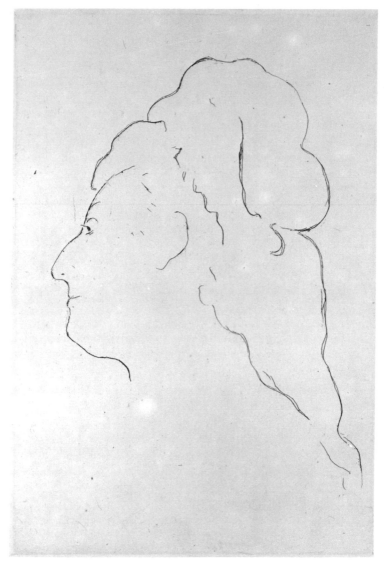

Fig. 141

Etching: one state
Unsigned; undated
Dimensions: 240 x 158 mm.
Date: 1870
Editions: 1894 Dumont; 1905 Strolin
References: M-N 44; Guérin 57; Rosenthal, 76; Hanson, no. 111, pp. 125-26

COMMENTARY: This portrait motif is taken from the oil version which Manet painted of his pupil and exhibited at the Salon of 1870 (J. W. B. 174). The image is reversed from the way it appears in the painting.

The linear elegance and purity of this conception is similar to what Manet had already employed in his second plate of the profile of Baudelaire (cat. 59).

In a sense, this interest in the descriptive power of pure line is a complement to the interest in bold, vigorous contrast of shape and values achieved without the use of line. This version of the profile of Eva is probably the first version, since the line in some places is repeated or doubled and reworked to reinforce its direction and shape.

69.

PROFILE OF EVA G. TURNED TO THE RIGHT (Fig. 142)

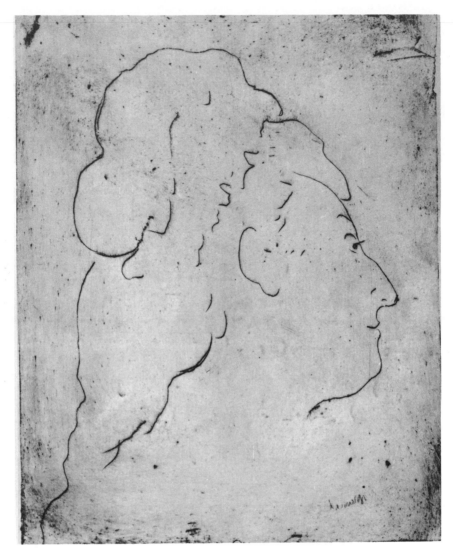

Fig. 142

Etching: one state
Signed right in reverse: "Manet;" undated
Dimensions: 199 x 158 mm.
Date: 1870
Editions: none
References: M-N 72 bis; Guérin 56; Rosenthal, 76

COMMENTARY: This version of the profile portrait must have been taken from a proof of the first version (cat. 68). The drawing on the plate may in fact have been done by means of a tracing, since the two images are exactly the same size. Here the lines are all single and thus appear to be more assured in rendering, like the line in the second plate of the profile portrait of Baudelaire (cat. 59).

LINE IN FRONT OF THE BUTCHER SHOP
[Queue devant la boucherie]P (Fig. 143)

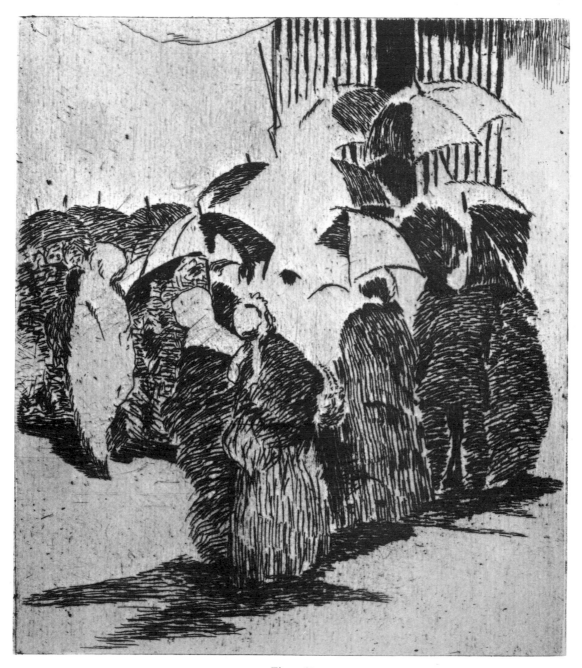

Fig. 143

Etching: one state
Unsigned; undated
Dimensions: 169 x 146 mm.
Date: 1870
Editions: 1890 portfolio; 1894 Dumont; 1905 Strolin
References: M-N 45; Guérin 58; Rosenthal, 145; Hanson, no. 114, p. 131;
 Isaacson, no. 32, p. 39

COMMENTARY: This plate seems to have been etched during the terrible four-month siege of Paris in 1870. Manet's letters to his wife during this period are filled with tales of the scarcity of meat, so it has been assumed that the etching depicts a line in front of a butcher shop, although there is nothing in the print specifically to confirm this identification. As this etching was not carried beyond the initial stages, it cannot be discussed as if it were in publishable condition. Nevertheless, enough is represented to allow us to draw some conclusions as to its composition and general thematic treatment. As in the transfer lithographs of *At the Café* of 1869, there is a deliberate scattering of focus in this depiction, although it is perhaps less pronounced than in the earlier print. The movement into depth on the right side of this etching is less emphatic than on the left, and the figures in the foreground move with the whole group to the right. The grouping seems to have been determined by an underlying geometric configuration, a feature which is not seen in Manet's other compositions of contemporary activity (the underlying form is of a V lying on its side).

The handling of this etching is not unlike some of the earlier Goyaesque prints (for an interesting discussion of possible Spanish sources of this work, see Isaacson, no. 32). The hatching, which is only sketchily indicated in this initial state, gives the bulk of the forms by strokes which define areas, not outlines. It seems justifiable, despite the incomplete nature of this plate, to infer from what is rendered that the tonal relationships were to have been bold and uncomplicated and that shapes would have retained their identity as was true in most of the prints of 1868 and 1869.

71.

THE BARRICADE {La barricade} (Fig. 144)

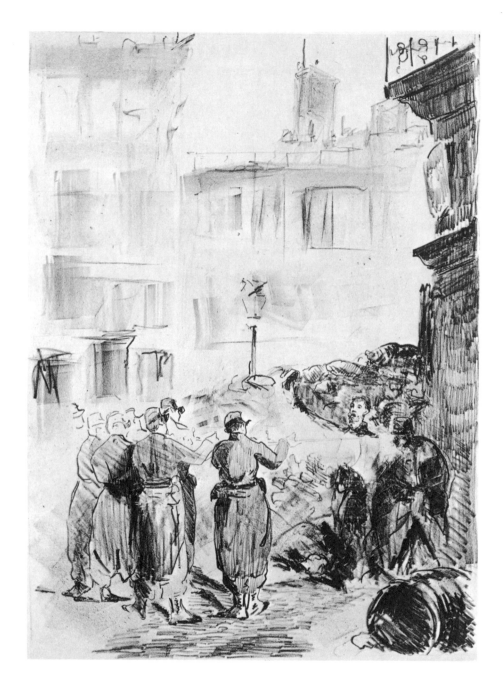

Fig. 144

Lithograph: two printings
Unsigned; undated
Dimensions: 460 x 333 mm.
Date: 1871
Editions: 1884 Memorial
References: M-N 82; Guérin 76; Rosenthal, 86-88, 157-158; Hanson, no. 115,
 p. 131; Isaacson, no. 34, p. 40
1st printing: without letters, a few trial proofs
2nd printing: with letters, bottom center, "Imp. Lemercier et Cie., Paris."
 According to Guérin, some examples of this printing also occur with
 letters covered up.

COMMENTARY: Both this and the following lithograph deal with subjects inspired by the events of the civil war in Paris when the National Guard was engaged in suppressing revolutionary factions. This print illustrates what was undoubtedly a rather common scene in those days, a group of soldiers executing a band of rebels on a street corner. As in the picture which formed the pictorial source for this print, *The Execution of Maximilian,* Manet's sympathies seem to be with the rebels rather than with the executioners. That Manet's sympathies lay in this direction is attested in a letter from Mme. Morisot to Berthe, dated June 5, 1871: "Tiburce [Morisot, Berthe's brother] has met two Communards, at this moment when they are all being shot. . . Manet and Degas! Even at this stage they are condemning the drastic measures used to repress them" (*Correspondence of Berthe Morisot,* comp. and ed. by D. Rouart, trans. by Betty W. Hubbard, New York, 1957, 63). Mr. Robert Walker of Swarthmore College has in his possession a proof of *The Barricade* inscribed by Manet to Tiburce, which may indicate that Manet thought of this print as a sort of protest against the drastic measures being taken by Government forces against the rebels.

Although this composition repeats the figure grouping used in *The Execution of Maximilian,* several significant differences are seen. Some elements of the earlier picture are completely suppressed; for instance, there are only six soldiers represented whereas in the original eight were shown. In addition, only one of the victims of the firing squad is shown at all clearly, as opposed to three in the earlier work. More important than the elimination of these figures, however, is the change in composition and in the manner of handling the crayon. The format has been changed from a horizontal to a vertical shape, providing additional space around the figures. In addition, this lithograph is much more sketchily handled with areas of tone used rather

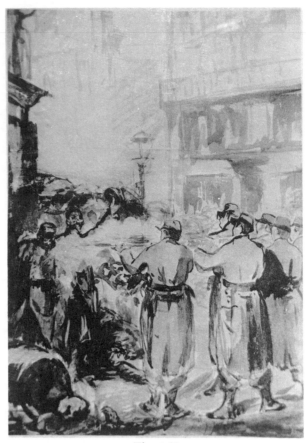

Fig. 145

than hatchings to achieve shading. This sketchy handling gives the print a quality of on-the-spot reportage not found in the earlier execution scene. A preliminary study for this print in the Museum of Fine Arts, Budapest (De Leiris 342; Fig. 145), is so similar in its dimensions to the lithograph that it suggests Manet used a tracing to transfer the main shapes onto the lithographic stone.

72.

CIVIL WAR [Guerre civile] (Fig. 146)

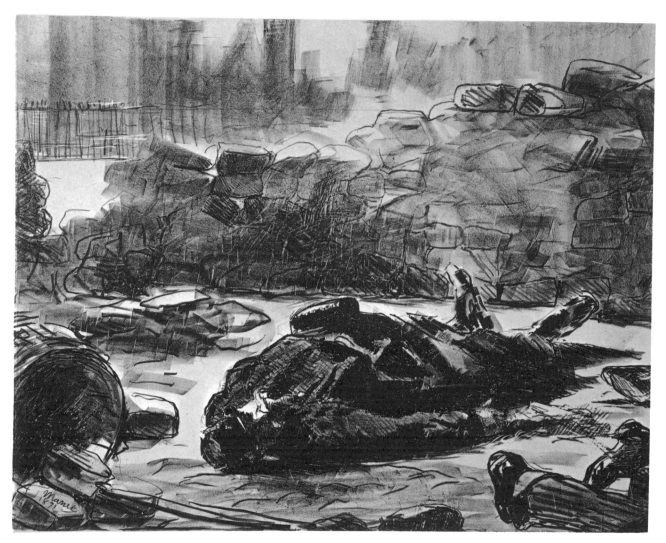

Fig. 146

Lithograph: two printings

Signed and dated lower left: "Manet 1871"

Dimensions: 394 x 505 mm.

Editions: 1884 Memorial

References: M-N 81; Guérin 75; Rosenthal, 86-88, 157-158; Hanson, no. 116,
 p. 131; Isaacson, no. 33, p. 40

1st printing: without letters, rare.

2nd printing: with letters, at bottom center, "Guerre civile;" at left, "Tiré à
 cent exemplaires;" at right, "Imp. Lemercier et Cie., Paris." Accord-
 ing to Guérin, some examples printed with letters covered up.

COMMENTARY: Like the preceding work, this lithograph repeats in modified form an image that Manet had created earlier, *The Dead Toreador*. However, the quotation here was probably not motivated by political reference as was the case with the repetition of the group from *The Execution of Maximilian* in *The Barricade*, but by primarily pictorial needs. It should be noted that the general conception, the dead figure lying in front of a wall, is very similar to a widely circulated photograph of a dead Confederate soldier taken on a battlefield of the American Civil War in 1863 by Alexander Gardner. Manet may have seen this photograph and been reminded of his own earlier image of a dead figure, which he then reworked in this print. It is also quite clearly reminiscent of Daumier's lithograph of the *Rue Transonain* (see Michael Fried, "Manet's Sources: Aspects of His Art 1859-1865," *Artforum*, VII [March, 1969], 76). Manet did not show only the dead soldier but included a pair of legs protruding from the lower right which, in their striped pants, clearly are identifiable as belonging to a civilian. This inclusion reinforces the commentary upon the horrors of war.

The composition is more restricted spatially than *The Barricade*, the movement being limited by the wall behind the dead soldier. The suggestion of atmosphere is just as impressively handled as in *The Barricade* by wide strokes with the side of the crayon. These strokes are combined with sketchy lines which are even more economically rendered, suggesting perhaps even greater control of the technique.

PORTRAIT OF BERTHE MORISOT (Fig. 147)

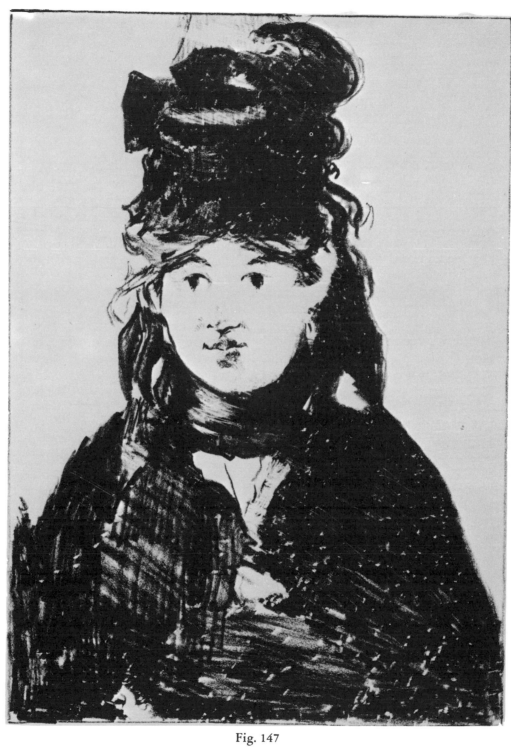

Fig. 147

Lithograph: two printings
Unsigned; undated
Dimensions: 204 x 141 mm.
Date: 1872
Editions: 1884 Memorial
References: M-N 83; Guérin 77; Rosenthal, 85-86; Hanson, no. 108, p. 125

1st printing: without letters, a few trial proofs
2nd printing: with letters at bottom center, "Imp. Lemercier et Cie., Paris."
According to Guérin, some examples printed with letters covered up.

COMMENTARY: This image, and the next two, cat. 74 and 75, were taken from an oil portrait which Manet executed in 1872 (J. W. B. 208). This version may have been transferred to the stone by means of a tracing from a photograph of the picture, for the image is not reversed and the contours are very similar to those in the oil.

As in the painting, the lithograph reproduces the strong value contrasts of the oil, but reduces their variety. The face is not modeled; its features are economically suggested with a few bold strokes. In the rendering of costume, the handling of the crayon is bold and vigorous, although line is not allowed to dominate as independent accent. The strokes used in the dress, for instance, while they do not follow the planes of the form, remain as suggestive of tone rather than of linear rhythms. A comparison of this lithograph with the print of *The Urchin* of 1862 (cat. 30) to which it has some similarities, reveals the greater breadth and vigor as well as the greater confidence with which Manet is handling these devices in his later work. He seems less intent here upon depicting details of texture and interior modeling than in the earlier work. Thus, the image is more immediate in its impact, with attention concentrated upon the whole rather than upon parts.

74.

PORTRAIT OF BERTHE MORISOT (Fig. 148)

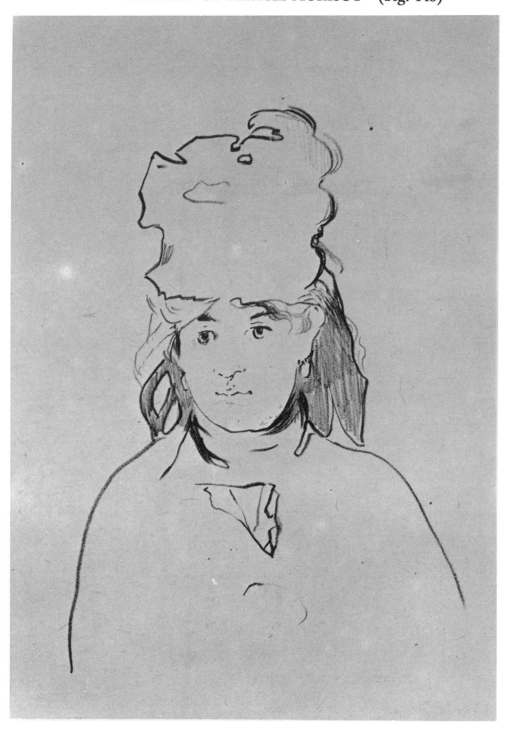

Fig. 148

Lithograph: two printings
Unsigned; undated
Dimensions: 190 x 135 mm.
Date: 1872
Editions: 1884 Memorial
References: M-N 84; Guérin 78; Rosenthal, 85-86; Hanson, no. 109, p. 125

1st printing: without letters, several trial proofs on China paper in larger
 size than 2nd printing.
2nd printing: with letters, bottom center, "Imp. Lemercier et Cie., Paris."
 According to Guérin, some examples printed with letters covered up.

COMMENTARY: This version of the oil portrait of Berthe Morisot is entirely linear in character, reproducing only the minimal outline of shapes to bring out the form. De Leiris suggests that this print was traced from a photograph of the painting. The treatment of the portrait in terms of pure line is not unlike what Manet used in the profile portraits of Eva Gonzales and Baudelaire. There is also a similarity to the handling of the white cat in the *Cats' Rendezvous* of 1868 (cat. 58). In all of these prints, Manet focuses interest upon the shape of the image by means of contour alone.

This lithograph provides an interesting comparison with the other version of the subject above. In each, Manet concentrates upon the two-dimensional silhouette and the reduction of three-dimensional to two-dimensional form. The contrasting methods of achieving this aim illustrate Manet's keen understanding of the special problems inherent in the black and white media and his willingness to experiment with as great a variety of effects as possible.

PORTRAIT OF BERTHE MORISOT (Figs. 149, 150)

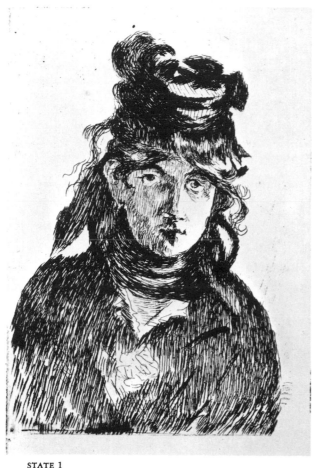

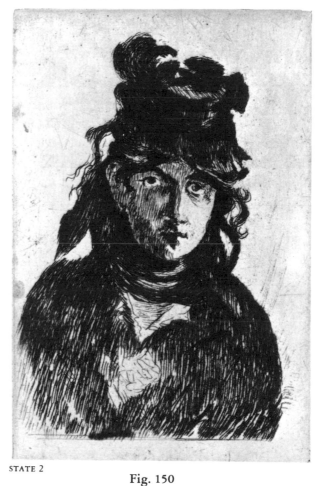

STATE 1 **Fig. 149**

STATE 2 **Fig. 150**

Etching: two states
Unsigned; undated
Dimensions: 120 x 79 mm.
Date: 1872
Editions: 1890 portfolio; 1894 Dumont; 1905 Strölin
References: M-N 41; Guérin 59; Hanson, no. 107, p. 125
1st state: The figure is defined in terms of long, vertical strokes with no
 cross-hatching or use of outline. The area of the hat is very dark; the
 dress is lighter with widely spaced lines.
2nd state: The whole image has been made darker with more densely spaced,
 parallel strokes, especially on the dress and the left side of the face.
 The silhouette of the figure is, however, unchanged in shape.

COMMENTARY: Like the two preceding prints, this etching comes from the oil portrait of Berthe of 1872, but is smaller in scale and the image is reversed as compared with that in the oil.

In the etching, Manet rejects to some extent the varied vocabulary of stroke which he used in *The Boy with Soap Bubbles* of 1869 in favor of a more simplified rendering with long, uniformly fine, vertical lines, similar to the handling in *The Philosopher* of 1866. Despite the similarity to the latter, however, the total effect is different, for the form is less confined within a simple silhouette. Many wispy shapes, the ribbons and the hair, break the simple contour. Yet these lines do not function as independent calligraphic accents, but retain their functions as delineators of the characteristic elements of Berthe's appearance.

PORTRAIT OF NINA DE CALLIAS (Figs. 151, 152)

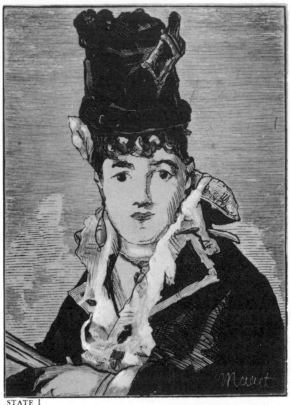

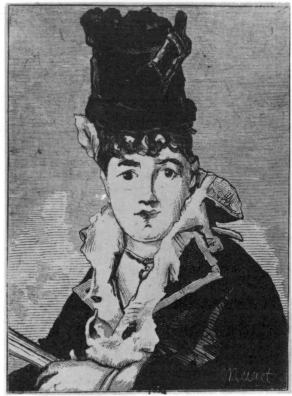

STATE 1

Fig. 151

STATE 2

Fig. 152

Wood engraving by Prunaire from drawings by Manet: two states
Signed lower right: "Manet;" undated
Dimensions: 102 x 76 mm.
Date: before February, 1874
Editions: none
References: M-N 100; Guérin 92; Hanson, p. 139
1st state: Printed in black. The image is broadly indicated in simple, bold
 areas of contrasting tones. From the woman's right ear is suspended
 a pear-shaped earring. The proof of this state here illustrated is
 touched with white gouache on the collar.
2nd state: The earring has been eliminated, as has some of the shading on
 the collar, to correspond with the corrections shown in the proof men-
 tioned above. This state is printed in red.

COMMENTARY: This wood engraving was intended for publication in *Revue du Monde Nouveau,* but was not used. It was probably executed at the same time as *La Parisienne* (cat. 77 and 78), the second version of which did appear in the periodical in March, 1874.

For this print, Manet actually made a gouache drawing on wood, which is today preserved in the Cabinet des Dessins in the Louvre. Prunaire made the final plate by photographically transferring Manet's drawing onto another wood block.

Nina de Callias, who was estranged from her husband, Hector Callias, was the *grande dame* of a famous literary salon in Paris. She was a great friend of Charles Cros, the poet and editor of *Revue du Monde Nouveau,* where Manet's wood-engraved portrait of her appeared.

77.

LA PARISIENNE [Mme. de Callias] (Fig. 153)

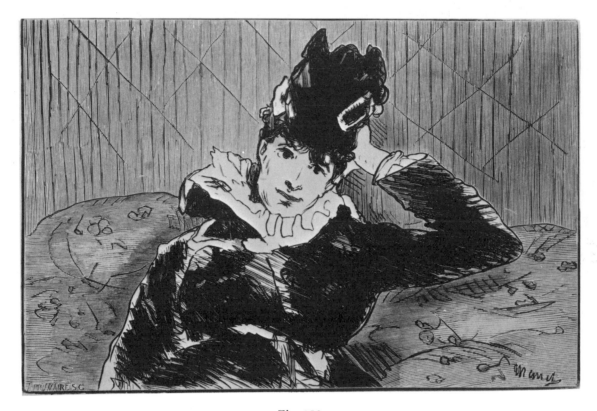

Fig. 153

Wood engraving by Prunaire from a drawing by Manet: one state
Signed lower right: "Manet;" at lower left: "A Pruaire sc."
Dimensions: 100 x 149 mm.
Date: 1874
Editions: none
References: M-N 99; Guérin 90; Rosenthal, 102; Hanson, p. 139

COMMENTARY: This print reproduces a portion of the oil portrait of Nina de Callias called *Woman with the Fans* (J. W. B. 237; Louvre Museum, Paris). This is the first of two versions of the subject which were executed from the painting. The second, cat. 78, includes a fan behind the figure which is not seen here.

LA PARISIENNE [Nina de Callias] (Fig. 154)

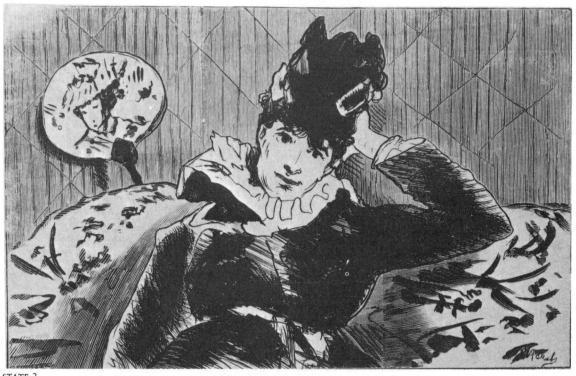

STATE 2

Fig. 154

Wood engraving by Prunaire from a drawing by Manet: two states
Signed lower right: "Manet;" lower left: "A. Prunaire sc."
Dimensions: 100 x 153 mm.
Date: 1874
Editions: 1874 Nina
References: M-N 99; Guérin 91; Hanson, p. 139; Isaacson, no. 35, pp. 40-41
1st state: (Guérin's description) The background is similar to that in the
version cited above except for the addition of a fan. The couch cover
here is white with black designs.
2nd state: On the fan, a face is drawn, which is not true in the first state.
Otherwise, the drawing is the same.

COMMENTARY: This wood engraving appeared in *Revue du Monde Nouveau* as an accompaniment to a poem by Charles Cros entitled "Scene in the studio" ("scène d'atelier"). The poem describes Nina posing for Manet at the end of 1873 (Charles Cros, *Oeuvres complètes,* Paris, 1964, 560).

As in the portraits of Berthe Morisot, Manet made use of the device of juxtaposing areas of sharply contrasting value in order to focus attention upon the silhouette. There is little modeling or textural variation within the silhouette and only three values, black, white, and gray, are used. The drawing of form is restricted to a few bold areas so that only the image as a whole is emphasized.

ILLUSTRATIONS for "LE FLEUVE" by Charles Cros (Figs. 155a-h)

CHARLES CROS

LE FLEUVE

EAUX-FORTES D'ÉDOUARD MANET

PARIS

LIBRAIRIE DE L'EAU-FORTE

61, rue Lafayette, 61.

Fig. 155a

Etching and aquatint
Editions: 1874 Cros
References: M-N 23-40; Guérin 63; Rosenthal, 147-148; Hanson, no. 132,
 p. 149; Harris, 228-29; Isaacson, no. 36, p. 41

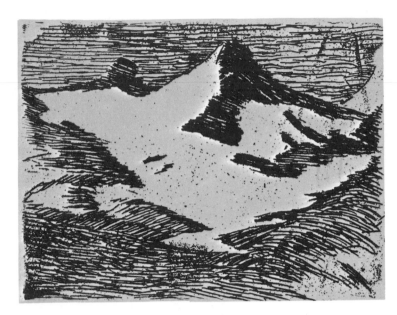

Fig. 155b

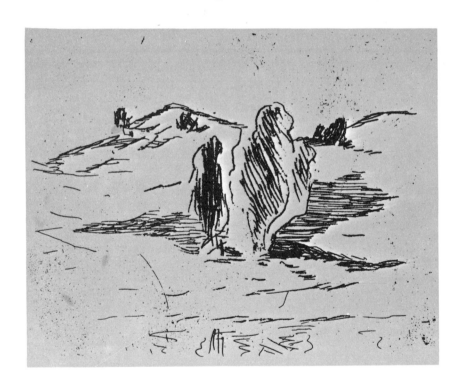

Fig. 155c

a) The dragonfly
 30 x 53 mm.

b) High mountains
 74 x 94 mm.

c) High valley
 65 x 100 mm.

d) River in the plain
 76 x 96 mm.

e) Parapet of the bridge
 74 x 125 mm.
 Signed with small M

f) Under the arch of the bridge
 116 x 155 mm.
 Signed at top: "M"

g) The sea
 75 x 125 mm.

h) Swallows
 34 x 51 mm.

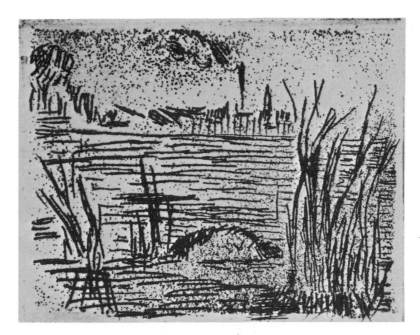

Fig. 155d

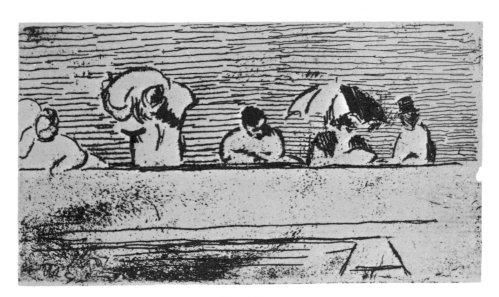

Fig. 155e

Rejected plates (Figs. 156a-d

a) The dragonfly c) River in the plain
 47 x 60 mm. 115 x 88 mm.
b) High mountains d) Under the arch of a bridge
 80 x 104 mm. 130 x 146 mm.

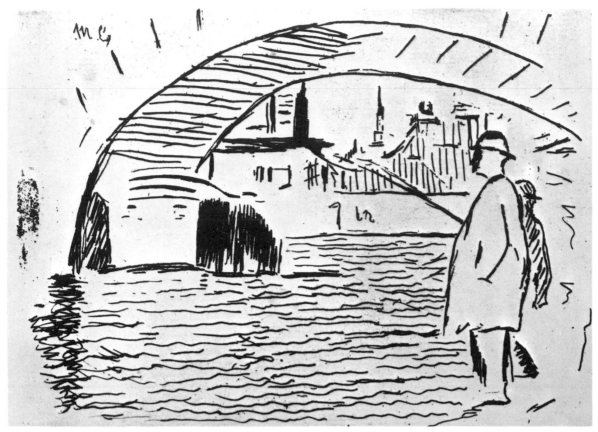

Fig. 155f

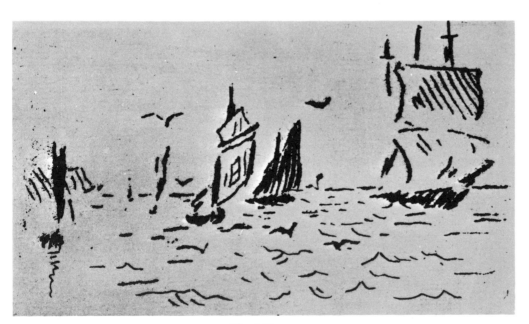

Fig. 155g

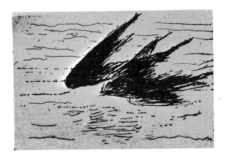

Fig. 155h

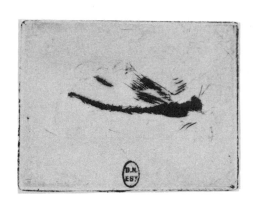

Fig. 156a

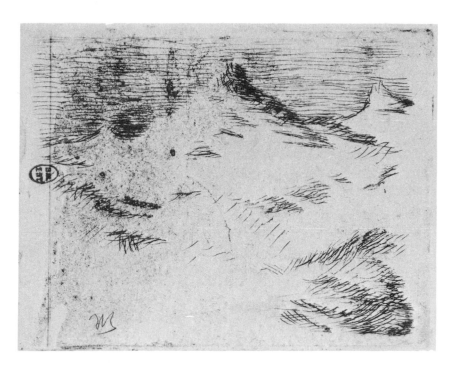

Fig. 156b

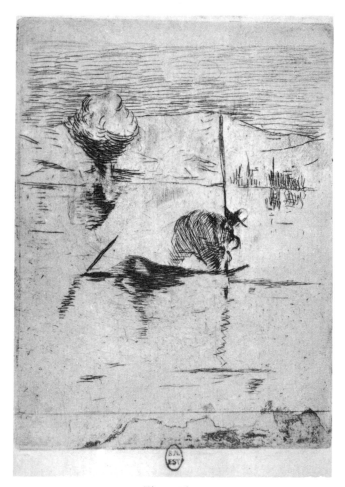

Fig. 156c

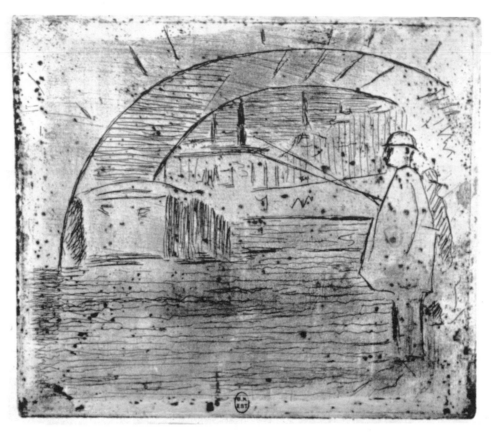

Fig. 156d

COMMENTARY: Cros originally dedicated *Le Fleuve* to Manet, but then changed his mind. However, he did dedicate two other poems to the painter, "Transition" and "Scène d'atelier" (see cat. 78).

Although these little etchings do not directly illustrate the poetry, they represent direct expressive images which suggest the themes treated in the poem. They are intended to delight the eye and to enhance the pages of print. In addition, each has its own special motif and handling, something which distinguishes it from the others (for a full discussion of the style of these works and their position in the development of Manet's art as an illustrator, see Harris, 228-229).

The four landscape views most strikingly resemble in their sketchy vivacity a series of "croquis à l'eau-forte" by Daubigny, etched in 1862, entitled *Voyage en Bateau* (Delteil 99-115). In addition, the scene of *High Mountains* resembles quite closely certain photographs of Mont Blanc which had been taken by the Bisson brothers and published in 1860, while the remaining vignettes are handled in the manner which is found in the pencil drawings in Manet's sketchbooks.

Finally, the two little end pieces, the *Dragonfly* and *Swallows,* seem to have been inspired in part by drawings such as those by Hokusai in the *Manga,* one of the first Japanese publications to have become known in Europe. In Ernest Chesneau's article in the *Gazette des Beaux-Arts* entitled "Le Japon à Paris" (tome 18, 2 per., 1878, 389), there is reproduced one of the images from Hokusai's woodcut books reported as belonging to Philippe Burty. There are also several figures from the *Manga* illustrated in Théodore Duret, *Les livres illustrées* (Paris, 1884), although none of them is exactly like either of Manet's images.

80.

POLICHINELLE (Figs. 157, 158)

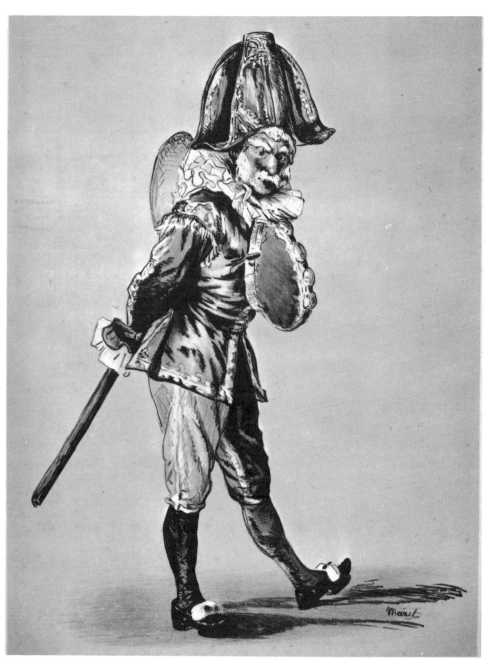

Fig. 157

Lithograph in seven colors: three states known
Dimensions: 460 x 335 mm.
Signed lower right: "Manet;" undated
Date: 1874 and 1876
Editions: 1876 Polichinelle
References: M-N 87; Guérin 79; Rosenthal, 93-94; Adhémar, *Nouvelles,*
 232-33; Hanson, no. 140, pp. 153-54
1st state: Only the black areas are drawn in.

2nd state: All the colors now put in. No letters.

3rd state: Two printings. 1st printing: with letters, at bottom left, "Imp. Lemercier et Cie.;" at the bottom center, "tiré à 25;" beneath in the center two lines of verse by Théodore de Banville. 25 examples on Japan, numbered and signed "E.M."

2nd printing: not numbered (total number not known), on white paper, much cruder colors than preceding printing.

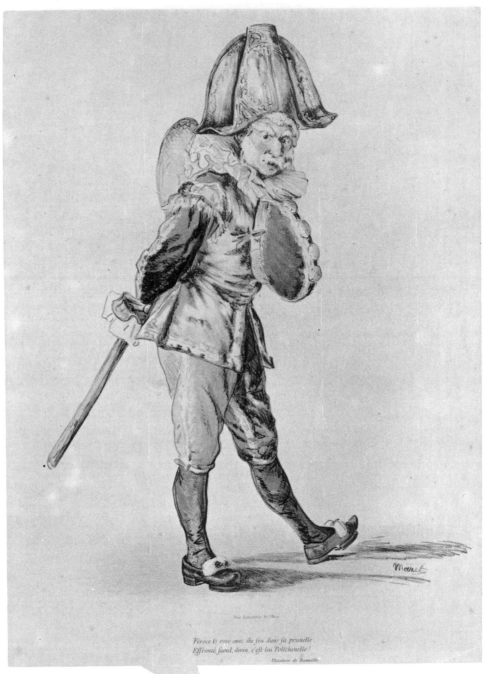

STATE 3

Fig. 158

COMMENTARY: This color lithograph is a reproduction of a motif first executed in watercolor and exhibited at the Salon of 1874 (De Leiris 416, Collection Brodin, Paris).

According to the letter of March, 1874, addressed to the engraver, Prunaire, cited in Adhémar, Manet was working on the stones in that year. Proust also says he held a competition for some verses to accompany the print at that time, but nothing came of it. Manet then requested Théodore de Banville to write some lines. Apparently, the print was to have been issued finally in 1876 in 8,000 examples for subscribers of *Le Temps,* but the authorities thought it was a caricature of General Mac-Mahon and forbade its publication.

81.

Frontispiece for an edition of "LES BALLADES" by Théodore de Banville
(Fig. 159)

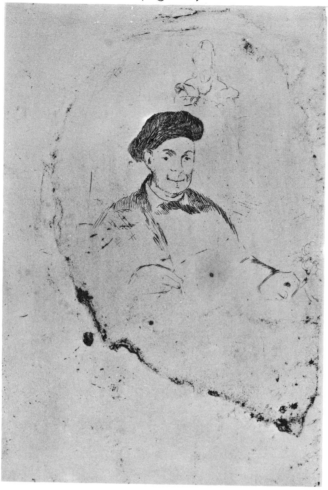

Fig. 159

Etching: one state
Unsigned; undated
Dimensions: 241 x 159 mm.
Date: summer, 1874
Editions: none
References: M-N 67; Guérin 60; Hanson, no. 138, p. 153

COMMENTARY: There are two pencil and wash sketches for this commission in existence (De Leiris 421, Collection E. Rouart; and 422, Cabinet des Dessins, Louvre Museum, Paris). This version of the etching clearly did not come to anything and was abandoned.

It is unclear whether Manet himself sought out this commission or whether he was asked by the publisher to do a frontispiece. In any case, he wrote to de Banville at the time about his conception, which we see represented in this and the following plates:

"Cher monsieur, j'ai envie de faire pour le livre des Ballades l'assembleur de rimes Banville à sa table, écrivant et fumant une cigarette. Dans la fumée qui s'en ira en spirales, j'indiquerai par de petites figures, les principales pièces de livre. Si cela vous va, j'irais faire un croquis chez vous à votre heure et le jour que vous voudrez" (quoted in Guérin 60).

It seems as if it must be more than mere coincidence that Mallarmé used exactly this image in one of his poems of *Hommage,* published in *Le Figaro* on August 3, 1895 (Mallarmé, *Oeuvres complètes,* Paris, Gallimard, 1945, 73, "Toute l'âme résumée").

Frontispiece for an edition of "LES BALLADES" by Théodore de Banville[P]
(Fig. 160)

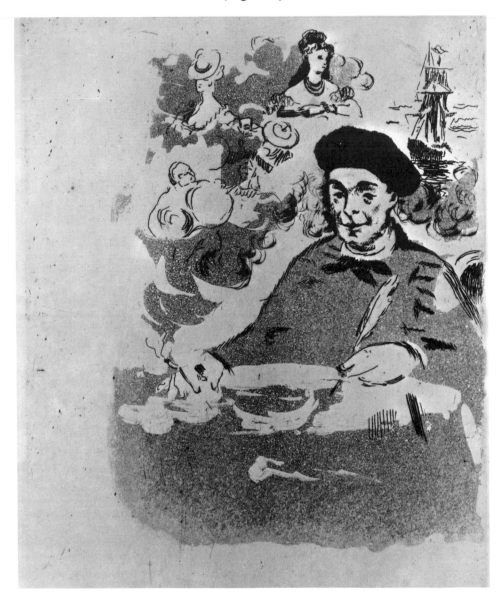

Fig. 160

Etching and aquatint: one state
Unsigned; undated
Dimensions: 236 x 157 mm.
Date: summer, 1874
Editions: 1894 Dumont; 1905 Strolin
References: M-N 42; Guérin 61; Adhémar, *Nouvelles*, 231; Hanson, no. 139,
 p. 153

COMMENTARY: In this second version of the frontispiece, the figure is turned to the left as he is in the sketch in the Louvre (see cat. 81). The image is the same as that in the first version, except for this reversal, suggesting again that Manet might have used a tracing.

This plate, too, was abandoned. Apparently, the deadline for the publication was September, for Manet wrote to de Banville on August 2 that he did not feel he was going to be able to make it:

"Tout arrive même de manquer la gravure à l'eau-forte qu'on désirerait le plus réussir. Je suis désolé

et honteux mais forcé de partir ces jours-ci. Il me serait impossible d'être prêt pour le mois de septembre. Je dois donc le moment à l'honneur et au plaisir que j'aurais eu à faire quelque chose pour un de vos libres. . . ." (Étienne Moreau-Nélaton, *Manet raconté par lui-même*, Paris, 1926, II, 16).

Of all the work of 1874, these two attempts at a frontispiece for de Banville's poetry are most closely linked to the style of Manet's earlier works. The manner in which he conceived of the commission is reminiscent of his attempt at a frontispiece to accompany his edition of etchings of 1862 (cat. 38). The page shows a collection of images loosely scattered over the surface of the sheet which symbolize the thematic content of the poetry. In the smoke around the writer's head, spiraling upward from his cigarette, various images — two women, two clowns, and a ship — are enwreathed. The images are frankly reminiscent of the past as are the poems themselves,

for the Parnassian group, who acknowledged de Banville as their leader, was noted primarily for a revival of older poetic forms used by writers such as François Villon. These forms, the *ballade*, the *juitain*, and the *rondeau*, demanded a precise structuring of words and rhythms (see A. Schaffer, *Parnassus in France*, Austin, 1929, 131-35).

Technically, this print is quite different from other etchings of the early '70's such as the *Portrait of Berthe Morisot* and the *Line in front of the Butcher Shop*. The figures surrounding the head of the poet are suggested with fine, rather lightly bitten lines which delineate contours without interior modeling. The figure of de Banville, on the other hand, is formed by large, simple areas of tone distinguished from the other parts of the page by aquatint or hatching. The figure is not outlined, but is separated from the surroundings with short, parallel, diagonal strokes.

83.

Illustrations for "LE CORBEAU," translation by Stéphane Mallarmé of Poe's "THE RAVEN" (Figs. 163a-g)

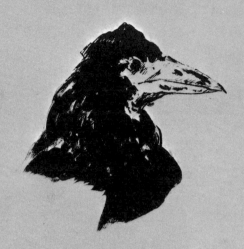

LE CORBEAU
(THE RAVEN)

Poème d'Edgar POE

Traduit par Stéphane MALLARMÉ

Illustré de cinq Dessins de MANET

TEXTE ANGLAIS ET FRANÇAIS

Illustrations sur Hollande ou sur Chine
AU CHOIX

Couverture et Ex-Libris en parchemin. — Tirage limité.

PRIX : 25 FRANCS.

Avec Épreuves doubles sur Hollande et Chine : 35 francs.

Cartonnage illustré, en sus : 5 francs.

Fig. 161

Transfer lithographs
Date: 1875
Editions: 1875 Poe
References: M-N 90-95; Guérin 85 and 86; Rosenthal, 100-101; Edgar Allan
Poe, *The Raven,* illustr. Edouard Manet, prep. Anne Blake Freedberg

("Picture Book Number 10," Boston, Museum of Fine Arts, n.d.);
Hanson, no. 133, p. 149; Harris, 230-33

a) *Poster and frontispiece: Head of a raven in profile* (Figs. 161, 162)
Dimensions: 162 x 152 mm.
Unsigned; undated
This image was used both on the poster announcing the publication
and on the outside cover of the edition. It was also used in 1899,
reproduced typographically on the cover of an edition of Mallarmé's
translations of Poe's poems published by Léon Vanier.

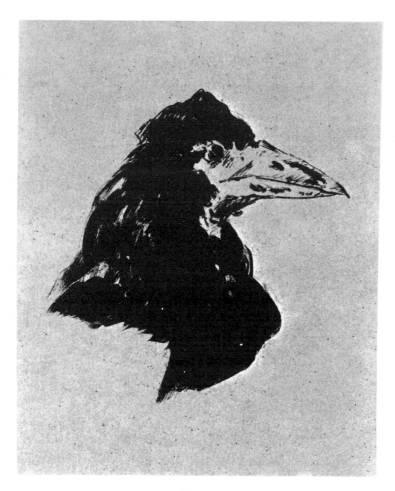

Fig. 162

b) *Under the lamp* (Fig. 163a)
Dimensions: 273 x 378 mm.
Signed lower left: "E. M."; undated
c) *At the window* (Figs. 163b, 163c)
Two states
Dimensions: 384 x 296 mm.
Signed left center: "E. M.;" undated
1st state: The landscape extends to the left only as far as the balcony
and is rather gray and indefinite in its form. Also, the silhouette
of the raven is somewhat obscured by the gray streaks in the
sky around it.

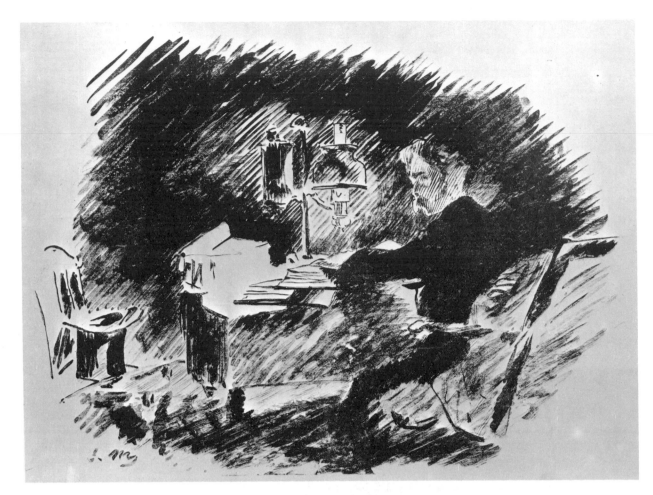

Fig. 163a

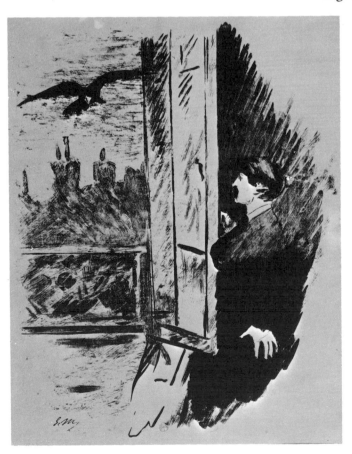

Fig. 163b

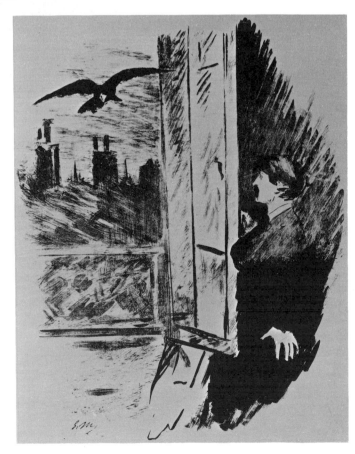

Fig. 163c

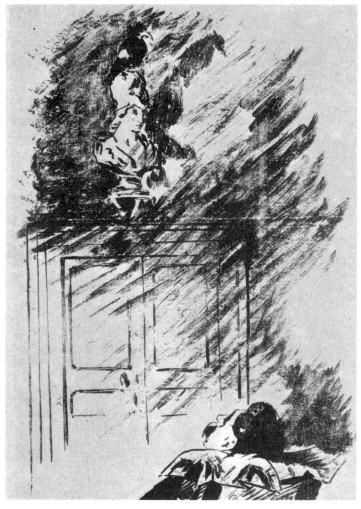

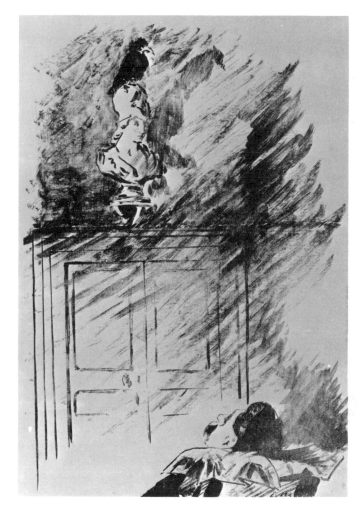

Fig. 163d Fig. 163e

 2nd state: The landscape silhouettes have been sharpened and made darker and extend farther toward the left than the line of the balcony. Also, the shape of the raven is more distinct because some of the clouds behind it have been eliminated.

d) *The raven on the bust of Pallas* (Figs. 163d, 163e)
 Two states
 Dimensions: 480 x 312 mm.
 Signed lower right: "E. M.;" undated
 1st state: The whole image appears as it was published except for a white spot in the middle of the Raven's body.
 2nd state: The Raven's body is now completely black.

e) *The chair* (Fig. 163f)
 Dimensions: 282 x 277 mm.
 Signed lower left: "E. M."; undated

f) *Flying raven:* ex libris (Fig. 163g)
 Dimensions: 63 x 240 mm.
 Unsigned; undated
 Accompanied by printed letters: "ex libris" above the bird. There is a preparatory study for this work which is in the shape of an oval (De Leiris 422).

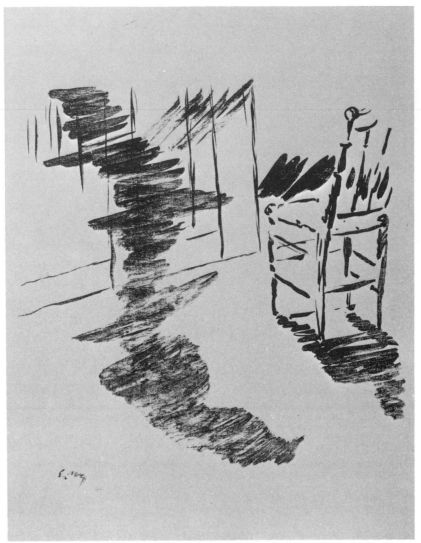

Fig. 163f

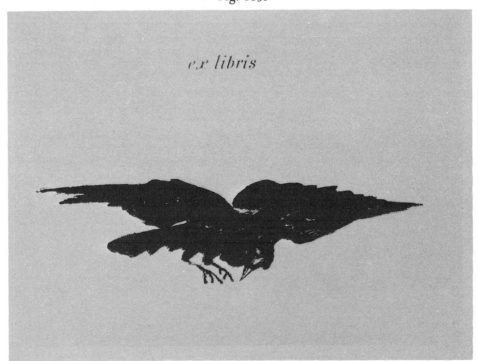

ex libris

Fig. 163g

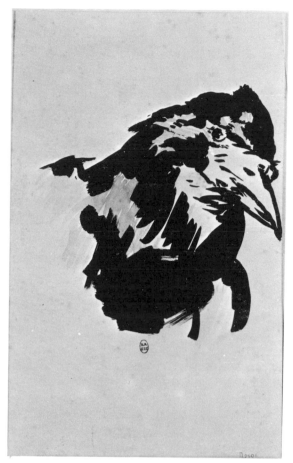

Fig. 164

Other pieces associated with the project, but not published:
g) *Bust of a raven and small dogs* (Fig. 164)

> Transfer lithograph
> Signed below dogs: "E. M.;" undated
> Dimensions: 250 x 320 mm.
> Date: January, 1875
> Editions: none
> Reference: Guérin 84

This sheet seems clearly to be associated with the Poe project. According to Guérin, a proof which was owned by Philippe Burty is dated in Burty's handwriting, January, 1875. It seems likely that this sheet represents an experiment with the technique of transfer lithography.

One of the two proofs in the Cabinet des Estampes in the Bibliothèque Nationale shows the head of the raven, which has been cut away from the other motifs on the page, touched with a light gray watercolor in some of the white areas of the bird's body.

The Japanese characters printed on the first sheet are not by Manet, but were apparently added by the printer.

The dogs are all the same. They are representations of Duret's dog, Tama, of whom Manet made some paintings at this same time.

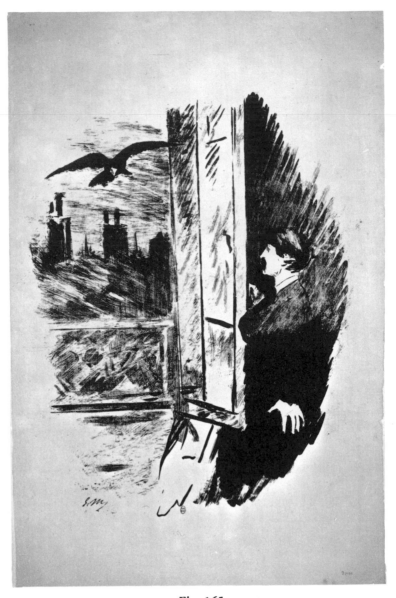

Fig. 165

h) *At the window* (Fig. 165)
 Unsigned; undated
 Dimensions: 400 x 280 mm.
 Only one proof known
 This print is a rejected version of the scene in 83c. The shapes are
 much more summarily treated than they are even in the published
 version.

COMMENTARY: This series of illustrations has been the subject of a careful detailed study elsewhere (Harris, 230-233), but certain details relevant to the appearance of the publication may be recorded here.

The period of time during which Manet was working on these illustrations can be surmised from two pieces of information. The first is the date of January, 1875, found on 83g, which suggests that Manet was just beginning the process of creating illustrations. The *terminus a quo* can be established by a post-card written by Manet to Mallarmé and dated May 27, 1875, in which the artist asks the poet to stop by at his studio that evening to put his signature on some copies of the publication (see Pléiades edition of *Oeuvres complètes par Stéphane Mallarmé,* Paris, 1945, 1518-19, notes by H. Mondor and G. Jean-Aubry).

The profile of the Raven later appeared reduced in scale on the cover of Mallarmé's translation of Poe's poetry, first published in Brussels in 1888. In the edition of Mallarmé, *Les Poèmes,* published by Léon Vanier in Paris in 1889, all of Manet's illustrations were reproduced photographically from the original lithographs in reduced scale along with two drawings representing *Annabel Lee* and *Le Cité en la mer.*

Illustrations for "L'APRES-MIDI D'UN FAUNE" by Stéphane Mallarmé
(Fig. 166)

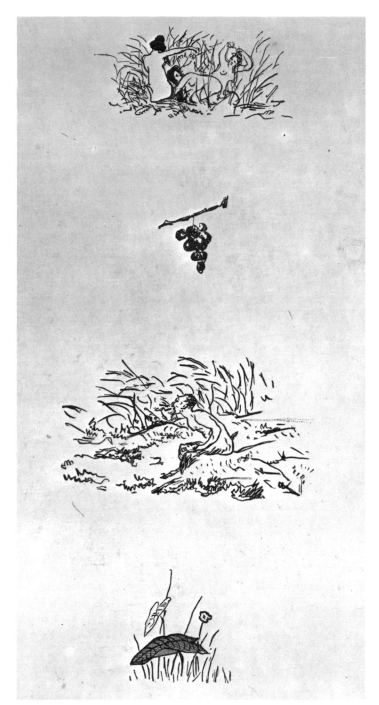

Fig. 166

Wood engraving
Unsigned; undated
Editions: 1876 Mallarmé
References: Guérin 93; Hanson, no. 134, p. 151; Harris, 233

a) Nymphs in the rushes
 45 x 95 mm.

b) Bunch of grapes
 40 x 35 mm.

c) Faun seated
 78 x 124 mm.

d) Leaves and a flower in grass
 55 x 53 mm.

COMMENTARY: Some proofs of these images exist in which all four scenes are printed on the same sheet (as here illustrated). Mallarmé described the first edition of the work, "One of those first costly pamphlets; a candy bag, but made of dreams . . . somewhat oriental with its Japanese felt, title in gold, and tie knots of black and Chinese pink." (G. Michaud, *Mallarmé,* trans. by M. Collins and B. Humez, New York, 1965, 89)

According to E. Noulet (*L'Oeuvre poétique de Mallarmé,* Paris, 1940, 221, note 2), Mallarmé was originally inspired to write his poem by a Boucher painting in the National Gallery in London. Certainly, Manet's image of the faun looks much like eighteenth century representations of such a demi-god, but its direct inspiration may have been the rococo-like image conceived by Jean Gigoux as an illustration of Lesage's *Gil Blas* (see American edition, New York, 1854, 729). According to Manet's biographer, Antonin Proust (*Edouard Manet: Souvénirs,* Paris, 1913, 54), Manet expressed great admiration for Gigoux's illustrations, which were wood engravings.

As I have pointed out elsewhere (Harris, 233), these images do not directly illustrate the poetry, but rather serve to embellish and to accompany it. Their extremely simplified drawing and small scale are perfectly suited to the fragile and evanescent mood which the poetry evokes.

85.

THE CONVALESCENT [La convalescente] (Figs. 167, 168, 169)

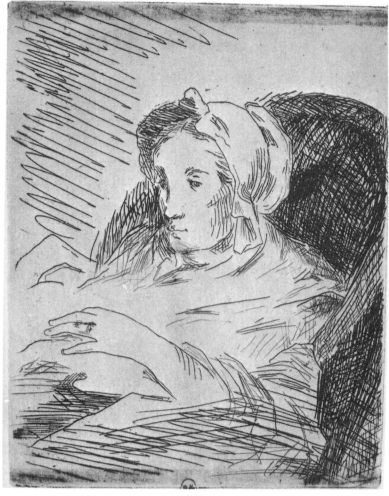

Fig. 167

Etching and aquatint: three states
Unsigned; undated
Dimensions: 128 x 110 mm.
Date: 1876-78
Editions: 1884 Bazire
References: M-N 21; Guérin 65; Rosenthal, 66; Hanson, no. 135, p. 151

1st state: The figure is described in pure etched lines. There is little drawing
 on the background behind the figure except for a few diagonal strokes
 at the left.

2nd state: The plate is much darkened by the reinforcing of the contrast
 between the white areas of the paper and the dark areas of the back
 of the chair and the space below the woman's arm. The background
 remains as it was.

3rd state: The background has been completely covered with zigzag hatchings
 and a light coat of aquatint, while the back of the chair is more
 uniformly darkened by additional strokes.

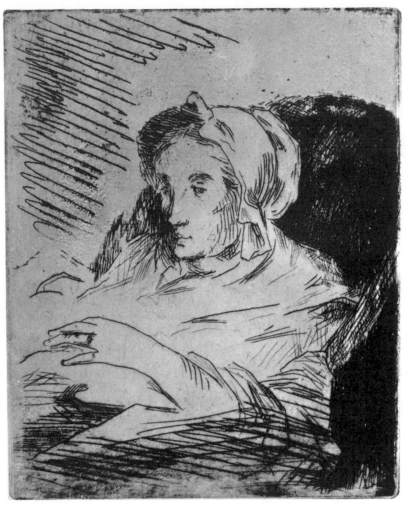

Fig. 168

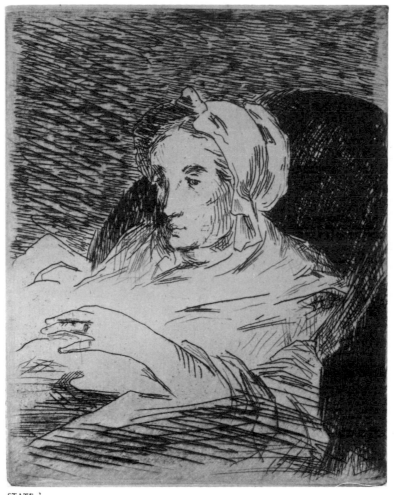

STATE 3

Fig. 169

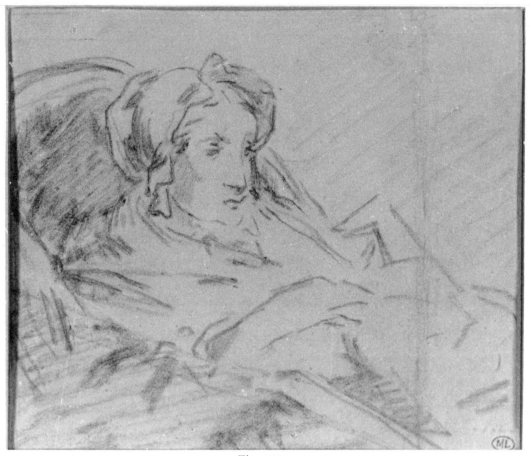

Fig. 170

COMMENTARY: This image could be a trial piece for an illustration of Poe's works as translated by Mallarmé. In September, 1876, Manet wrote to Mallarmé suggesting another collaboration (Henri Mondor, *Vie de Mallarmé,* Paris, 1941, I, 392), but nothing in the form of a publication came of the suggestion. Late in the summer of 1881, Manet wrote to Mallarmé about the Poe illustrations that Mallarmé had requested, saying that he was finding it very difficult to work and apologizing for not having accomplished anything. He added, "Mais aussi certaines choses que vous m'indiquiez me semblaient impossibles à faire—entre autres la femme qu'on voyait dans son lit par une fenêtre. Vous autres poètes vous êtes terribles et il est souvent impossible de figurer vos fantaisies." (Mondor, I, 418)

A source for the image might be Rembrandt's etching of Saskia in her sickbed (Hind 196), which has a somewhat similar motif and handling. Manet first sketched the figure in chalk in the same dimensions as the etched plate (De Leiris 453; Cabinet des Dessins, Musée du Louvre, Paris; Fig. 170). The woman pictured might well be Mme. Edouard Manet, as the features bear quite a strong resemblance to some portraits which Manet painted of his wife in the '70's (J. W. B. 311, 312).

In some respects this print resembles Manet's earliest etchings in its freedom and boldness of linear treatment. However, it cannot really be confused with prints of the early '60's, for it exhibits a far greater linear control and economy of modeling. The conception is related in spirit to the wash drawings which Manet was doing for his transfer lithographs of the '70's. Active lines convey a sense of atmosphere and motion. The absence of lines elsewhere provides a feeling of air and insubstantiality of solid form.

AU PARADIS (Fig. 171)

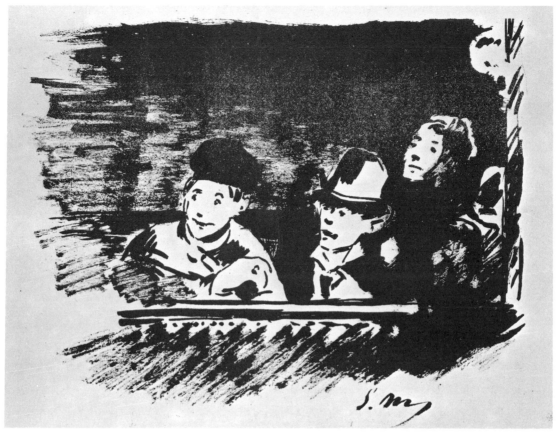

Fig. 171

Transfer lithograph: two printings
Signed lower right: "E. M.;" undated
Dimensions: 245 x 340 mm.
Editions: 1880 *Revue de la Semaine*
References: M-N 89; Guérin 82; Rosenthal, 102; Hanson, no. 176, pp. 185-86
1st printing: without letters, with a frame which has been cut in certain
 examples.
2nd printing: with letters: in lower center, "Au Paradis, dessin inédit de
 Manet;" at right, "Imprimerie Lehman et Cie., 57 Rue d'Hauteville,
 Paris;" at left, "Croquis parisiens, 1er série;" at right "2e année,
 no. 12."

COMMENTARY: The subject which Manet treats here is descended from many earlier precedents, notably, perhaps, those by Daumier, but he does not treat the scene as caricature. Rather, he here presents a perfect illustration of his concept of the *Aspect,* that glimpse of modern life's exciting and characteristic moments. Unlike his first print in the transfer lithograph process, *At the Café* of 1869, this is a very reduced view, with no emphasis upon the complete scene, but the image conveys the sense of life just as fully as does the earlier, more complex representation.

The technique resembles the illustrations for *The Raven* most closely. The immediacy, the absence of a frame around the picture, and the reduction of the modeling to a few strokes of dark wash all are features which Manet first exploited in his 1875 illustrations. The later print differs only in the degree of simplification which is used. The whole audience is symbolized by the three figures, whose rapt attention is suggested so economically with a few brush strokes.

LA BELLE POLONAISE (Fig. 172)

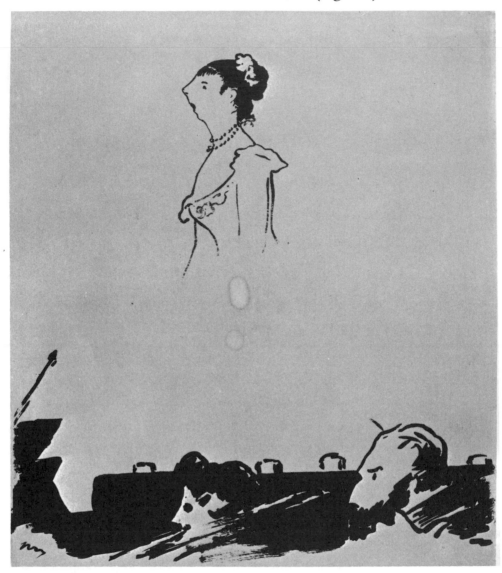

Fig. 172

Transfer lithograph: one state, only one example known
Signed left: "M.;" undated
Dimensions: 285 x 265 mm.
Date: 1878-81
Editions: none
Reference: Guérin 83

COMMENTARY: Several works by Manet show a figure similar to the one isolated and wittily depicted in this print. In the painting entitled *At the Café* (J. W. B. 303; Walters Art Gallery, Baltimore), we see a similar image; this painting was executed in 1878. There are also several drawings in which this figure appears, but none of them is exactly like the print (De Leiris 459 and 460, both dated 1876). Because of its brevity and assimilation of elements from a number of different works, I would place this work later than the 1878 painting of the same subject.

As in *Au Paradis* (cat. 86), Manet has focused attention on the most characteristic aspects of the scene by eliminating all but vital clues. He does not feel any necessity to establish a connection between the singer and the orchestra; it is perfectly clear what is going on without the addition of details. A sense of the relationship in space between singer and orchestra is hinted at by the sketchy rendering of the woman's figure, but Manet leaves it at that. At this period, he handles graphic notations as if each area of wash and each line were a word, leaving the spectator to put the words together to form sentences.

88.

JEANNE: SPRING [Le printemps]ᴾ (Fig. 173)

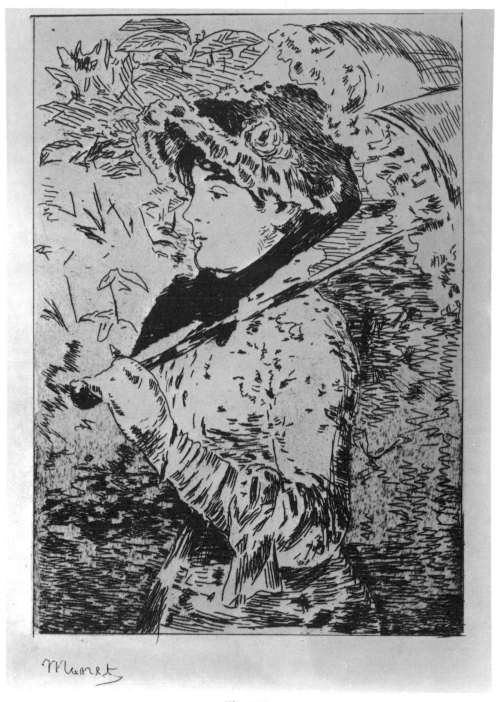

Fig. 173

Etching and aquatint: one state
Signed outside the frame beneath the drawing: "Manet;" undated
Dimensions: 154 x 107 mm.
Date: 1882
Editions: 1890 portfolio; 1894 Dumont; 1902 *GBA;* 1905 Strolin
References: M-N 47; Guérin 66; Rosenthal, 149; Adhémar, *Nouvelles,* 234-35;
 Hanson, no. 164, p. 175

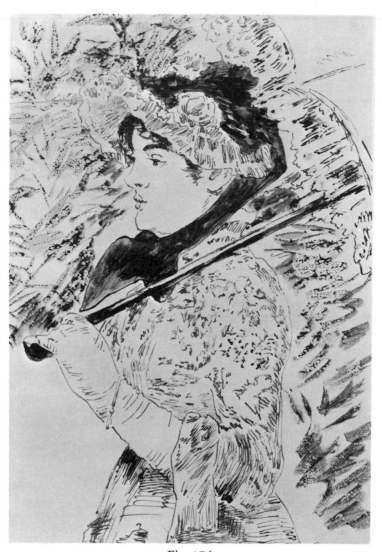

Fig. 174

COMMENTARY: The oil painting from which this etching was taken (J. W. B. 470; New York, Payne-Bingham Collection) was exhibited at the Salon of 1882. The print was not published during Manet's lifetime. The etching was made with the aid of a drawing taken from a photograph of the oil painting (De Leiris 588; Fogg Art Museum; Fig. 174). This drawing was traced from a photograph of the painting in reverse on thin paper which had been treated with a photographic emulsion and sizing to give it transparency. The drawing was reproduced in the *Gazette des Beaux-Arts* in 1882 (De Leiris, p. 11), but its relation to the etching is uncertain, as the print is smaller than the drawing.

The letter quoted by Adhémar (p. 235), which instructs Guérard not merely to see that the place is bitten (as Guérin suggests was done), but also to "work" the plate "d'un bon coup de burin," suggests that Guérard may have taken a partly worked plate and, using a tracing from a photograph, perhaps based on the reproduction in the magazine, worked the plate to its final appearance.

This etching represents in a graphic medium a theme which appears frequently in Manet's late oeuvre, the single female figure seen in profile. There is only one other oil portrait which represents a season (*Autumn*, J. W. B. 480), but the motif is very common in both oils and pastels of the late '70's and early '80's. It seems obvious that at this period, Manet viewed the female figure not only as memorable in its own right, but also as a characteristic symbol of the life of his times.

CONCORDANCE OF CATALOGUE NUMBERS

H=Harris
G=Guérin
M=Moreau-Nélaton

H	G	M	H	G	M	H	G	M	H	G	M
1	67		23	68	76	45	46	62	67	80	
2	55	46	24	11	53	46	36	58	68	57	44
3	4	22	25	12	54	47	43	35	69	56	72bis
4	1	70	26	13	52	48	44	38	70	58	45
5	8	5	27	14	55	49	48	34	71	76	82
6	5	50	28	15	66	50	49	33	72	75	81
7	10	51	29	70	78	51	34	59	73	77	83
8	19	56	30	71	86	52	40	37	74	78	84
9	41	65	31	27	11	53	39	17	75	59	41
10	3	68	32	69	77	54	73	79	76	92	100
11	17	10	33	23	3	55	33	13	77	90	99
12	16	4	34	24	31	56	64	20	78	91	99
13	18	57	35	32	7	57	51	18	79	63	23-40
14	6	14	36	47	71	58	74	80	80	79	87
15	7	6	37	28	49	59	31	15	81	60	67
16	9	8	38	29	48	60	37		82	61	42
17	20	61	39	62	1	61	38	16	83	85, 86	90-95
18	21	2	40	35	39	62	50	64			
19	25	12	41	72	85	63	54	36	84	93	
20	26	9	42	42	60	64	52	43	85	65	21
21	30	40	43	22	32	65	53	19	86	82	89
22	2	69	44	45	63	66	81	88	87	83	
									88	66	47

List of Illustrations

[237]

[243]